Michael Angelo Rooker 1746–1801

PATRICK CONNER

Michael Angelo Rooker

1746–1801

B.T. BATSFORD LTD · LONDON
IN ASSOCIATION WITH THE
VICTORIA & ALBERT MUSEUM

*Printed in Great Britain by
Butler & Tanner Ltd, Frome and London*

for the Publisher

*B. T. Batsford Ltd
4 Fitzhardinge Street
London* W1H 0AH

Contents

List of illustrations

Colour plates *between pages 144 and 145*

Black-and-white illustrations

NOTE: *drawings and watercolours are by Michael Angelo Rooker unless otherwise identified. This list does not include monochrome illustrations forming the catalogue of works held in the collection of the Victoria & Albert Museum (p. 147).*

I EDWARD AND MICHAEL ANGELO ROOKER

III THE CITY SCENE

Views of London

NOTE:
Bold numerals given in the text in parentheses are references to
illustrations in the **catalogue**; references such as 'fig. 9' indicate
illustrations in the general chapters.

Foreword

If J.M.W. Turner is the Byron and the Shelley of watercolour painting, then Rooker has something in common with Keats – the Keats who believed that poetry should be unobtrusive, 'a thing which enters one's soul, and does not startle it or amaze it with itself but with its subject';[1] who relished the precise, sensuous qualities of colour and texture in natural objects, rather than their metaphysical overtones; who, unlike many of his contemporaries, found mountain scenery ultimately oppressive, and preferred the more fertile and domestic pastures of the southern counties. Even as Turner was beginning to undertake subjects of Byronic grandeur, and, like Shelley, to seek out the 'solitary places', fiery sunsets and thunderstorms merging sea and sky, Rooker looked with affection at the familiar elements of the countryside. Keats's lines 'upon a little hill' could stand as Rooker's epitaph:

> Linger awhile upon some bending planks
> That lean against a streamlet's rusty banks,
> And watch intently Nature's gentle doings . . .

Recent years have seen a surge of interest in the art of Turner, and in particular in its 'sublime' qualities. It may now be a suitable moment to consider an artist who, although an immediate precursor of Turner, was totally at odds with the Sublime. Michael Angelo Rooker could scarcely have displayed less of the 'grand style' associated with his great Italian namesake. Exaltation, terror, high drama, vastness and generalization were foreign to Rooker, who was concerned with the specific, the everyday, the intimate. Yet he was much occupied with architectural ruins – which were often associated, in the poetry and the painting of the time, with grandeur and sublimity. Here lies one of the most remarkable aspects of his art. Subjects which to other artists represented savage desolation are tamed and domesticated by Rooker, partly through his virtuoso technique, which draws our attention to the material components of a building, and the characteristics of individual bricks and plants, rather than to overall effect; as some of his contemporaries acknowledged, the Sublime calls for generalization, and is diminished by specificity.[2] A second contributor is the atmosphere of gentle sunshine in which he bathes his subjects, the better to pick out the textures and sculptural qualities of crumbling masonry, and to dispel any Gothick *frissons* or melancholic musings. The third and most subtle means by which Rooker's effect is achieved is his use of figures; these aspects of his art, and its relation to the work of other 'topographical' artists of the time, are discussed in a later section of this book.

Since no biographical account of Rooker exists, I have also tried to bring together the scattered evidence which bears on his life. His career coincided

with something of a revival of the graphic arts in Britain – not merely in oil painting, through the agency of Gainsborough, Reynolds and Wilson, but also in engraving, book illustration and scene-painting, all activities in which Rooker participated. He grew up in the centre of the English art world, was closely involved with the Royal Academy in its early days, and helped to develop the infant art of English watercolour. Yet through all the upheavals of the late eighteenth century he pursued his own modest and independent ideal, preserving in his art a distinctive quality of 'warmth' which is more than a matter of sunshine and shadow. It perhaps has something in common with Keats's experience as he took a Sunday walk near Winchester on 21 September 1819: 'Somehow a stubble plain looks warm in the same way that some pictures look warm – this struck me so much in my Sunday's walk that I composed upon it.'[3] *To Autumn* was the result.

It has been a pleasure to study Rooker, and I am grateful to Michael Kauffmann and John Murdoch of the Victoria and Albert Museum for giving me the opportunity to do so, by initiating the project and continuing to lend their support. Special thanks also to James Miller, a fellow-enthusiast for Rooker's art, who has sent back news of interesting drawings from various remote outposts. In addition to the many curators and librarians who have generously lent their assistance, I should like to record my gratitude to Mr David Alexander, Dr D.G.C. Allan, Mr Reginald Alton, Mr Robin Atthill, Miss Anne Buddle, Dr Bridget Cherry, the Hon. and Mrs Alan Clark, Mr D.T.-D. Clarke, Mr Howard Colvin, Dr David Cordingly, Mr Stephen Croad, Mr William Drummond, Mr Bamber Gascoigne, Mr John Harris, Mr Ralph Hyde, Mr Terence Hodgkinson, the late Mrs Cecil Keith, Mr Paul Laxton, Dr John Newman, Miss Helen Mary Petter, Mr Harry Pitt, Dr Marcia Pointon, Mr Bruce Robertson, Mr Ian Robertson, Miss Sybil Rosenfeld, Mr David Scrase, Miss Lindsay Stainton, Dr John Villiers, Mr Henry Wemyss, Mr Andrew Wilton, and Mrs Leslie Wright.

In trying to track down works which have passed through the hands of dealers or sale-rooms I have been kindly assisted by Thomas Agnew and Sons, the Fine Art Society, the Leger Galleries, Leggatt Brothers, Spink and Son, Christie's and Sotheby's. Finally I must acknowledge that much of my research on Rooker and his contemporaries has been achieved with the aid of fellowships from the Leverhulme Trust and from the Yale Center for British Art, New Haven; my particular thanks are due to the staff and associates of the Yale Center for their friendly hospitality.

NOTES

1. *The Letters of John Keats 1814–21*, ed. Hyder Rollins, Cambridge, 1958, vol. I, p. 224 (letter of 3 February 1818). For the response to landscape on the part of the Romantic poets see J.R. Watson, *Picturesque Landscape and English Romantic Poetry*, 1970.

2. See Carl P. Barbier, *William Gilpin*, Oxford, 1963, pp. 106–7, for William Gilpin and Sir George Beaumont on this topic.

3. *Letters*, op. cit., vol. II, p. 167.

Michael Angelo Rooker 1746–1801

I Edward & Michael Angelo Rooker

EDWARD ROOKER

The profession, if not the vocation, of artist has often run within families, but Michael Angelo Rooker's debt to his father was unusually great. Edward Rooker was Michael's teacher and collaborator, and almost certainly the means of his son's *entrée* into the theatre. He was moreover a most capable practitioner in his own right, although his reputation is now long gone. In 1811 there were still a few who remembered him:

> Edward Rooker was not only the most celebrated Harlequin of his time but also the first ruler in this kingdom, the king not excepted.[1]

This riddling contribution to Ackermann's *Repository of the Arts* was quickly resolved by an imaginary dialogist, who replied, 'I understand, you mean the first ruler of architecture,' and proceeded to elicit a brief but valuable account of the elder Rooker's life. After serving as a pupil of the engraver and printseller Henry Roberts in High Holborn, Edward Rooker pursued two professions with equal success: that of actor – in which capacity he became the principal Harlequin at Drury Lane – and that of engraver, specializing in architectural subjects. According to the engraver William Byrne, who had previously shared a house with Edward Rooker, the latter believed that the exercise he took each evening in playing Harlequin 'was of service to him in counteracting what he thought was a gouty affection which often seized his stomach'.[2] He died on 22 November 1774, at his house in Great Russell Street, Bloomsbury.[3]

> He had invited friends to dine with him, His wife going into the Bedchamber He having continued in Bed rather longer than usual, and finding him indisposed went for something to relieve and on returning found him dead.[4]

He was buried in the parish churchyard of St Giles-in-the-Fields four days later.[5]

Edward Rooker is often stated to have been born in 'about 1712',[6] but Byrne, who was evidently well informed on the subject, asserts that 'He died on His *birthday* at the age of *50*' – which would give his year of birth as 1724. On this reckoning he would have been in his early twenties in the late 1740s, which is plausible, for at this time his first engravings were published and he made his appearance on the London stage. He is first recorded as an actor on 27 February 1749, at the New Wells in Lemon Street. By the following April he was appearing at another minor playhouse, the New Wells, London Spa, Clerkenwell; and on 8 December 1752 his name is first listed among the company at the Theatre Royal, Drury Lane, where he remained as one of Garrick's principal actors for 20 years. Although best known in his role of Harlequin, in which 'he was remarkable

for his agility',[7] he appeared in a variety of plays and pantomimes, including the elaborate *Fêtes Chinoises* produced at the height of the fashion for chinoiserie in 1755. Evidently he was considered suitable for the *buffo* roles, such as Stephano in *The Tempest*, and 'Drunken Man' (one of his first parts at Drury Lane) in Garrick's *Lethe*. He was still appearing as Harlequin in October 1774, a month before his death. His widow was given a benefit on 10 May 1775, at a performance of *The Conscious Lovers* and *Harlequin's Jacket*, receiving a third share of £114.[8]

Pantomime actor and engraver: an unusual combination of professions which had little in common as regards the specific skills required, but which were perhaps comparable in status – decidedly inferior to the tragic actor in one case, and to the oil painter in the other. Engravers were for many years denied entry to full membership of the Royal Academy, much to their resentment; other artists claimed that engraving was 'wholly devoid ... of those intellectual qualities of Invention and Composition, which Painting, Sculpture and Architecture so eminently possess'.[9] In the eighteenth-century theatre a similar hierarchy of roles was operative, again based upon the intellectual and creative demands which were thought to be attached to each; on this scale Harlequin ranked low. A musical prelude devised by Edward Rooker's colleague at Drury Lane, the majestic David Garrick, compares the functions of Tragedy, Comedy and Pantomime, each of which pleads to be considered worthy to occupy the new Drury Lane theatre. Harlequin, representing Pantomime, makes a modest appeal to the audience on behalf of his art:

> Without my help your brains will be all muddy:
> Deep thought and politics so stir your gall,
> When you come here you should not think at all;
> And I'm the best for that ...[10]

A conversation of Joseph Farington's dinner table reveals a little more of the current nuances of artistic rivalry.

> Edwards speaking of old Rooker, remarked how extraordinary it was, that He who in the morning was employed in engraving the fine plate of St. Paul's, should in the evening play Harlequin on the Stage. Hearne did not think it extraordinary. The engraving of that Plate was a mechanical process, ruling lines &c, it was not to be considered *as an effort of mind*, but a dexterity of hand in ruling lines &c. It required no sentiment, no elevation, such as would actually raise a man above the other practise [*sic*].[11]

So the oil painter Edward Edwards and the watercolourist Thomas Hearne were implicitly agreed that playing Harlequin was an occupation

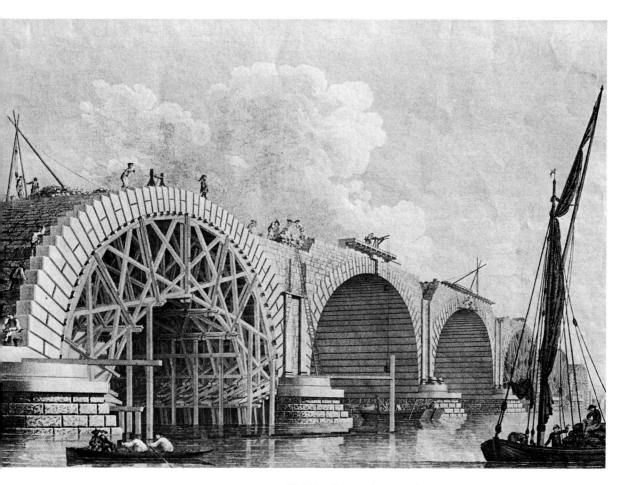

FIG. 1 *Blackfriars Bridge under construction*
Drawn and engraved by Edward Rooker
Victoria & Albert Museum

bordering on the vulgar; but Hearne, outdoing Edwards in his post-pran-dial snobbery, regarded architectural engraving as an equally lowly occupation.

Hearne was mistaken, however, in suggesting that Rooker's graphic work was merely a display of dexterity. The plate in question was a sectional view of St Paul's Cathedral published in 1755 by Samuel Wale and John Gwynn, a magnificent engraving nearly three feet tall by two feet wide, which presents the cathedral adorned with an imaginary rococo decorative scheme 'agreeably to the original INVENTION of Sr. Christopher Wren', detailed to the last plunging *putto*. Horace Walpole judged this plate to be 'the first specimen of architectural engraving', and declared that 'Mr Rooker is the Marc Antonio of architecture'.[12] Gwynn's task was more hazardous: while taking measurements of the dome, Gwynn missed his footing and was saved from an early death by a projecting piece of lead. When the measurements were almost complete a pickpocket removed the book which contained them, and Gwynn had to start afresh; such, at any rate, was the story told by the younger Rooker to Farington.[13]

Edward Rooker's achievement as an engraver coincided with a minor renaissance in English engraving, which – Hogarth excepted – had pursued an unremarkable course in the first half of the century. While William Woollett was emerging as England's leading engraver of landscapes, and Robert Strange won a European reputation for his prints after Old Masters, Edward Rooker specialized in topographical and architectural views. In the years 1748-9 he had a hand in three ambitious projects, beginning with an engraving (even larger than the section of St Paul's) of the proposed palace of Whitehall, as designed by Inigo Jones. There followed an engraving, after Gwynn and Wale, of Wren's unexecuted plan for rebuilding the City of London after the Great Fire; the text exhorted readers to retrieve as much of the plan as possible, when 'unavoidable dilapidations' arose.

The third project, published on 14 April 1749, was *A perspective view of the Foundling Hospital, with Emblematic figures*, engraved by Grignion and Rooker after Wale. Since 1740 a number of artists, led by Hogarth, had contributed paintings to decorate this new hospital, and the display soon became a fashionable attraction. In this way the idea of regular exhibitions gained currency, and the artists associated with the hospital gained a sense of solidarity. At a momentous meeting of 12 November 1759, at the Turk's Head Tavern in Gerrard Street, it was resolved that a sixteen-strong committee, drawn from all the branches of the graphic arts, be set up to arrange an annual exhibition of their work.[14] Two places were allotted to

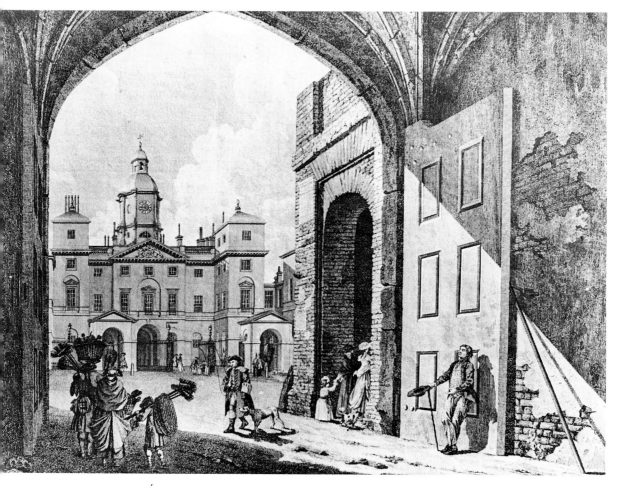

FIG. 2 *Horse Guards, Whitehall*
Engraved by Edward Rooker after Michael Angelo Rooker
Victoria & Albert Museum

engravers, who thus enjoyed a short-lived period of influence on the destiny of British art; Edward Rooker was elected to one of them, and remained an active force in the artists' quest for recognition. In 1765 he was one of the original directors of the Society of Artists of Great Britain, and in the following year he was the sixth signatory of the declaration of the Society of Incorporated Artists (as the society was now known), in a list of 211 which included almost every artist of merit practising at the time.[15]

Edward Rooker was now at the peak of his career. His work in the 1750s included three fine engravings of London views after Canaletto,[16] and the section and interiors of *A merchant's house, Canton* which are the most convincing of William Chambers's *Designs of Chinese Buildings* ..., 1757. He contributed to many of the principal architectural publications of the period, including Chambers's other illustrated works, *A Treatise on the Decorative Part of Civil Architecture*, 1759, and *Plans ... of Kew*, 1763;[17] Stuart's *Antiquities of Athens*, 1762; and Robert Adam's *Ruins ... at Spalatro*, 1764. The grand eighth edition of Philip Miller's *Gardener's Dictionary*, 1768, has an allegorical frontispiece engraved by Edward Rooker, and a curiosity among prints of this period in his life-size engraving of 1763 of George III's coronation crown, 'embellish'd with 2621 Brilliants of the finest water ... surpassing in Richness and Beauty all the Preceding Crowns in England'.

Of his many topographical engravings perhaps the best known are a set of six London scenes published in the years 1766-8: *St James's Palace, St Paul's Church (Covent Garden), Covent Garden Piazza, Scotland Yard* (in fact Whitehall Court), *Blackfriars Bridge under construction* (fig. 1), and *The Horse Guards*. The original series was published by Edward Rooker himself,[18] but reprints were issued after his death by Boydell, first on the same scale and then in reduced form. The first five of these London views, which were based on drawings by Paul and Thomas Sandby, clearly exhibit qualities which were to characterize the work of Michael 'Angelo': a sensitive depiction of architectural textures, and a variety of human activity – carters and builders at work, watermen touting for business, children playing, assignations being made. In the sixth of the series, for which the artist was the younger Rooker, there is an added element of mock-heroic. This is a view (fig. 2) of the Horse Guards whose construction had been completed only eight years before, seen from beneath the Tudor gatehouse of the old Whitehall Palace. A family of tinkers passes through the archway, laden with baskets and bristling with brooms, while an official-looking figure moves across to intercept them. High up on the wall a handbill alludes to the engraver's second profession: it announces a benefit performance of *As You Like It* for Mr [Edward] Rooker.[19]

Edward Rooker also collaborated with Paul Sandby in a very different enterprise, the etching of John Collins's designs for an edition of Torquato Tasso's *Jerusalem Delivered*, an epic fairy-tale which was particularly popular throughout Europe in the eighteenth century. Edward Rooker and Paul Sandby worked together to produce three bold and turbulent etchings which, although far removed from the delicate illustrations of the same poem drawn by their contemporary Fragonard, were equally remote from the style of the Englishmen's own topographical work. All are scenes of wild fantasy. In one, turbanned gentlemen move among gnarled oaks mingled with palm trees; in another, *The forest as enchanted* ..., dragons and devils – both species breathing fire – threaten Rinaldo in a deep thicket, beside the menacing branches of a blasted oak. These have been described as

> one of the largest and most noble performances in British Etching. The handi-
> work is powerful, even fierce, inked and bitten with tremendous vigour ...
> *tours-de-force* of the most impressive kind ... if we could see more of him [Edward
> Rooker] as an Etcher we might have to acclaim a Master.[20]

From 1760 to 1768 Edward Rooker contributed thirteen engravings to the exhibitions of the Society of Artists, beginning with the *Section of St Paul's* in the Society's first exhibition and concluding with two views of Covent Garden Piazza in 1768.[21] In this year the Society was torn by internal dispute, and a powerful body of artists left to found a rival institution – the Royal Academy, as it became. Most of the original directors of the Society of Artists became founder members of the Royal Academy, but Edward Rooker found himself ineligible, as an engraver, for membership of the new body. Meanwhile Robert Strange maintained an acrimonious battle against the Royal Academy, and perhaps hardened its resolve to exclude engravers, who, as the oil painters often pointed out, had less to gain from public exhibitions, since their work could in any event be duplicated and circulated. In 1770 a new class was introduced – Associates of the Royal Academy – which was to function both as a means of giving the engravers some degree of recognition and as a half-way stage on the path towards full membership; not surprisingly, the leading engravers were not tempted by this gesture, and Edward Rooker did not become an Associate.

In the last years of his life he was as active as ever, engraving drawings by his son for the *Oxford Almanack* (see p. 106), landscapes by William Pars and Richard Wilson, country-house views by Paul Sandby, and elevations of the new Gothick palace and gatehouse designed by Thomas Atkinson for the Archbishop of York at Bishopsthorpe. He lived to see his son firmly

established in his profession, and when he died in November 1774 Michael 'Angelo' was able to take over the various projects which Edward had left unfinished. The issue for January 1775 of the monthly *Copper-Plate Maga-zine*, which had begun in the previous year to publish a series of engravings by Edward Rooker after Paul Sandby, offered instead an engraving (of Wynnstay) by the younger Rooker, together with the following statement:

> It is with the utmost concern that we acquaint our encouragers of the death of Mr. Edward Rooker, whose loss we deplore not only as an artist, but as a man. His demise is a public calamity, and is universally lamented. To console us, however, in some degree, we are convinced by the perspective view annexed, that genius and taste is, in some instances, hereditary; and that Mr. Rooker junior inherits all those eminent abilities as an artist, which were so justly and universally attributed to his father.[22]

MICHAEL ANGELO ROOKER

Like his father, Michael Angelo Rooker had the good fortune to spend most of his life in the centre of London's artistic and theatrical activity. In the 1760s both Rookers gave their address as Great Queen Street, which at that time connected Drury Lane with Lincoln's Inn Fields. (In the twentieth century Kingsway cut a swathe through the intervening streets, curtailing Great Queen Street at its eastern end.) In this street of hand-somely pilastered houses – reputedly the first regular street in the metro-polis[23] – London's first academy for drawing and painting from life had been founded in 1711, under the governorship of Sir Godfrey Kneller and subsequently Sir James Thornhill. Great Queen Street maintained its ar-tistic connections in the middle and later years of the century, when the portrait painter Thomas Hudson lived in the house previously occupied by Kneller; Benjamin Wilson, the artist-cum-scientist whom Rooker was to depict at work in the Pantheon (fig. 49), lived at no. 56, in which Boswell later composed part of his biography of Johnson. The Academicians Na-thaniel Hone and John Opie, and the engravers Sir Robert Strange, Thomas Worlidge and James Basire, were all resident in Great Queen Street at some time in the latter part of the century.[24] The Free Masons Tavern, in the same street, became the venue of the Royal Academicians' annual dinner on the occasion of the King's birthday.

The Rookers, however, did not live in one of the grand houses in this notable terrace. One of its largest houses, which had served as the Spanish Ambassador's residence when it was first built in 1637, was pulled down a century later, and in 1740 twelve smaller houses were erected on the site. These formed Queen's Court, which was approached through an archway;

and it is here that Edward Rooker is recorded as a ratepayer from 1755 to 1760.[25]

The younger Rooker moved house at least four times in his adult life, but it seems that he never left the neighbourhood in which he was brought up. None of his recorded lodgings was more than half a mile from the parish church of St Giles-in-the-Fields. In 1768 he was 'at Mr. Smith's, Long Acre'; from 1774 to 1786 he gave his address as 'Opposite the Museum, Great Russell Street', where once again he was a neighbour of Benjamin Wilson. By 1789 he had moved back towards Covent Garden and was living at 53 Long Acre; from 1793 until his death his home was 23 Dean Street in Soho.[26] Dean Street, which meets Oxford Street at its northern end, was at that time a thoroughly respectable location, whose artist residents had included Thornhill, Smart, Hayman, Rigaud, Hamilton and Beechey. (By the 1850s the character of the district had altered; when Karl Marx and his family lodged in two rooms at the top of 28 Dean Street, it was described by a Prussian agent as 'one of the worst, therefore the cheapest, quarters of London'.[27]) From 1798 no. 23 was owned by Henry Morland, picture-dealer and brother of George Morland the convivial painter of rustic scenes, who, constantly on the move to avoid his creditors, often stayed there during the years before his death in 1804.[28] Rooker no doubt spent several of his own last years in the Morlands' *ménage*.

Rooker has had no biographer, but the principal circumstances of his life can be gathered from contemporary accounts and from the testimony of his friends and acquaintances. He was an only child, and did not marry; unlike several of his fellow artists, he appears to have had no illegitimate children. Apart from what has been said above of his father, there are few traces of his family. Only one Rooker achieved more than a passing mention in the *Gentleman's Magazine* during the eighteenth century – and if he was any relation of Edward and Michael, they probably did their best to forget him. This 'Mr Rooker', formerly a grocer in Fleet Street, was said to have tried to kill himself by standing under a suspended weight and cutting the rope; in 1763 he was finally found dead in a lane near his house at Ealing, 'dismembered, and his throat cut in a shocking manner'. The cause of death was given as lunacy on the part of Mr Rooker.[29]

The career of Michael Angelo Rooker, far from lunatic, has often been summarized in biographical dictionaries, but almost all of the information contained in these summaries is derived ultimately from an obituary notice in the *Gentleman's Magazine* of May 1801; its author was probably the architect Henry Hakewill, the principal executor of Rooker's estate and no doubt his closest surviving friend. Several documents relating to Rooker's

work, written it appears by Henry Hakewill, were handed down by Hakewill descendants until in 1964 they found their way into the British Museum. Among them are a diary of one of Rooker's sketching-tours (see Appendix 1), and a manuscript obituary with a note at the foot, 'Copy this & take it to the Gent's Magazine'; the version printed in the *Gentleman's Magazine* does indeed correspond with the manuscript almost exactly. Most of the other Hakewill documents refer to the sale of Rooker's effects at Squibb's Auction Rooms, which took place after the artist's death in March 1801.

Michael Angelo Rooker was born almost certainly in 1746, despite the fact that his date of birth is generally given as 1743. W.T. Whitley, the great compiler of information about British artists of the eighteenth century, observed that 'according to his own statement, preserved in the records of the Royal Academy, Rooker first saw the light on March 25th, 1746'.[30] Unfortunately no such statement can be traced today, either in the library of the Royal Academy or in the Whitley papers at the British Museum, but Whitley's assertion is supported by the records of the drawing competitions which Rooker entered as a boy. These competitions were organized by the Society of Arts (now the Royal Society of Arts), which offered prizes for the best performances in several categories and age ranges; and in 1759 Rooker, in the Class of Polite Arts, was awarded the first share of the premium for 'Drawings of any kind, under the age of fourteen'. His offering was *An Academy figure*. In the following year Rooker, having presumably passed his fourteenth birthday, won fourth share in the premium for a different category: 'Views from Nature, taken upon optional Spots, by Youths under the Age of 19 Years.' On this occasion Rooker had opted for a view of *The [River] Brill from the Bowling Green House near St Pancras*, executed in chalk.[31] This is the earliest of his drawings which survives (fig. 3), and it already suggests the influence of Paul Sandby. The premium system, which was first adopted in 1755, seems to have succeeded in attracting strong competition, to judge by the many names in the premium lists of young men who later won reputations as painters, sculptors or engravers: they include Cosway, Mortimer, Gresse, Pars, Earlom, Russell, Vivares, Grignion, Wheatley, Hoare, Hearne, Hodges, Edwards and Farington.

In the 1760s Rooker appeared before the public as an artist, exhibiting nine views at the Society of Artists. Either he or his father had at least one pictu·e on display in every annual exhibition from 1760 to 1768, although until 1767 they seem to have avoided exhibiting on the same occasion. All or most of his offerings were watercolours (the medium is not always stated

FIG. 3 *The Brill from the Bowling Green House near St Pancras*, 1760
Royal Society of Arts

in the catalogue): the first, shown in 1763 when he was seventeen years old, were described simply as *Three views from nature*, followed by *Two stained drawings from nature* in 1765, and in 1766 *A view of the Horse Guards; in water colours*.[32] ('Stained drawing' and 'water colours' here refer no doubt to the same technique; there is no evidence that Rooker ever employed opaque colours, as did Paul Sandby and a number of contemporaries.) Edward Rooker may well have encouraged his son to practise draughtsmanship so that father and son could work in tandem; several of Edward Rooker's engravings of the late 1760s and early 1770s were based on drawings by Michael, and but for Edward's untimely death the partnership might have flourished for many more years.

It was probably for a period during the 1760s that Rooker worked under Paul Sandby – an apprenticeship which is not mentioned in Hakewill's obituary of Rooker, but which seems entirely likely. Edward Edwards, who must have known both Sandby and the Rookers well, asserted that after Rooker had been taught engraving by his father, he was 'placed under the care of his father's friend, P. Sandby, to be instructed in drawing and painting landscape'.[33] The matter of Sandby's 'pupils' is a little mysterious, because an authoritative memoir of Sandby relates that since he

> never could be prevailed upon to take under his instruction any professional pupil but his son, it is to be presumed, that that gentleman is the repository of his discoveries and peculiar methods of working in his art.[34]

But this memoir was almost certainly composed by the son himself, Thomas Paul Sandby – under the transposed initials 'S.T.P.' – and is therefore not wholly objective; several other young artists (Cleveley, Gandon, Beechey, Munn) appear to have worked with or under Paul Sandby. In any case the function of Rooker may have been that of assistant or junior partner to the older artist, rather than pupil in the strictest sense.

By the late 1760s Rooker was writing his name as 'Michael Angelo Rooker', and since then he has seldom been referred to without the 'Angelo'.[35] It is Paul Sandby who is supposed to have supplied this memorable middle name 'in a jocular way',[36] but we may suspect that Edward Rooker may have had the same notion in mind when he chose the name 'Michael', an uncommon one at the time, for his son. Other artists' sons were named after the great masters of painting: Benjamin West called one of his sons 'Raphael', and two more of Rooker's contemporaries, the sons of a landscape painter, were John Raphael Smith, renowned for his mezzotints, and the miniature painter Thomas Correggio Smith. John Raphael's son also became an artist – John Rubens Smith.

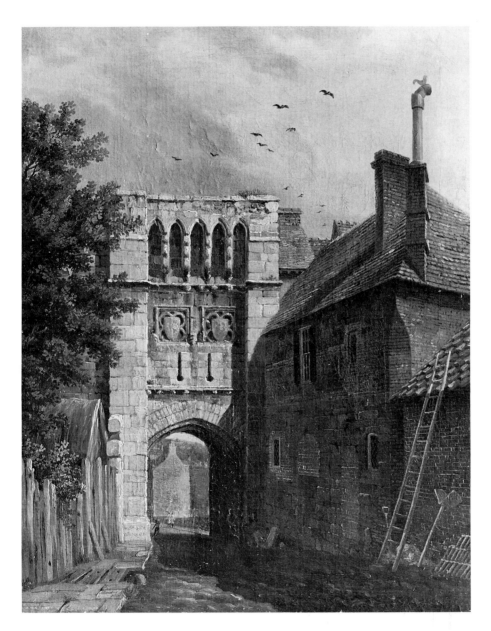

FIG. 4 *Westgate, Winchester* (oil), RA 1779
Manchester City Art Gallery

In 1768 came the great secession from the Society of Artists, and the foundation of the Royal Academy, of which a central feature was its Schools of Design, free of charge and supervised by 'the best Artists' – in fact nine elected Academicians. The first students were admitted in January 1769, having satisfied the Keeper of the Academy, and the Council, as to their abilities. The Schools rapidly established themselves as the principal academy of art, and were attended by many, probably most, of those who became celebrated in the next half-century as painters, sculptors or engravers. The first year's intake, which was unusually large, included Rooker, who was probably not hindered by the fact that the Keeper, George Michael Moser, had sat with Rooker's father on the council of the Society of Artists. One of the two artists admitted on the same day as Rooker was John Hakewill, which suggests that there may already have been some friendship between the Rooker and Hakewill families. Several other artists who later practised topographical watercolours entered the Schools in the same year, notably Edward Edwards, Thomas Jones, Joseph Farington and William Pars.[37] None of these would at the time have regarded themselves, or been regarded, as topographical draughtsmen; 'drawing' was not one of the categories of profession under which students could enrol, and all the above-mentioned artists, including Rooker, described themselves as 'Painter'.

At this date there was probably no young artist who visualized a career devoted entirely to watercolours, and Rooker must certainly have hoped that he might make his way as a painter of landscapes in oils. During his years at the Schools, if we assume that he attended for the full six-year span, most of his exhibits at the Royal Academy were oil paintings, and the fact that several replicas of his oils survive indicates that he was not unsuccessful in selling his work. In 1779 he made a final effort to make his mark as an oil painter, showing five topographical oils at the Academy exhibition including *Westgate, Winchester* (fig. 4); subsequently this medium seems to have occupied only a small place in his repertoire. He would have been aware that even the most eminent British artists were finding it difficult to dispose of their landscapes. By the mid-1760s Paul Sandby had ceased to produce landscapes in oils. Richard Wilson complained of the 'general want of employment' for landscape artists in the 1770s, and Gainsborough, who valued his landscapes more highly than his portraits, was unable to inculcate the same preference in his patrons: some of his finest landscapes remained in his house unsold.

Rooker must have been encouraged to persevere in oils by his election, in 1770, to the status of Associate of the Royal Academy. He was among

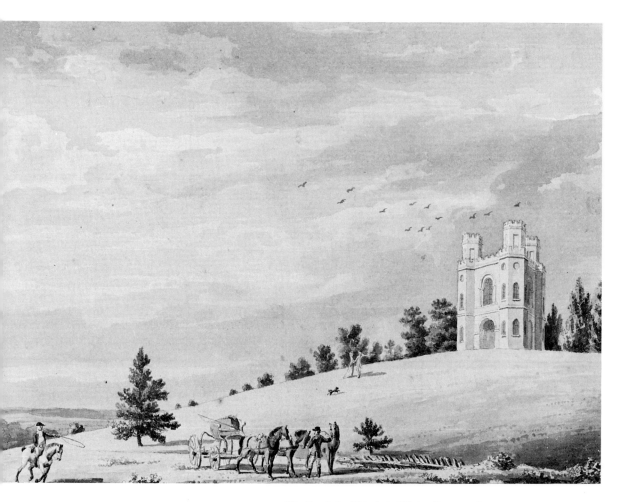

FIG. 5 *The New Lodge (Belvedere), Windsor Forest*, 1776
Drawn by Michael Angelo Rooker after Paul Sandby
By gracious permission of HM the Queen

the first group of painters, architects, sculptors and engineers, 16 in all, to be elected to this rank.[38] As an Associate he was not allowed to participate in the Academy's business, but he was now eligible for election to full membership; and election to full membership depended, according to the statutes of the Academy, on prowess as a painter, sculptor or architect. It was of course possible for an engraver or a watercolourist to achieve the rank of full Academician, provided that he or she was elected in one of these three capacities – as were Paul Sandby and Francesco Bartolozzi, who held their places as 'painters'. Rooker thus had a strong incentive to win a reputation in oils, and thereby obtain the coveted initials 'RA'. When he stopped exhibiting oil paintings at the Academy's exhibitions he in effect abandoned the pursuit of that title.

Fortunately Rooker had several strings to his bow. He had trained under his father as an engraver, by all accounts, but seems to have made little use of this experience in the 1760s, concentrating instead on watercolours. Almost all his engravings date from the years immediately following his father's death in 1774, when he took over a quantity of the latter's unfinished business. By now a new trend was becoming evident in the demand for topographical engravings. According to an early commentator, 'the idea of commencing a part-work containing well executed engravings, with short descriptions of their subjects' was 'accidentally formed' by the bookseller George Kearsley, who had been publishing engravings after French artists until he found that an engraving after Paul Sandby received an unexpected degree of admiration from the connoisseurs of the time.

> Kearsley, who was by no means blind to his own interests, immediately laid aside all foreign productions, and employed Sandby alone. Several volumes were filled with his designs; and from that time this branch of art has been advancing gradually but steadily towards perfection . . .[39]

Viewing this development today, we cannot feel such confidence in the notion of an 'advance towards perfection'. We can accept nevertheless that Kearsley's production, which was entitled *The Copper-Plate Magazine, or Monthly Treasure, for the Admirers of the Imitative Arts*, initiated a rewarding format. The original *Copper-Plate Magazine* (not to be confused with its successor of the 1790s[40]) offered 24 engravings, almost all of country houses, published from 1774 to 1778. The first three – Wakefield Lodge, Strawberry Hill, and Datchet Bridge, near Windsor – were engraved by Edward Rooker, as noted above, after drawings by Paul Sandby; the rest were engraved by the younger Rooker. Sandby was the draughtsman in all cases but three, in which Rooker provided the original drawing himself: Jennings

Park, Bagshot Park and Brockenhurst. For the purposes of engraving Rooker would have redrawn Sandby's original sketches, and one example survives (*New Lodge, Windsor Forest*, fig. 5) of such an 'intermediate' drawing.

This was the only series of topographical engravings in which Rooker played a major part. In the 1780s and 1790s other publishers adopted the idea of issuing such views at regular intervals, at a cost of a shilling or two each, but Rooker was scarcely involved; to the *Virtuosi's Museum*, 1778–81,[41] which contained topographical views mostly after Sandby, he contributed only two more engravings, Luton Tower and Dunemace Castle in Ireland. One of the most active of his successors was the engraver William Watts, who had lived for some time with the Rookers after the death of his own father; he 'repeatedly mentioned the great kindness he received in the family of the latter artist [Edward Rooker], with whom he served his time'.[42] Rooker did retain for himself one commission for engraving: the frontispiece for the annual Oxford Almanack, which he continued to supply – working from his own original drawing – until 1788.

At the end of the 1770s Rooker took up the post of scene-painter at the Haymarket Theatre, and was able to turn his attention away from both oil painting and engraving. (It is possible also that, as Hakewill claimed,[43] Rooker found that the practice of engraving was causing damage to his eyes, but there is little evidence of failing eyesight in any of his surviving works.) He was now free, when not occupied by his duties at the Haymarket, to work in the medium of watercolour in which he had shown such promise as a boy. Moreover there were now clear signs of encouragement for the watercolour artist. In the 1760s three organizations had been formed which enabled artists to place both oils and watercolours regularly before the public: the Society of Artists, the Free Society of Artists, and the Royal Academy. For oil painters these institutions brought a welcome decrease in the power of the picture-dealers, but there was also benefit for the watercolourists, who were just beginning in the 1770s to employ their medium as a basis for their compositions, rather than merely as an embellishment of an inked or pencilled outline; the system of exhibitions allowed new ideas and techniques to be communicated rapidly to the public and to other artists. Such exhibitions must have been particularly valuable to the more retiring artists, such as Rooker, who was not, like Paul Sandby, on terms of easy familiarity with the gentry who commissioned views of their country houses. By exhibiting his watercolours at the Royal Academy he could advertise his work without having to make himself personally acceptable to his potential clients.

Another kind of patron on whom the topographical draughtsman had hitherto been largely dependent was the publisher of engravings, who required drawings of a certain tonal quality to meet the needs of the engraver, and of a certain size to suit the ambitions of his project. Once the engraving had been executed, the original drawing had served its purpose. In the last quarter of the century, however, the market for topographical prints expanded at a great rate, and an increasingly discerning public began to attach significance to the artist who in the past had often remained anonymous. In 1778 the plates of the *Copper-Plate Magazine* were advertised as 'engraved by the best Artists, from original designs by P. SANDBY, Esq., R.A.' It must have seemed to 'the best Artists' – who until now had amounted to Michael Angelo Rooker in almost every case – that if any prestige were to be gained from such productions, it would fall not to the engraver but to the originator of the designs.

The system of regular public exhibitions did not instantly emancipate artists in either oil or watercolour, but it must have been a principal cause of the revaluation of the watercolour medium which took place over the next thirty years. It was during this period that 'watercolour painting' began to be distinguished from 'draughtsmanship' and to emerge as an art in its own right. As the topographical artist was freed from the obligation to flatter a landowner or satisfy a publisher, he was enabled to develop his own recognizable style, to experiment with unorthodox compositions and (with the aid of technical advances in colour-making) to extend his palette. Meanwhile the would-be collector, pupil or patron of the arts, who might previously have hired the local artist in much the same way as he would have hired a plasterer or stonemason, could now compare the work of several dozen candidates at an exhibition hall.

The conditions under which watercolours were hung, on the other hand, were far from satisfactory, especially at the Royal Academy. In some cases they were placed immediately beside the oils, to their disadvantage, for the gentle colours and delicate lines of the watercolours tended to be shouted down by the large and highly varnished performances alongside them. The watercolours sent in by RAs were better hung than the others, but this only served to draw attention to the prejudice against watercolours which prevailed in the Academy, since the artists concerned had been elected on the merits of their oil paintings.[44] In 1804 – shortly after Rooker's death – the inadequacies of this procedure had become sufficiently aggravating, and the body of specialist watercolour artists sufficiently strong, for these artists to create their own society and exhibition facilities. No doubt this development was long overdue; nevertheless one may speculate that if the

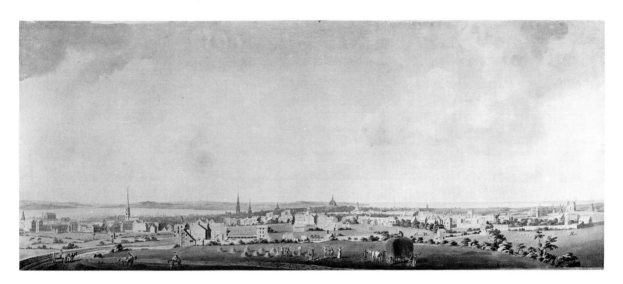

FIG. 6 *Liverpool from the bowling green*, 1769 Walker Art Gallery, Liverpool

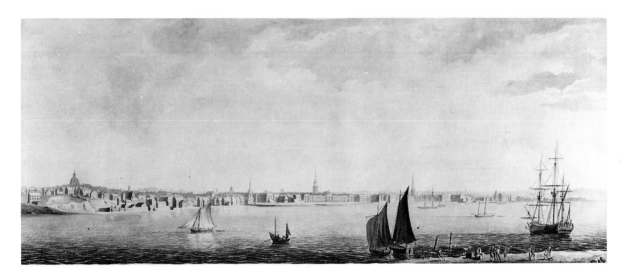

FIG. 7 *Liverpool from Seacombe boat-house*, 1769 Walker Art Gallery, Liverpool

watercolourists had displayed their work in separate premises from an earlier date, they would not have attracted the attention which they received in the prestigious Royal Academy.

Rooker himself made considerable use of the Academy's summer exhibitions, showing no fewer than 119 works there between 1769, the year of the institution's first exhibition, and 1800, the year before his death. He opened his account in some style with two views of Liverpool, thirty inches long and immensely detailed (figs. 6–8). They were bought by the Earl and Countess of Sefton (the latter's portrait, by Gainsborough, hung in the same exhibition), while the resulting engravings by Edward Rooker were advertised at four shillings each. The Rookers were associated at this time with two leading figures in the Liverpool art world: the cartographer Peter Perez Burdett, first President of the Liverpool Society of Artists formed in emulation of the Royal Academy, and George Perry, who published the Rookers' views and planned a history of Liverpool. Perry died prematurely in 1771, but some of his material was published two years later, with eight engravings after Burdett by Edward Rooker.[45] The new sense of pride in both the commerce and the culture of Liverpool is reflected in a poem written by Perry, 'The Prophecy of Commerce':

> ... O Mersey! fairest of my numerous train,
> Pleased, I behold through time's perspective glass
> Thy banks adorned with Lerpool's rising towers!
> A naval forest crowds her spacious docks ...

Although less grandiose in style, Rooker's views also testify to the emergent power of the city, whose tall new buildings dominate not only the river but also the scattered fields inland, while a 'naval forest' is clearly visible above the rooftops (fig. 8).[46]

Rooker's Liverpool connections may have brought him the commission, ten years later, to draw the new Iron Bridge at Coalbrookdale (fig. 9). George Perry had worked at the Coalbrookdale ironworks before moving to Liverpool, and among the subscribers to the 'Plan, Views and History of Liverpool' were both Rookers, 'Mr. Abram Darby', and 'Mr. Samuel Darby'.[47] Abraham Darby III, who was responsible for the building of the bridge in 1777–80, paid Rooker £29 in fee and expenses to draw what became, in its engraved form, the best-known image of the famous structure: one of the prints was bought by Thomas Jefferson in London, and later hung in the presidential residence in Washington.[48]

Rooker was not an adventurous traveller, however. While his fellow watercolourists sailed to distant continents in search of exotic subject matter

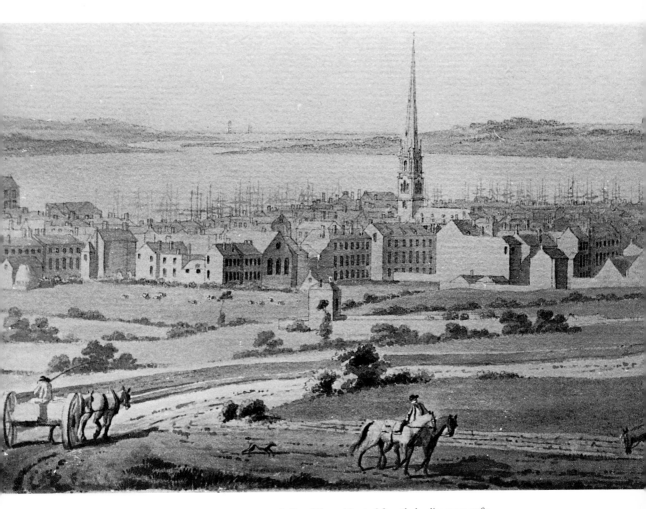

FIG. 8 Detail from *Liverpool from the bowling green*, 1769
Walker Art Gallery, Liverpool

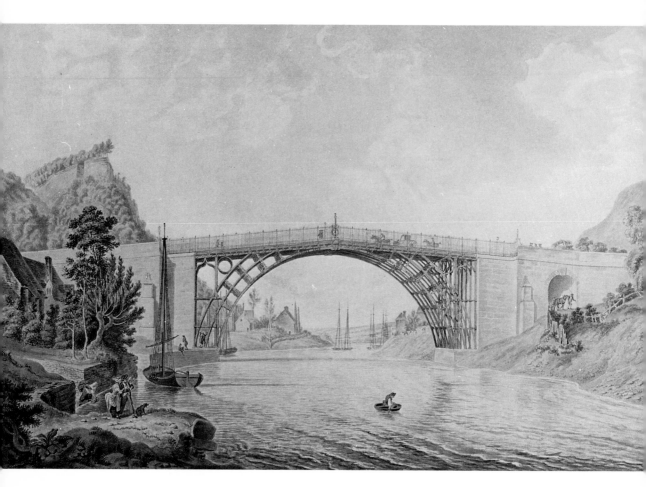

FIG. 9 *The Cast Iron Bridge near Coalbrookdale*, 1780
Aberdeen Art Gallery

(Hearne to the West Indies, Ibbetson to the East Indies, Alexander to China, the Daniells to India), Rooker remained in Britain. Of this we can be confident, since the Rooker Sale catalogues list 900 sketches and drawings, two-thirds of them topographical, and most of these specifically titled. Moreover we can safely infer that he never travelled to Scotland or Ireland, nor to the further extremes of the West Country; nor did he undertake the tour of the Lake District which was becoming increasingly popular in his lifetime.

The Lake District was not rich in the medieval antiquities in which Rooker specialized; Rooker may have been deterred by what William Gilpin admiringly described as the 'great simplicity' of the Lakeland countryside, with its lack of intricate detail. But his travels were more probably determined by practical circumstances. Rooker's longer forays, to Liverpool and to Yorkshire, were made early in his career, before he took up his position at the Haymarket Theatre – a post which kept him in London for much of the year, and brought him financial security (see p. 123). Independent of individual patrons, Rooker had no need to offer himself as a travelling companion or drawing master, and after his early years he ceased to follow the practice of his mentor, Paul Sandby, in drawing the houses and estates of country gentlemen; he could travel to suit himself. One may guess that Rooker shared the opinion of the antiquary Richard Gough, who declared in 1768 that views of private houses were

> interesting to none but the owner's vanity. Badeslade, Kip and Harris neglected many curious things, while they laboured on mansion houses, with full dressed gentlemen and ladies parading in meanders of distorted box and yew.[49]

Rooker's series of annual sketching tours began it seems in 'about 1788',[50] and this date is supported by the fact that between 1781 and 1789 Rooker exhibited nothing at the Royal Academy except a pair of landscapes in 1786; but from 1789 onwards he exhibited at least four topographical watercolours every year until his death, omitting only the year 1791. He undertook these excursions, as he told Farington, 'in the Summer Seasons . . . Sometimes He walks 18 miles a day. His expences are on average about two guineas a week'.[51] The Haymarket's season operated from June to early September, but presumably Rooker's scene-painting work was completed by the time the season's productions opened, and he was able to find time to tour in the late summer. The extract from his diary (see Appendix 1, p. 173) shows that in 1796, when he still held his post at the Haymarket, he travelled in East Anglia from 20 July to 16 August. Late

summer was, in any case, the time of year most favoured by artists for
sketching tours. As a morbid contemporary wrote,

> It has been the custom of European artists, from the days of Claude to this
> period, to make their pictures in the autumnal season, that they might avail
> themselves of the advantages of the variety of hues, which the approach of
> death spreads over decaying animation.[52]

It was during one of his tours that Rooker was, so the story runs, mis-
taken for a spy. Reports of this kind were not uncommon. In 1778 Samuel
Hieronymus Grimm, sketching at Newcastle upon Tyne, 'was dogged and
on the point of being arrested for a Spy had not Broadie the Landlord
turned the constables out'.[53] In the 1790s the hostilities between England
and France made it particularly likely that a stranger with a sketch-pad
would be viewed askance. A certain Carey, who made a sketching tour of
north Wales in the summer of 1795, told Farington that at Caernarvon
and Barmouth 'he was suspected to be a Spy'.[54] It seems that Rooker was
arrested in Suffolk, a more likely site for a French invasion, probably in
1796.[55] The episode was recounted in the *Gentleman's Magazine* for Decem-
ber 1810 by an eye-witness, Samuel Ashby of Bungay, who wrote that he
had become acquainted with Rooker 'at a village in Suffolk, in the course
of a pedestrian tour, which he [Rooker] was taking, but a few years before
his death, in search of subjects for his admirable pencil'. The author 'had
the gratification to be instrumental in releasing Mr. Rooker from his state
of "durance vile", and from the tribunal of a rustic inquisition'.[56] Ashby
then proceeded to tell his story in rhyming doggerel, of which two verses
are worth repeating, if only on account of the author's contriving to find
a rhyme for 'Rooker' in the penultimate stanza.

> And as the little curious prying wight,
> Sketch'd from the mould'ring cloister's broken site,
> Soon by the spot some farmer hobbinowls
> Came jogging – nothing vicious in their jowls –
> And, seeing poor Apelles, one cried, "I
> Dars for to say, that waggabone we sees
> There, with his rule and plummet on his knees,
> Is nothing more, nor less, than a French Spy!" ...

> ... "We're loyal, friend! your looks betray the spy!
> These gem'men all think so – and so thinks I!
> You 'fore our Justus must disprove the fact;
> Swear you are he his-self, the painter Rooker;
> If not – God bless the King! we must, odzooker!
> Straitway commit you on the vagrant act." ...

Ashby's reference to Rooker as 'the little curious prying wight' suggests that the artist was not a notably prepossessing figure. George Dance's profile portrait of Rooker, drawn in 1793, confirms this impression (fig. 10); few of Dance's portraits in the series to which this belongs are flattering to their sitters, but Joseph Farington, who sat to Dance on the same morning as Rooker, testified that the likeness in Rooker's case was 'admirable'.[57]

His character is less easy to gauge. Edward Edwards, who must have known him since the two were fellow students at the Royal Academy Schools, stated rather defensively that, 'it ought to be observed, that though something rough in his manners, he was a man of integrity and honesty'.[58] Henry Hakewill's influential and generally reliable obituary notice of Rooker presents us with a private, almost reclusive individual.

> He read much, and was well informed on most subjects of general history and the arts; mixed but little in society, and was very reserved. His performances, on this account, were known only to a confined circle of his friends; and it was with difficulty even they could at any time procure a drawing from him, although he had great numbers finished in his port-folio.[59]

Yet against this view of the artist as an introverted and inaccessible figure must be set the evidence of Farington's *Diaries*, which reveal that, among his friends at least, Rooker could be sociable enough. Farington repeatedly notes his presence at gatherings of artists, at the houses of West, Soane, and Baker, and at the meetings and dinners of the Royal Academy – after which he might go on with Farington and a few others to the Bedford or one of the other coffee-houses until the small hours. He was among the company that assembled at William Beckford's house in Grosvenor Square to see the celebrated Altieri Claudes;[60] and between 1796 and 1799 he frequently dined at the Royal Academy Club, which met on alternate Fridays in the winter months.

Farington, however, was always conscious of the Royal Academy's role in Society, and of the advantages of maintaining cordial relations with royalty and aristocracy. In such company a man 'sometimes rough in his manners' was a potential source of embarrassment to Farington, and one can imagine his horror when Rooker was accidentally placed next to a guest of honour at the grand opening dinner of the 1796 Academy exhibition. Nothing excited Farington more than these annual dinners. 'At 3 o clock I went home to dress and returned to the Academy at 4. The room now filled fast. Richold had laid plates for 140 ...' Unexpectedly a dozen eminent guests arrived who had not replied to their invitations, and had to

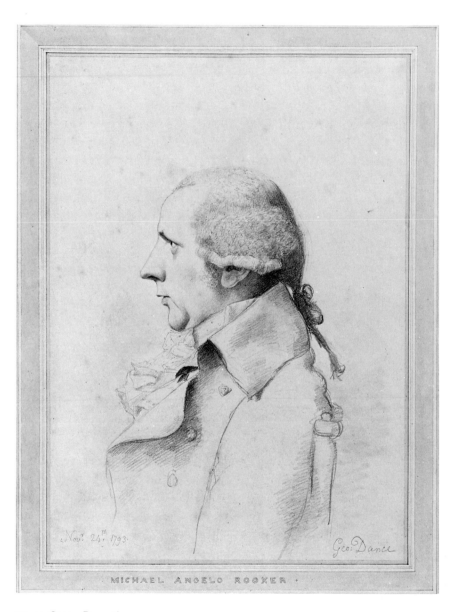

FIG. 10 George Dance the younger,
Portrait of Michael Angelo Rooker, 1793
British Museum

sit wherever they could find a place. The Marquis of Buckingham sat by the singers, and Charles James Fox found a vacant space between Zoffany and Rooker. After the meal Farington, prompted by Downman, went up to Fox and proposed that he move to a more suitable position. Farington wrote,

> Fox very good humouredly said He was very well situated but on my repeating my wish went with me & took his seat between Mr. Price and Mr. Knight. I observed this attention to Mr. Fox was much approved of. Malone told me it was a good maneouvre.[61]

So the unfortunate Fox was removed from the company of the professional artists on the lower table and placed on the higher table between the connoisseurs – and, incidentally, near to Farington himself. A few days later it was suggested to Farington that, since Fox strongly disliked Richard Payne Knight, Farington's manoeuvre had been less adroit than he had imagined.[62]

Rooker was clearly a man who pursued his own path, paying scant attention to passing fashion. Having developed his own style in the 1770s, he maintained it with little change until his death, despite the disapproval of 'Anthony Pasquin' (see p. 138). Characteristically, he was among those who were not deceived by the 'Secret' which excited the art world of 1797. A group of seven well known artists paid ten guineas apiece for the privilege of learning the 'Venetian Secret', the formula of colouring supposedly used by Titian and other Italian masters. Gillray's caricature of the episode shows a multitude of artists clamouring to learn the secret recipe, while a monkey urinates on the portfolios of the artists who had not taken part in this absurd exercise – Fuseli, Beechey, de Loutherbourg, Cosway, Sandby, Bartolozzi, Rooker and Turner. Of the oil painters Beechey was lucky to have been included in this group, since he had certainly wanted to learn the process; and Sandby, Bartolozzi and Rooker, who were not principally oil painters, could more easily afford to be sceptical. Sandby composed an unprintable song about the affair, and Rooker probably shared his amusement at the gullibility of the seven eager colourists.[63]

Rooker died on 3 March 1801.[64] The event was pathetically recorded by Farington, who wrote:

> Poor Michael Angelo Rooker, associate of the Royal Academy died at his apartments in Dean St. yesterday. – He was at the Academy Club on Friday last. Daniell observed that he has been for some time drooping. – and that on that day He did, during their sitting go to the fire and hang over it.[65]

Dayes had perhaps also heard the news from Thomas Daniell:

Poor Michael! dejected and broken in spirit, for want of due encouragement, drooped into eternity the last day of February '...[66]

The artist left a substantial estate, almost all of which was divided, according to his will, between his three executors. These were his aunt Ann Jennings of Drew Turnstile, Holborn; her unmarried daughter Elizabeth Jennings, who, when Rooker's will was drawn up in 1794, was living with him in Dean Street; and the architect Henry Hakewill. The will stipulated that his property should be sold and the proceeds reinvested 'in some of the public funds' for the benefit of these three equally.[67] In the event the proceeds amounted after tax to £1126 12s 6d.[68] Taking into account Farington's statement that 'Rooker had saved about £800 in the 3 pr. cents',[69] we can estimate that each major beneficiary received over £600.

It may be worth noticing that Rooker was not the only elderly artist to be befriended by Henry Hakewill. Some years later Hakewill arrived with Sir George Beaumont in a mourning coach to take Farington to the funeral of Thomas Hearne. Afterwards they took a cold collation at Dr Monro's cottage, and went on to dine at the Beaumonts', where (Farington wrote) 'we all regretted Hearne did not make a will'.[70] This oversight was not repeated when, four years later, the wealthy artist Henry Edridge was seriously ill. Monro told Farington that, 'Hakewill who has been very attentive to Edridge has, He believes, induced him to settle his worldly affairs'. Within the month Edridge was dead, and it transpired that the young Monro and Hakewill were his joint executors, receiving £1000 apiece.[71] Hakewill's attentiveness was handsomely rewarded.

Notes

1. 'Conversations on the arts', in R. Ackermann, *Repository of the Arts*, VI, 1811, pp. 316–17.
2. *The Diary of Joseph Farington*, ed. K. Garlick and A. Macintyre, vol. IV, 1979, p. 1338 (entry for 1 January 1800).
3. 'Conversations on the arts', op. cit.
4. *Diary*, op. cit.
5. St Giles's register of burials: information kindly supplied by the Rev. Gordon Taylor, FSA.
6. Thomas Dodd, 'Memoirs of English engravers 1550–1800', BM Add. MS. 33,404, p. 77; Samuel Redgrave, *A Dictionary of British Artists*, revised ed. (1878), p. 367. Joseph Strutt's *Biographical Dictionary of Engravers*, 1785, 1786, does not give a date of birth for Edward Rooker.
7. Strutt, ibid., vol. 2, pp. 274–5.
8. See *The London Stage 1660–1800*, pt 4, ed. George W. Stone, 1962, vols. 1–3. The assertion in the entry on Edward Rooker in the *Dictionary of National Biography* that 'his name does not appear in the theatrical records' is now contradicted by the splendidly thorough records of playbills in *The London Stage 1660–1800*, which contain 119 references to Edward Rooker.
9. Sidney Hutchinson, *The History of the Royal Academy 1768–1968*, 1968, pp. 89–90.
10. *The Theatrical Candidates*, in *The Dramatic Works of David Garrick*, 1798, vol. 3, p. 249. Harlequin, however, is allowed the best of the argument: 'O the joy when I appear!/ House is full,/Never dull!/Brisk, wanton, wild and clever! (p. 250).
11. *Diary*, II, p. 638 (entry for 12 August 1796).
12. *Anecdotes of Painting in England*, 1888 ed., iii. p. 265 and n. 12. A part of the engraving is reproduced in Edward Croft-Murray, *Decorative Painting in England*, vol. I, 1962, pl. 132.
13. *Diary*, II, p. 729 (entry for 23 December 1796); and H. Colvin, *A Biographical Dictionary of British Architects 1600–1840*, 1978, p. 372.
14. 'Papers of the Society of Artists of Great Britain', *Journal of the Walpole Society*, VI, 1917–18, p. 116. At another meeting at the Turk's Head, on 7 December 1760, Edward Rooker was one of those who undertook to appear at 'the Artists' Feast' in the Foundling Hospital, wearing a suit of clothes made by the children of the institution's out-station in Ackworth, Yorkshire (John Brownlow, *The History and Objects of the Foundling Hospital*, 1881, p. 99). He was still a member of the Society in 1772, although not a director (Algernon Graves, *The Society of Artists . . .*, 1907, pp. 321–3).
15. John Pye, *Patronage of British Art*, 1845, pp. 116 ff.
16. See W.G. Constable, *Canaletto*, 2nd ed. revised by J.G. Links, 1976, vol. 2, p. 684.
17. John Harris, *Sir William Chambers*, 1970, p. 175, records Chambers's payments to Edward Rooker in 1761–3.
18. The first four were advertised, and subscriptions invited, in the *Public Advertiser* on 10 November 1766 (p. 4) and 11 November 1766 (p. 3); the cost to subscribers was 16 shillings for the four. Publication was announced in the *Public Advertiser* of 29 January 1767 (p. 1), with a notice that 'Mr Rooker has begun others, and intends for the future to publish two together'. On 4 February this announcement was repeated with the following addition: 'Wanted, an ingenious Lad who has Learned to draw. A handsome Premium is expected.'
19. Edward Rooker received benefit performances at Drury Lane regularly from 11 May 1753 to 30 April 1774: see *The London Stage 1660–1800*.
20. Col. Maurice H. Grant, *A Dictionary of British Etchers*, 1952, pp. 175–6.
21. Graves, op. cit., p. 218.
22. Quoted by J.L. Roget, *A History of the 'Old Water-Colour' Society*, 1891, vol. 1, p. 35.
23. Sir John Summerson, *Georgian London*, revised ed., 1970, p. 34.
24. See *The Survey of London*, vol. V, 1914, pp. 57–60; Henry Wheatley and Peter Cunningham, *London Past and Present*, 1891, vol. 3, pp. 135–7; and the rate-books for St Giles-in-the-Fields, Holborn Public Library.
25. Rate-books for St Giles-in-the-Fields (Drury Lane). Edward Rooker paid rates of 14 shillings, rising in 1758 to 15 shillings – about a quarter of the levy made on the houses in Great Queen Street itself.
26. Algernon Graves, *The Society of Artists . . . A Complete Dictionary*, 1907, p. 218.
27. *Survey of London* xxxiii, *Parish of St Anne, Soho*, pt. I, 1966 pp. 130–3; *Poor Rate for Dean Street*

in St Anne's, Soho, 1798, Westminster Public Libraries A517.

28. *Survey of London*, ibid.

29. *Gentleman's Magazine*, xxxiii, February 1763, p. 94.

30. *Art in England 1800–1820*, 1928, p. 27. A search through the baptismal registers of London parish churches has failed to reveal an entry for Michael Rooker. There are three other reports of his date of birth: Farington's *Diary* for 4 March 1801 (the day after Rooker's death) asserts that, 'He would have been 54 years of age had He lived to the 25th of the month.' If this were so, Rooker would have been born in 1747. Hakewill's obituary in the *Gentleman's Magazine*, on the other hand, gives his age at death as 55, while Dayes believed that he died on 'the last day of February, 1801, aged about fifty-seven' (*The Works of the late Edward Dayes*, 1806, p. 347).

31. See Robert Dossie, *Memoirs of Agriculture, and other Oeconomical Arts*, vol. 3, 1782, pp. 400, 414.

32. Graves, op. cit., p. 218. Horace Walpole's catalogue for the 1765 exhibition has the comment 'good' added beside Rooker's contributions (BAC Library, New Haven; this observation is omitted from the transcript printed in the *Journal of the Walpole Society*, vol. 27). Rooker's exhibit of 1766 is presumably the drawing for his father's engraving of the Horse Guards, published in the same year.

33. Edward Edwards, *Anecdotes of Painters*, 1808, p. 265.

34. See Paul Oppé, 'The memoir of Paul Sandby by his son', *Burlington Magazine*, 88, 1946, pp. 143–7.

35. Sidney Hutchison, 'The Royal Academy Schools, 1768–1830', *Journal of the Walpole Society*, xxxviii, 1960–62, p. 134; and MS. registration book in the Royal Academy Library.

36. Edwards, op. cit., p. 264.

37. The students admitted to the RA Schools from 1769 to 1830 are listed in Sidney Hutchison, op. cit., pp. 132 ff.

38. See Sidney Hutchison, *The History of the Royal Academy 1768–1968*, 1968, p. 50.

39. *Arnold's Magazine of the Fine Arts*, vol. II, no. 5, September 1833, p. 435.

40. *The Copper-Plate Magazine, or Monthly Cabinet of Picturesque Prints*. The word 'Monthly' in the title was later changed to 'Elegant'. This latter work, published by Harrison and Walker, ran to 250 mediocre engravings, none of them contributed by Rooker.

41. Published by Kearsley; a reprint was issued in 1781 by Boydell.

42. *Art Journal*, March 1852, p. 76, and *Gentleman's Magazine*, April 1852, p. 420. Both these obituaries of Watts mistakenly refer to 'Thomas Rooker': the DNB amends this to 'Edward Rooker'. The *Art Journal*, ibid., cites 'Mr. Rooker' as the founder of the *Copper-Plate Magazine*, and asserts (again unreliably) that 'Mr. Rooker made a considerable sum of money by the experiment'.
 William Watts's *Seats of the Nobility and Gentry*, published from 1779 to 1784 by John and Josiah Boydell, comprises 84 country-house views all engraved by Watts, who also provided the original drawings in some cases. One view – *Harewood House, Yorkshire* (pl. VII) – is based on a painting by M.A. Rooker.

43. *Gentleman's Magazine*, May 1801, p. 480. Edwards, op. cit., pp. 265–6, asserts merely that Rooker 'disliked the practice of engraving'.

44. See J.L. Roget, *A History of the 'Old Water-Colour' Society*, 1891, vol. I, pp. 129–30.

45. William Enfield, *An Essay towards the History of Leverpool*, 1773. An advertisement for the two engraved panoramic views, together with Perry's 'Plan of Liverpool and projected History', appeared in the *Liverpool General Advertiser*, 28 July 1769, p. 1.

46. For Rooker's two views see *The Annual Report and Bulletin of the Walker Art Gallery, Liverpool*, vol. 5, 1974–5, pp. 42–3; Perry's poem is printed in Enfield, op. cit., p. 4.

47. See Henry Smithers, *Liverpool, its Commerce . . .*, 1825, pp. 419–20, and the subscription list in Enfield, op. cit.

48. Darby's account for 23 January 1781 (Shropshire County Record Office); and see Stuart Smith, *A View from the Iron Bridge*, 1979, pp. 6, 20–25. Cat. no. 14 in the latter work is not drawn by Rooker.

49. [R. Gough], *Anecdotes of British Topography*, 1768, p. xxix.

50. *Gentleman's Magazine*, May 1801, p. 480.

51. *Diary*, 11 November 1796.

52. 'Anthony Pasquin', *A Liberal Critique . . .*, 1794, pp. 20–21.

53. Bodleian Library, Oxford, Gough Maps 25, f. 47; quoted in R. M. Clay, *Samuel Hieronymus Grimm*, 1941, p. 92.

54. *Diary*, 30 June 1795.

55. See Appendix 1, p. 173. There is no reason to suppose that Rooker made any other tour of Suffolk.

56. *Gentleman's Magazine*, December 1810, p. 568.

57. *Diary*, 24 November 1793.

58. Edwards, op. cit., p. 266.

59. *Gentleman's Magazine*, May 1801, p. 480.

60. *Diary*, 8 and 9 May 1799.

61. *Diary*, 23 April 1796.

62. *Diary*, 26 April 1796. Uvedale Price was an old friend and travelling companion of Fox.

63. See Farington's *Diary*, 3 March 1797. Farington was one of the seven who employed the formula; he first learned of it at the Academy Club, which Rooker regularly attended. For the nature of the formula see John Gage, 'Magilphs and mysteries', *Apollo*, July 1964, pp. 38–41. The 'Song for 1797' consists of 23 lewd stanzas beginning 'Old Titians Smutchpan display . . .' (Pierpont Morgan Library, RV Autographs: Misc. Artists).

64. Rooker's burial is recorded in the register of St Giles-in-the-Fields on 7 March 1801, with 'St. Anne's' noted alongside the entry, indicating that the corpse was brought from the neighbouring parish of St Anne's, Soho.

65. *Diary*, 4 March 1801.

66. Dayes, op. cit., p. 347.

67. Public Record Office, London, Probate II: vol. 4, Abercrombie 1355, no. 198, pp. 248–9. The other beneficiary was 'my old friend Tobias Miller of Long Acre, Engraver', who received £10. The will was witnessed on 1 October 1794 by Robert Jackson and Roger Moser; it was proved on 21 March 1801.

68. Sale documents in Dept of Prints and Drawings, British Museum, 1964, 12.12.3.

69. *Diary*, 29 March 1801.

70. *Diary*, 20 April 1817.

71. *Diary*, 24 May 1821.

FIG. 11 *Llanthony Abbey*
Whitworth Art Gallery, Manchester

II Rooker the artist

Llanthony Abbey (figs. 11–12) is in many ways typical of Rooker's art. It is dated 1796, and probably stems from a Welsh tour undertaken two or three years before. In the 1790s Llanthony Abbey was falling down at a rapid rate, so that 'exact views' were highly prized by antiquarians.[1] Shortly after Rooker's visit the upper stage of the tower was removed, and 1837 saw the collapse of the nave arcade which catches the sun in Rooker's view. The ruins were already domesticated to some extent: the south tower had been converted into a shooting-box, and the owner had provided a house for his steward in the west range. To this day Llanthony has the rare distinction of a public bar in the abbey cellars; the point from which Rooker took his view is now occupied, unobtrusively enough, by public lavatories.

Rooker's close attention to the crumbling architecture forms a sharp contrast with Turner's dramatic treatment of Llanthony Abbey (fig. 13), executed two years before Rooker's, and justly celebrated today as an early experiment in the Sublime. For Turner, the abbey is a small, albeit focal, contributor to a general effect of wild, elemental grandeur, created principally by the storm, the torrent and the bleak mountain towering above. The little brook nearby, described by one visitor as a 'limpid stream',[2] now appears as a raging river. One may visualize the abbey in Turner's picture as another emblem of desolation; alternatively it may be seen as a foil to the raging elements, a safe refuge amid hostile Nature – for Turner does not emphasize the ruinous aspect of the abbey. In either case, the abbey is primarily a symbol to Turner, whereas to Rooker it is an elaborate architectural sculpture, of which the creeper and the dilapidations are an essential part. Turner's every device suggests turbulence (bending branches, films of low-lying cloud, smoke blowing away from a cottage chimney), while the tranquillity of Rooker's scene is established by the clear morning sun, the ball-game in the former cloisters, and the jackets discarded on the bank.

The effect of Thomas Hearne's drawing of the same subject (fig. 14) is something of a compromise between the extremes of Turner and Rooker. As befitted a drawing which was to be engraved in a series of views of antiquities, Hearne's picture attends closely to the forms of architecture; yet it conveys an impression of bleakness and isolation by means of the cool tones which he habitually employed and by giving due weight to the mountains, which, although they dominate the site from most points of view, are all but excluded from Rooker's benign scene.

The foreground incident in *Llanthony Abbey* is characteristic of Rooker, for almost all his finished watercolours contain small foreground features,

FIG. 12 Detail of *Llanthony Abbey* Whitworth Art Gallery, Manchester

FIG. 13 J.M.W. Turner, *Llanthony Abbey* British Museum

FIG. 14 Thomas Hearne, *Llanthony Abbey* Victoria & Albert Museum

FIG. 15 *Buildwas Abbey* Whitworth Art Gallery, Manchester

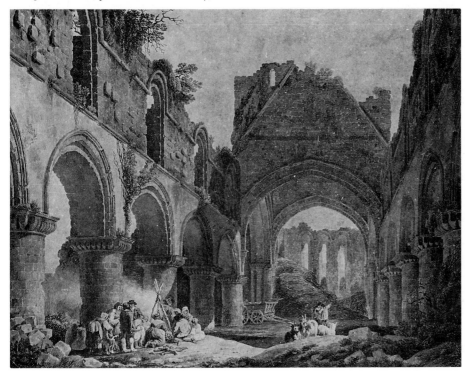

FIG. 16 *Usk Castle* (sketch) National Library of Wales, Aberystwyth

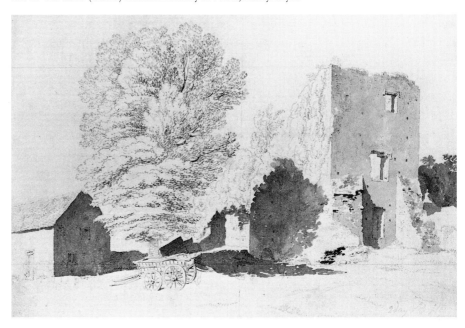

FIG. 17 *Usk Castle* (finished version) Whitworth Art Gallery, Manchester

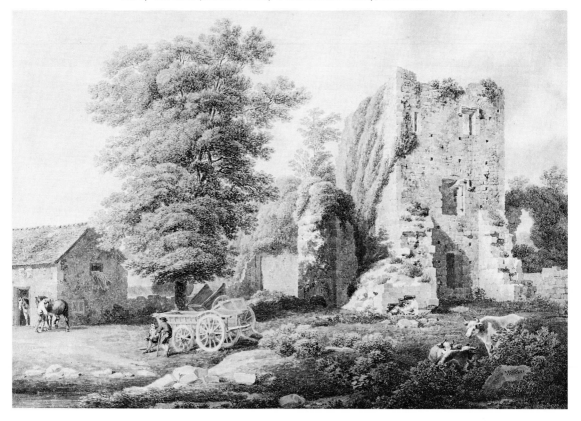

either animate or inanimate, which contribute strongly to the overall effect of the picture. The massive architecture of Buildwas is another ruin which, interpreted by other artists, appears stark and forbidding; but in Rooker's view of the subject (fig. 15) a band of gypsies is shown gathered around a camp-fire, with a cooking-pot hung above it from a tripod of sticks. They share the quire with a group of goats, while a wagon is parked beneath the crossing, and hay is piled high in the presbytery – banishing all associations of monastic piety. The figures would have been added to the composition in the artist's studio, but they were no doubt in his mind from the outset: the on-the-spot sketch for 'Usk Castle' (fig. 16), for instance, not only establishes the broad balance of light and shade but also treats the central cart in detail, and already carries pencilled indications of the animals and figures which are to take their place in the final version (fig. 17).

Many of these props – as Rooker the scene-painter must have regarded them – are derived, in spirit if not in detail, from the Dutch paintings and prints of the seventeenth century. The Rooker Sale included quantities of loose prints identified as 'Ten, Dogs, by Hondius, Potter, &c.', or 'Sixteen, Goats, by Berchem and others'.[3] More generally, Rooker's concern with the peculiar qualities of stone and wood, and with the individual forms of trees and ruins, calls to mind Jan Both, Nicolaes Berchem and Abraham Bloemart; the logs which often appear in Rooker's views (fig. 18) are trimmed descendants of the stumps and blasted trees of Dutch landscape art. From Ruisdael and van Goyen English artists learned to value the pictorial qualities of wooden posts and planks, and even to regard them as sufficiently interesting to form the principal focus of a composition. One such picture is Jan Wyck's wash drawing of London from Blackheath (fig. 19), in which a rough palisade upstages the nominal subject of the scene. Wyck, who came to England with his father and spent most of his life there, was one of many Dutch-born artists who helped to establish in Britain a tradition of small-scale topographical drawings which paid particular attention to idiosyncratic detail.[4] The drawing reproduced here was no doubt known to Rooker, since it was in the collection of Paul Sandby and was engraved in 1776.

Rooker's treatment of brick and stone is reminiscent above all of the minute, sunlit manner practised by Jan van der Heyden, who according to one contemporary,

painted every brick ... so precisely that one could clearly see the mortar in the joints, and yet his work did not lose in charm or appear hard if one viewed the pictures as a whole from a certain distance.[5]

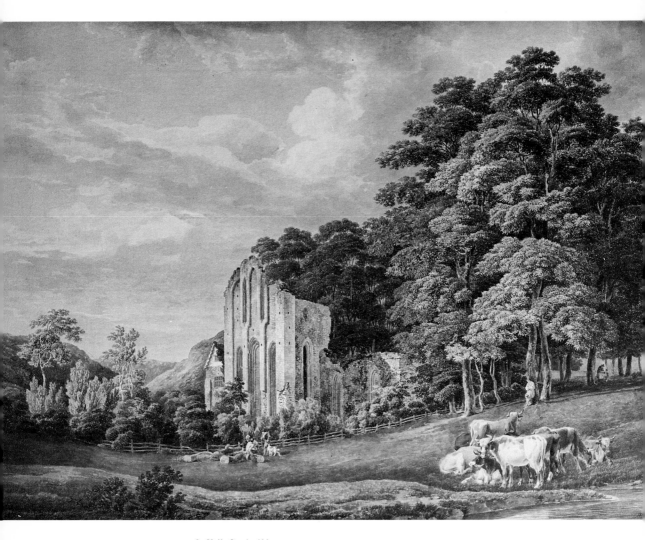

FIG. 18 *Valle Crucis Abbey*
Royal Academy of Arts

Van der Heyden's scenes are generally well supplied with foliage and active figures or animals, which relieve the sharp regularity of the buildings. Watercolours in a similar style were executed in Holland throughout the eighteenth century, and many of Rooker's qualities may also be seen in the work of Dutch contemporaries such as Jacob Cats and Johannes Hubert Prins.

A more immediate source for Rooker was the work of Paul Sandby, with whom he was associated in the early 1770s and perhaps before (see p. 28). Sandby's early etchings of Scotland display a thoroughly Dutch preoccupation with bristly trees, twisted branches and uneven woodwork. His use of figures must also have impressed Rooker. Many of Sandby's etchings and watercolours contain episodes which are comic or absurd – a bull chasing travellers up a tree, a woman attacked by a bear, or riders tripping over a stray pig (fig. 20). Rooker's pictures have similar incidents, but these are more often potentially humorous than overtly so: a dogfight or an unseating may seem likely to develop, but the point of farce is not quite reached.

FIGURES IN ACTION

The role of figures in a painted landscape is a subject which has occupied several writers in recent years. One suggestion is that the figures in eighteenth-century landscapes are not simply decorative adornments, but have a social and political significance: they serve (perhaps subliminally) to reassure the middle-class or aristocratic purchaser of the picture that the labouring classes were contented with their lot, that they 'were, or were capable of being, as happy as the swains of Arcadia'.[6] Or if there is a demand for a greater degree of realism (so the argument runs), then the peasants may be portrayed at work, thereby representing the 'deserving' poor, who must work to improve their condition if they are to arouse the sympathy of the middle class. So the bundles of sticks carried by peasants in a canvas by Gainsborough are 'their passports to our hearts'.[7]

One objection to this interpretation is that patrons and artists were well aware of the distinction between what is admirable in life and what is admirable within the conventions of painting.[8] A second weakness is that it tends to explain too much. The artist can hardly fail to satisfy the patron. If his figures are unrealistically well-dressed, they reassure by evoking an Arcadian fantasy. If they are ill-dressed and idle, they satisfy a 'demand for realism' and also reassure the patron that their poverty is merited. If they are ill-dressed and industrious, they satisfy the patron's belief that the labourer must strive to earn his bread. A recent commentator has claimed

that the little figures in Richard Wilson's landscapes – generally inactive spectators – 'accept their place in the universal schema, and act to support its preservation on the earthly plane'.[9] But how, we might ask, could Wilson have depicted figures who did *not* 'accept their place in the universal schema'? Should they be drawn shaking their fist heavenwards, or at least in the direction of the local manor house?

Rooker's figures, unlike Wilson's, are generally engaged in some identifiable activity, but are not easily analysed in terms of their social connotation. Many are occupied in manual work, even though the antiquities drawn by Rooker would not naturally call for toiling figures in the vicinity. They dig, carry logs, pick fruit, drive animals or push a wheelbarrow, and when not actually wielding a spade or pitchfork they are often carrying one. In other cases they are actively at play – hide-and-seek, ball games, bowling a hoop or bathing. Occasionally they are fast asleep. Not often are they bystanders or tourists pointing out the beauties of the scene. Sometimes we are shown labourers hard at work while gentlefolk direct or look on (figs. 52–54, 59): is this Rooker's protest against the injustice of a social system, or is he simply condoning the status quo? Several of his pictures include a beggar with hat outstretched, who is generally ignored by the more prosperous characters nearby – although in one case (fig. 21) a particularly disadvantaged figure, with a wooden leg, a pair of crutches and a wife and child in tow, seems to have attracted some attention. Are these beggars an ironic comment on an uncharitable society – a foretaste of the criticism that Pugin was later to make manifest in his engravings to *Contrasts?*

It is not impossible. Yet eighteenth-century tourists were often capable of regarding scenes of poverty and misery with a remarkable degree of equanimity. At Tintern Abbey William Gilpin noted in detail the wretchedness of the beggars who had made the ruins their permanent residence. He followed one crippled woman to her dwelling, which he found so dank and loathsome that he was surprised it had kept her alive. The word with which he describes his response is 'interested' – 'we did not expect to be interested, but we found we were'.[10] Pity is certainly implicit in Gilpin's account, but he offers no moral judgement on beggars or society. We may guess that Rooker viewed gypsies and beggars with similar detachment. He did not banish them from his pictures (as other artists did) in the interests of the picturesque, but included them as 'interesting' aspects of his chosen subjects.

Another factor to be considered is the threat of war with France, which must have occupied the thoughts of even the most self-sufficient and de-

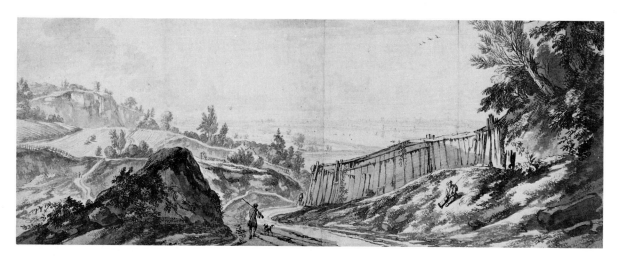

FIG. 19 Jan Wyck, *London from Blackheath* British Museum

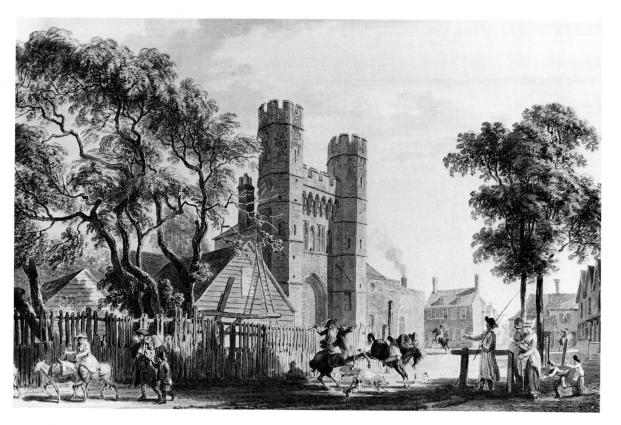

FIG. 20 Paul Sandby, *The Cemetery Gate of St Augustine's Monastery, Canterbury* Tate Gallery

FIG. 21 *Bury St Edmund's, Abbey Gateway* Birmingham Museums and Art Gallery

FIG. 21 *Bury St Edmund's, Abbey Gateway* Birmingham Museums and Art Gallery

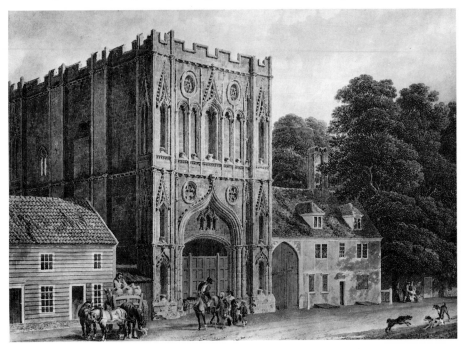

FIG. 22 *Oswestry Church* National Gallery of Ireland

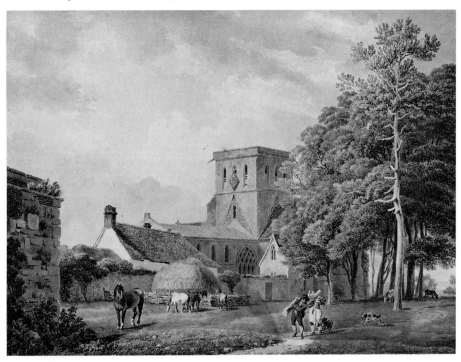

tached of artists. Rooker's vignettes of rural life and craft could be seen as symptoms of a general concern with ancient traditions now in jeopardy. In his *Essay on the Picturesque*, 1794–8, Sir Uvedale Price considered the prospect of women washing their clothes in a river, by a small cascade, on a summer's evening; it struck him as 'the most delightful image of peace and security', and reminded him of the passage in the *Iliad* where, as Achilles is pursuing Hector, they come to the fountains of Scamander:

> Where Trojan dames, ere yet alarm'd by Greece,
> Wash'd their fair garments in the days of peace.[11]

The humiliation of Hector and the sack of Troy were subjects which Price would have pondered as he prepared his manuscript in the momentous year of 1793, in which Louis XVI and Marie Antoinette were imprisoned and executed; in which France declared war on Britain, and defeated the British fleet at Dunkirk. By the same token the combined imagery of ancient structures and continuing rural tradition must have carried a special poignancy in the uncertain years of the 1790s.

Quite apart from any such external reference, however, Rooker's figures play a significant role within the conventions of the picture itself. They support the unusual sense of priorities which pervades Rooker's work. He repeatedly gives precedence to the trappings of everyday domestic and rural life which appeared in the neighbourhood of an ancient church or ruin. Often he adopts a viewpoint which the antiquary might consider perverse, in that it places a cottage, an inn or a hayrick directly between the spectator and the ancient structure which is the nominal subject of the picture (figs. 22–4). At Hurst in Berkshire (colour pl. I), for instance, other topographical artists might well have restricted their attention to the pleasant little Norman-cum-Jacobean Church of St Nicholas; possibly Rooker visited the village with this subject in mind. But in the event the church appears in the background of Rooker's view, for he has given pride of place to the local inn, with its double flight of wooden steps to the garden, and its patrons, smoking or drinking or playing bowls. (Only later did the 'Bunch of Grapes' become famous as a haunt of the cricketer W.G. Grace.)

A comparable case is *Caerphilly Castle from the Boar's Head Inn* (fig. 24), which relegates the castle to the distance and makes a feature of a row of 'indifferent cottages', as they were described at the time.[12] To the travel writers, Caerphilly presented a contrast between present squalor and the remnants of ancient glory, but this is not the effect of Rooker's drawing, for he seems appreciative of the neat series of cottages, with gables to the

FIG. 23 *South Gate, Yarmouth* National Gallery of Ireland

FIG. 24 *Caerphilly Castle from the Boar's Head Inn* Private collection

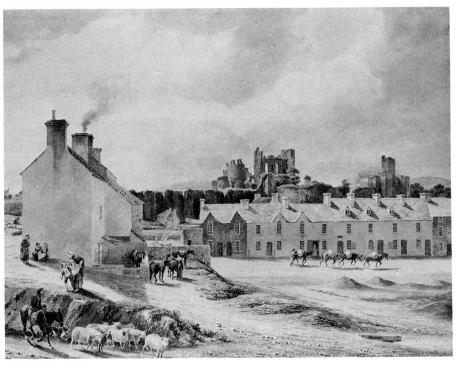

left and dormers to the right, and the procession of pack-horses passing in front of them. To the left of this terrace, and abutting directly on to the dark curtain-wall of the castle's defences, can be seen another small group of cottages which stand in what was formerly – and has since become again – the outer moat of the castle. In both these instances the figures and animals reinforce the emphasis which Rooker lends to the attributes of modern life at the expense of the relics of antiquity. In less extreme cases also, the rustic figures whom he places among the ruins are associated not with the stately architecture but with the rickety shelters and piles of wood or hay which have been created beside or within it.

This effect is all the more striking in Rooker's pictures because the architecture is so closely observed, and is not merely a backdrop to the human drama, as are the Oxford locations in Rowlandson's parodies of *Almanack* designs (see fig. 66). Rooker's figures act as a psychological counterweight to the architectural subject. It is as if Rooker felt that the minute and painstaking detail of the architecture might create a sense of self-importance, even of obsession, which must be relieved by some exceptionally spirited action on the part of the figures. This applies also to some of his city views. *The Clarendon Building* (fig. 59) represents with great fidelity a dignified, slightly ponderous structure, but adds a surreptitious touch of informality firstly by opening the windows to a varying extent, and secondly by placing a road-mending gang immediately in front of the building.[13]

A similar phenomenon has been discerned by Roland Barthes in Dutch seascapes of the seventeenth century. The figures 'urbanize' the sea: the abundance of human activity on shore and on board ship 'reduces the forces of Nature to the rank of objects, and transforms the Creator into a facility'.[14] In the case of Rooker's pictures of antiquities, the powerfully-built rustic figures, conspicuous and carefully drawn, are not simply observers, as are the elegant touring gentlefolk who are to be seen in many contemporary views; they are inhabitants, participators, possessors of the scene. Instead of directing the spectator's attention towards the antique subject, they bring that subject within their own terms of existence. Their response to a majestic relic of knightly or monastic power is to sit on it, stack hay against it or shelter cows beneath it. It has been observed that as Turner pursued his ideal of the 'landscape sublime' in the late 1790s, he suppressed the figures which had peopled his earlier watercolours, in order to convey 'the brooding hostility of nature to man'.[15] Rooker does the opposite. He introduces his figures with the effect of presenting the ancient relic as something natural and acceptable, a part of the course of everyday

human affairs, and not an occasion for melancholy sentiment. His figures are equivalent to the modern Athenians who disturb the lofty musings of Byron's Childe Harold in the ruined Temple of Jupiter: they sit unmoved or 'carol by', blithely unaware of the temple's former glory.[16] Here, then, lies the special flavour of Rooker's watercolours of ancient remains: architecture drawn with the most delicate touch, accompanied by anti-heroic figures (and often animals) who deflate any swelling of romantic emotion.

Antiquarian and Picturesque

The development of topographical watercolour in Britain has often been associated with the professions of surveying and map-making, in some cases for military purposes. But the art of Sandby, Rooker, Hearne and Dayes belongs also to an intellectual tradition of empirical study which was concerned with specific details of British antiquities. In the seventeenth century this tradition was embodied in the Royal Society, which from its foundation regarded the precise recording of data as one of its principal functions; it therefore sought 'Plotts and Draughts' of ancient structures as well as plants, animals and fossils, and expected its draughtsmen to be proficient in representing all of these.[17] Artists and engravers such as Wenzel Hollar (fig. 25), David Loggan and Michael Burghers came to Britain to meet this demand for precise and detailed drawing, particularly of ancient architecture, and helped to create a native school of topographical draughtsmen. The most accomplished views of British cathedrals and churches to be executed in the seventeenth century were the 56 illustrations to Dugdale and Dodsworth's massive *Monasticon Anglicanum* which were engraved by Hollar. Some of Hollar's engravings for this work were based on drawings by English draughtsmen,[18] and Francis Place, who was associated with Hollar in other projects, emerged as the first British topographical artist worthy of the name.

While some antiquaries employed professional draughtsmen, others attempted to make their own drawings. John Aubrey, for example, taught himself to draw and colour, and took lessons in painting from a visiting Dutch artist. He was well aware of the usefulness of graphic art in the study of antiquities: his projected 'Monumenta Britannica' included a series of drawings of doors and windows, most of which could be dated independently, and which could thus be used as the basis of a history of stylistic development. He also drew a number of prospects of his ancestral home, which included such homely details as 'dog Fortune at 2 chaines distant';[19] although this project (grandly entitled 'Designatio de Easton Piers') was crude and unpublishable, the urge to record is evident. Seventeen years

before, in 1653, John Evelyn made a drawing of Wootton House in Surrey (showing the Italian garden he had helped to design), which has been described as the first self-conscious depiction of a country house by an Englishman.[20] No doubt a strong motive for both Aubrey and Evelyn, as for the many proprietors who commissioned pictures of their houses in the eighteenth century, was to celebrate their wealth and status; but there was also the motive of preserving what was vulnerable. Aubrey wanted to see a volume published of Wiltshire houses, a volume which

> would remaine to Posterity, when their Families are *gonne* and their Buildings ruin'd by Time, or Fire: as we have seen that Stupendous Fabrick of Pauls church not a stone left on stone, and lives now only in Mr. Hollars Etching . . .[21]

As an undergraduate before the Civil War, Aubrey had commissioned drawings of Osney Abbey, believing (correctly) that it would soon disappear. One of the resulting views was engraved by Hollar for the *Monasticon.*

A similar consciousness of rapid decay and impending loss lies at the root of much of the topographical and antiquarian draughtsmanship of the eighteenth century. The ruins of Britain were assiduously sketched well before the term or the concept of the Picturesque had entered the public mind. While William Gilpin was as yet unborn, the antiquary William Stukeley was touring the medieval sites, making drawings and protesting against the continued destruction of venerable buildings. At Glastonbury in 1723 he found that the tenant of the Abbey had just pulled down the old abbot's lodging, 'and built a new house out of it . . . But my friend Mr. Strachey had taken a drawing of it very luckily just before . . .'[22] By the last quarter of the century the practice of drawing and engraving views of threatened buildings was so widespread that one observer ironically suggested that it had become a substitute for conserving the buildings themselves.

> 'Is such a thing engraved?' – 'O, Yes.' – 'Then it is preserved to posterity.'– 'I mean to re-build my old castellated house, but I shall have it engraved first.' – 'The corporation intend to blow up the castle; but it is engraved.'[23]

In the second half of the eighteenth century, the 'antiquarian' interest in ruins merged with, and was diluted by, a Picturesque interest which was more a matter of emotional and aesthetic response than of archaeological scholarship. Thus at least the issue may be stated in general terms; but even in the seventeenth century the two elements were often closely associated. The early antiquarians often betrayed what would later be con-

sidered a Romantic enthusiasm: Anthony Wood, at Eynsham in 1657, was 'wonderfully stricken with a veneration of the stately, yet lamented, ruin of the abbey there', and 'spent some time with a melancholy delight in taking a prospect.'[24] Stukeley went

> to sigh over the ruins of Barnwell Abbey, and made a draught of it, and us'd to cut pieces of the Ew trees there into tobacco stoppers, lamenting the Destruction of so noble monuments . . .

By 1721 he toured, sketched and wrote as a man 'much in love with Gothic architecture'.[25] There is no great difference between the attitude of William Stukeley, Secretary of the Society of Antiquaries, and that of the poet Thomas Gray, who in 1762 visited York Minster with his friend William Mason. In one chapel the poet 'was much struck by the beautiful proportions of the windows', recalled Mason, 'which induced me to get Mr. Paul Sandby to make a drawing of it' and also to endeavour, in a letter to Mr Gray, to explain to what foundation it belonged.[26]

Thus the aesthetic and historical impulses reinforced one another, both in the study of antiquities and in their representation on paper. It is impossible not to detect an element of poetic sympathy in Hollar's views of antiquities, and those eighteenth-century artists who worked directly for antiquaries – a list which includes Place, Grimm, Sandby, Griffith, Girtin and Dayes – did not thereby abandon their pictorial sensibility. Rooker's views of crumbling ruins are not only drawn with unprecedented accuracy; they are also – to borrow another phrase of Mason's – 'the charmingest ruins in England', a delight to the eye as well as to the mind. They correspond with the policy of a periodical entitled *The Topographer*, which was established in 1789 for the purpose of preserving the memory of 'the venerable mansions of antiquity', but allowed an important place in this enterprise to the imagination and 'the melancholy delight of a Poet': 'These are the feelings which actuate the labours of the antiquary of true taste.'[27] A similar attitude was adopted by the young John Britton, who was a diligent follower of the Picturesque tour, calling on Uvedale Price at Foxley and Richard Payne Knight at Downton ('truly picturesque and romantic'), but was concerned also with exactitude in the delineation of architecture: 'scientific artists' was his description of Prout, Cotman, Fielding, Turner and the others whom he employed in his *Architectural Antiquities*. For his comprehensive survey *The Beauties of England and Wales*, Britton's intention was that 'accuracy of representation should be combined with picturesque effect'.[28] The success of the project demonstrates that this was a marketable compromise, although the subtleties of his artists' drawing were generally eroded by the engraving process and the octavo format.

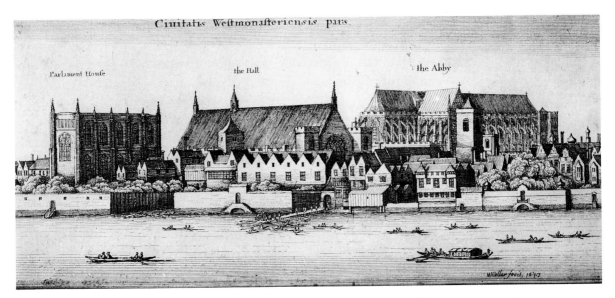

FIG. 25 Wenzel Hollar, *Westminster Hall and Abbey* (etching), 1647 The Royal Pavilion, Art Gallery and Museums, Brighton

FIG. 26 Thomas Underwood, *Queen Eleanor's Cross, Waltham*
Victoria & Albert Museum

FIG. 27 William Alexander, *Queen Eleanor's Cross, Waltham*
Victoria & Albert Museum

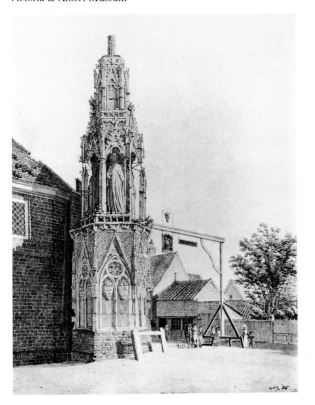

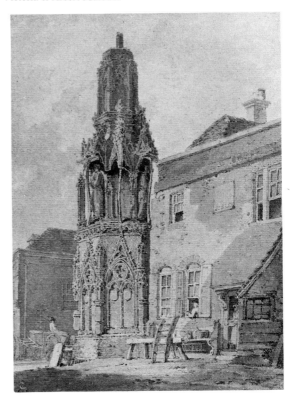

Rooker was one of the first British artists to attempt the combination which Britton sought. His watercolour of Queen Eleanor's Cross, Waltham (colour pl. II) is an interesting case, since the monument was of particular interest to antiquaries: one of the three 'Eleanor's Crosses' surviving from the twelve set up to mark the resting places of the Queen's burial cortège in 1290, it was the source of much anxiety in the Society of Antiquaries, which twice took measures to preserve the Cross from passing carriages, and then in 1795 tried to have the entire monument removed to the security of the lord of the manor's estate.[29] Several watercolours of the Cross were executed for use in an antiquarian context: a view by Jacob Schnebbelie engraved for *Vetusta Monumenta* III;[30] another by Thomas Underwood (fig. 26), which was engraved with some alterations for J.C. Barrow's *Picturesque Views of Churches*; and another by William Alexander (fig. 27), one of a series of drawings of crosses which he hoped to publish in a book on the subject. Alexander also commissioned drawings for this series from such artists as Girtin and Turner,[31] and in this instance Alexander's drawing, which is dated 1812, is evidently based on a drawing made by Turner some twenty years before.[32] The inn to the right had been enlarged earlier in the century, so that (as William Stukeley complained to the Society of Antiquaries in 1757)[33] its roof rested against one of the statues of Queen Eleanor; Alexander's drawing suggests that a few bricks had been cut away from the roof by the end of the century, but the Queen still looks uncomfortably hemmed in.

Rooker's view, by contrast, was presumably not intended for any historical publication. Its summary treatment of brickwork and road surface is typical of Rooker's early work, and it may well be the *Waltham Cross* exhibited at the Royal Academy in 1775. The sculpture of the monument is painted in precise detail, but now the Cross is by no means the only object of interest: it occupies a much smaller proportion of the composition, and must compete for attention with the carriage and the wooden framework carrying the inn-sign. A beggar has the boldness to lean against one of the two projecting posts provided by the Society of Antiquaries. The picture is indeed a combination of 'accurate representation' with 'picturesque effect', carried out a generation before Britton exploited this formula on a wider scale.[34]

By the 1780s a major change had occurred, which gave Rooker, Hearne and their contemporaries a great advantage over the topographical artists of preceding generations. Antiquities were now no longer the preserve of a small group of scholars, but had become the subject of a widespread amateur interest, an interest which was stimulated above all through the

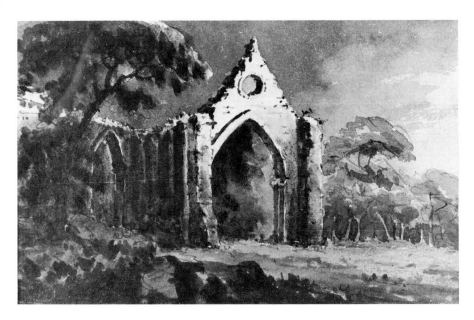

FIG. 28 William Gilpin, *Ruined church* Private collection

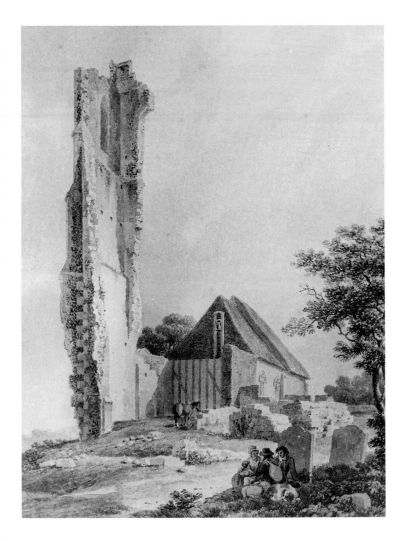

FIG. 29 *Leiston Abbey*
The Royal Pavilion, Art Gallery and
Museums, Brighton

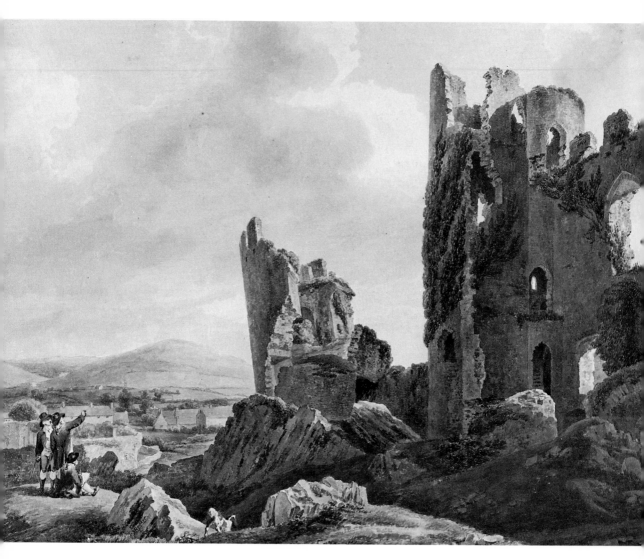

FIG. 30 *Caerphilly Castle*
Fitzwilliam Museum, Cambridge

medium of engraving. The notion of a popular illustrated topographical book was scarcely conceived in the year 1760. Once born, it matured rapidly and flourished, until (one is tempted to add) it was flogged to death in the era of steel-engraving. The large folio volumes of *England Displayed*, 1769, claimed that all previous accounts of Britain's great monuments were 'deficient from necessity' in one particular:

> a want of perspective views and other plates absolutely necessary to elucidate all performances of this kind, if the authors are desirous of conveying adequate ideas to their readers. This defect we have been very careful to supply . . .[35]

Even so, there was seldom room in this publication for more than one engraving, crude and anonymous, to each county. More enterprising was the *Antiquarian Repertory*, issued in bi-monthly numbers from 1775 under the supervision of Francis Grose, which was aimed unashamedly at a non-specialist audience. In the past (ran the Advertisement) the study of antiquities was regarded as something of a joke:

> the idle amusement of a few humdrum, plodding fellows, who wanting genius for nobler studies, busied themselves in heaping up illegible Manuscripts, mutilated Statues, obliterated Coins, and broken Pipkins.

But the *Repertory* set out to change this image:

> . . . without a competent fund of Antiquarian learning, no one will ever make a respectable figure, either as a Divine, a Lawyer, Statesman, Soldier, or even a private Gentleman . . . it is the *sine qua non* of several of the more liberal professions, as well as many trades.[36]

In a similar tone the manuals of the seventeenth century had recommended 'limning' as a pursuit for gentlefolk. Grose now presented the gentleman (or would-be gentleman) with a range of venerable subjects fit for his pencil, or perhaps for a visit in the company of a professional draughtsman. Failing that, he might content himself with the ever-increasing literature of topography, with its hundreds of engravings after drawings by the Sandbys, the Rookers and several dozen others. The tourist in search of the Picturesque in the late eighteenth century was expected to have acquired at least a smattering of knowledge of architectural styles. Even the comic tourist 'Dr Syntax' is made to pause in the course of his frantic quest for sketching subjects:

> Let me expatiate here awhile:
> I think this antiquated pile
> Is doubtless in the Saxon style . . .[37]

EXACT AND SINGULAR: ROOKER *contra* GILPIN

The literary advocates of the Picturesque were divided on certain points of principle. The practice followed by Rooker of precise, distinct representation was anathema to the leading popularizer of the Picturesque tour, the Rev. William Gilpin. Gilpin's notion of the Picturesque involved a reordering of the elements of nature into an imaginary, harmonious whole; it was a matter of capturing an essence, a spirit, an emotion. To Gilpin, 'exact' amounted to 'servile'. His aesthetic was rooted in what he called the grand or Homeric style of landscape, a landscape of awe and sublimity which had no place for the particulars of nature.[38] Not greatly interested in antiquarian detail, he tended to respond to the totality of a situation ('Oh! these ruins! I could live & dye among them.')[39] In his own watercolours too (fig. 28) he avoided recognizable topography, although here his principle was reinforced by his awkwardness as a draughtsman – something of which he was painfully aware; his brother Sawrey seems to have inherited the larger share of artistic facility. And so Gilpin 'generalized' his scenes, in both form and colour, seeking 'the grey atmosphere, which gives such picturesque indistinctness to objects . . .'[40]

'Picturesque indistinctness' would have seemed a contradiction not only to Rooker but to many who were caught up in the current enthusiasm for 'scientific' travelling in Britain and abroad, which set a premium on exact recording of remarkable objects. 'Singular' forms were prized above all – glaciers, ice caverns, volcanic craters, freakish piles of masonry, and unusual-shaped rocks, which were themselves sometimes likened by travel writers to architectural ruins.[41] This taste was well catered for at Leiston Abbey in Suffolk, which Rooker sketched from several angles on 6–8 September 1796 (see Appendix 1, p. 173), taking full account of the curiously formed towers of stone and brick. One of Rooker's views of this site (colour pl. III) shows the arch from the west, and in the foreground an octagonal brick tower, which was seemingly once part of a gatehouse but in its isolation presents a mysterious appearance. To a historian in 1848 it seemed too small for a garden-house, too slight for a prison . . . 'a sort of architectural enigma'.[42] A further drawing (fig. 29) depicts a chapel with its rudimentary bell-tower overshadowed by a single wall of the former church tower, which rises up unsteadily through three storeys, an *objet trouvé* on a grand scale.

Further examples of the 'whimsical effect' and 'unatural (*sic*) shapes' so disliked by Gilpin[43] could be found at Caerphilly Castle, justly regarded as the most magnificent ruin in Wales. For the tourist the principal sights were the roofless hall (which was re-roofed a century later), with its well

FIG. 31 *Caesar's Tower, Warwick Castle* Royal Academy of Arts

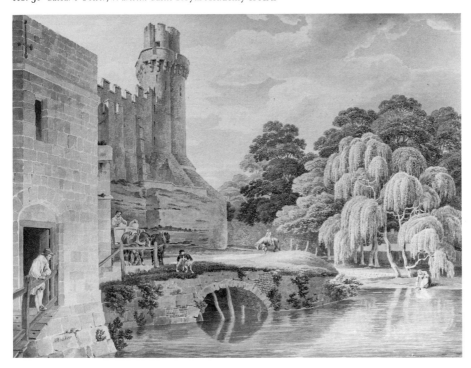

FIG. 32 *Leiston Abbey* Whitworth Art Gallery, Manchester

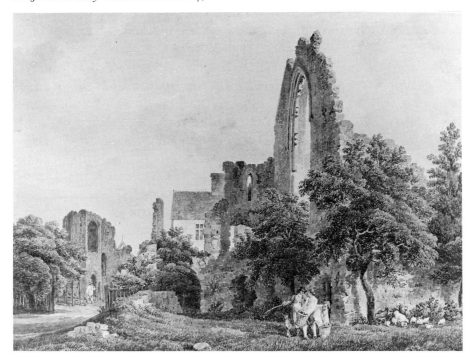

preserved ogee arches, and above all the leaning tower at the south-east corner of the inner walls: both were duly sketched by Rooker.[44] The leaning tower 'has reclined eleven feet from its base, and looks tremendously', observed one visitor, while another claimed that it 'every moment threatens destruction to the unwary passenger'.[45] Rooker (fig. 30) depicts the tower at its correct angle of inclination (10°), thereby resisting the temptation to exaggerate which overcame many who described the site and almost all who sketched it.

It was not only the professional topographical artist who found himself in conflict with Gilpin's advice to 'generalize'. Gilpin's disdain for observable particulars brought criticism from a number of correspondents, among them the poet and garden designer William Mason, who thought Gilpin 'outrageously deficient in point of verity':

> If a voyager down the river Wye takes out your Book, his very Boatman crys out, 'nay Sr you may look in vain there no body can find one Picture in it the least like.[46]

The Topographer of 1789 thought Gilpin old-fashioned in his failure to supply 'exact portraits of scenes' – 'for facsimiles will exist in encreasing favour, when the works of taste and fancy are no longer known'.[47]

Even the individual components of Rooker's pictures are often in conflict with Gilpin's proposals. A timber-wagon, such as that which appears in Rooker's well known view of Bury (**11**), meets initially with Gilpin's approval as 'an object of the most picturesque kind'. But Gilpin goes on to declare that the wagon should be pulled by oxen, rather than horses, to be truly picturesque; and it should be seen not in the streets of a town but in a forest, where 'the tree when dead adorns again the landscape which it adorned when living'.[48] Similarly, in Gilpin's mind a weeping willow (see fig. 31) is better seen in a 'humble' setting, perhaps a pool with a footbridge, than against the ruins of an abbey or castle, whose sublimity requires that an oak tree accompany it. And a forest scene becomes undignified to Gilpin's eye, if a cottage be added to it; a castle, a bridge or an aqueduct would be more in keeping.[49] Rooker, who offended against all these precepts, was clearly more interested in effects of contrast within a picture, while Gilpin sought 'harmony'. So again, Gilpin objects to moving figures and animals in the foreground of a landscape painting, arguing that these counteract the dignity and repose of the subject[50] – which, as I have suggested, was exactly the effect (and perhaps even the purpose) of Rooker's active figures and animals. In fig. 32 rustic apple-pickers are placed deliberately beneath the most majestic feature of the Abbey; and they in turn are mocked by the chickens foraging beside them.

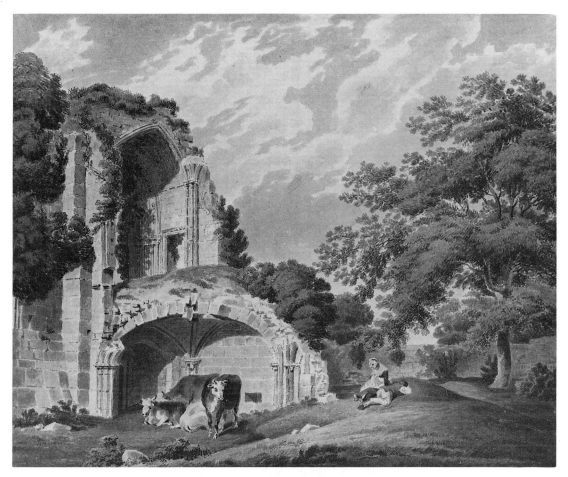

FIG. 33 *Kenilworth Castle* Walker Art Gallery, Liverpool

FIG. 34 Kenilworth Castle: June 1980 (Photograph: author)

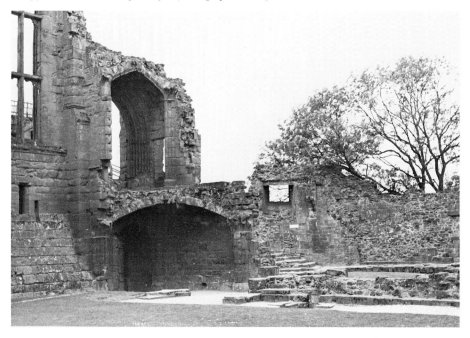

Rooker's aesthetic has much more in common with the Picturesque in the more radical sense put forward in 1794 by Uvedale Price, who rejected Gilpin's conception of 'picturesque beauty' on the logical grounds that the 'picturesque' and the 'beautiful' were distinct qualities which might in some circumstances militate against each other.[51] But the disagreement between Gilpin and Price was not merely semantic. For Price the Picturesque was a matter of irregular and intricate particulars.

> A building with scaffolding has often a more picturesque appearance than the building itself when the scaffolding is taken away ... old, mossy, rough-hewn park pales of unequal heights are an ornament to landscape.[52]

Like Rooker he admired these features in the painters of the Dutch school, such as Wouvermans, who 'accustomed his eye to that variety and play of outline, which arise from a mixture of vegetation with wood-work and masonry of every kind'.[53] Price wrote not only as a theorist but as the son of an amateur draughtsman and as a connoisseur of paintings and drawings, one who believed that there was a clear difference between the perception of 'a practical imagination' and that of 'the lover of painting': the former may be struck by general effects of contrast or romantic scenery, but only the latter will mark the detail, which holds the attention and fixes the circumstances in the memory.[54]

It can be no coincidence that the only two books on the Picturesque in Rooker's library were Price's *Essay on the Picturesque* and the same author's *Letter to Repton*.[55] And if Price's outlook seems especially close to Rooker's it also represents, as Gilpin's principles did not, a majority of the professional watercolour artists of the time.[56] The manifesto of 'Dr Syntax', created by Price's friend William Combe, clearly speaks for Price and Rooker rather than Gilpin:

> The first, the middle, and the last,
> In *picturesque* is *bold contrast*.[57]

RUIN AND HAYSTACK

In the last quarter of the eighteenth century, the fashion for inspecting and extolling ruined architecture reached a peak which has never been equalled. This is the period in which one may justly speak of a 'cult of ruins'. Ruins had, of course, been widely admired for many years before, and for many reasons. They could be regarded simply as examples of magnificent architecture; from this point of view, the less ruinous the building, the better. Alternatively they might be appreciated as a stimulus to the imagination, which recreates the building. Here presumably there is a

FIG. 35 *Tintern Abbey* Private collection

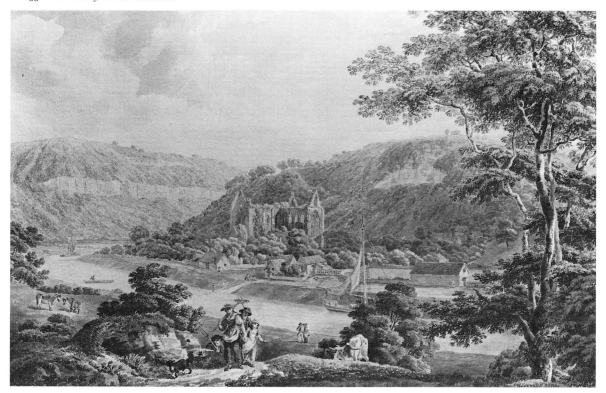

FIG. 36 Edward Dayes, *Tintern Abbey* Whitworth Art Gallery, Manchester

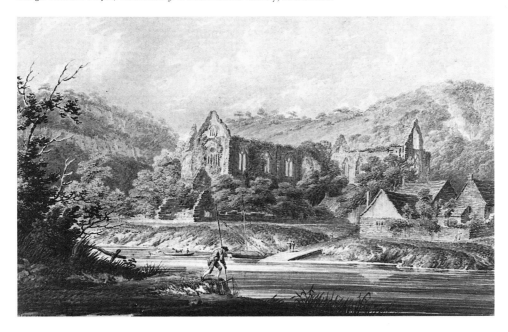

happy medium between an intact building, which offers no scope to the imagination, and a total ruin, which is invisible.[58] In a purely antiquarian context, ruins are valued as historical records, rare survivals from a distant and ill-documented past. In a moral or instructive aspect, ruins have often been seen as a salutary reminder that man's achievements are transitory, that empires must fall, perhaps even that the greatness of the past can never be retrieved. Or ruins could serve as a catalyst to the emotions, especially melancholy and a mild degree of 'horror'.

To all these motives and feelings, which recur in English literature and poetry from the sixteenth century to the present day, was added in the late eighteenth century a new and powerful source of interest, the aesthetic appeal of ruins, or (to use a contemporary phrase) 'ruins as objects of sight'.[59] Modern critics have perhaps been over-impressed by the moralizing sentiments so frequently uttered by early visitors, which often amount to no more than a pious formula, of the same order as *per Dominum Nostrum* ... intoned rapidly before the soup can cool. An acute analyst of the ruin-cult in the 1790s catalogued several possible reasons for admiring ruins, but noted

> how little their admirers are in general sentimentally affected by them. A gay party rambling through the walls of a delightful pleasure-ground, would find an unpleasant damp striking upon their spirits on approaching an awful pile of religious ruins, did they really feel the force of its association.

By this time association and sentiment were no longer the principal forces at work—

> The newest and most fashionable mode of considering them [ruins] is with respect to the place they hold in the *picturesque*; and it is chiefly under this head that they have become such favourites with landscape painters and landscape writers.[60]

Visitors now looked for interesting shapes, silhouettes and patterns in the architecture, and above all they looked for the combination of artefacts with nature, for Gothic tracery wreathed with creeper, the stains of moss and lichen on the masonry, and the satisfying contrast of grey with green. For Alexander Pope, a forerunner of Picturesque attitudes in many respects, the appeal of Netley Abbey (see fig. 71) lay not simply in the finery of the architecture but in the

> Vaults & Rooms, coverd with Ivy and Weeds, & some flowers ... the quire ... fill'd with fallen Fretworks, & window frames of Stone, mixed with high heaps of Rubbish, & great Trees of Elder &c. growing among them.[61]

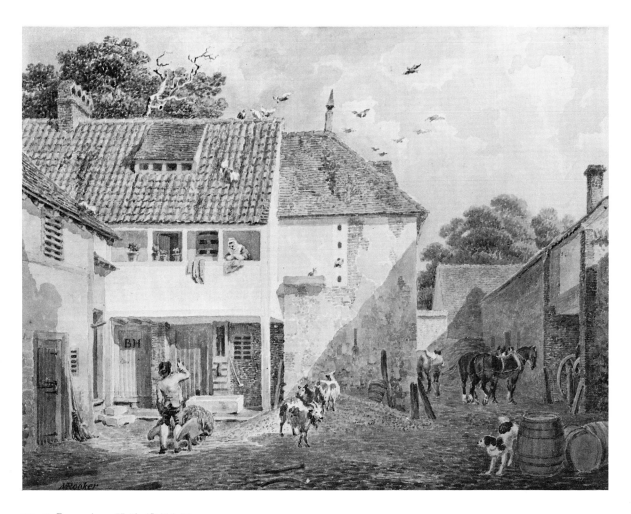

FIG. 37 *Farmyard near Thetford* British Museum

Horace Walpole, visiting the same site twenty years later, also appreciated the vegetation and would even have added to it.[62] Both these individuals were ahead of their time, however; only gradually did such an aesthetic response become widespread. The early popular travel guides called on their readers to learn from ruins rather than to feast their eyes;[63] at the same time they offered crude engravings in which architectural and natural details are conventionalized and arbitrary, and which pay scant attention to the pictorial aspects of the scene. If an interesting piece of architecture was in reality obscured by a tree, that tree might be removed in the engraved view.[64] As Picturesque and antiquarian pursuits merged in the last two decades of the century, both publishers and public became more aware of the relationship between a building and its natural environment; the increasingly fine discriminations drawn in the literature of touring are parallelled by the close attention paid by artists to the combination of the natural with the man-made. Rooker, in particular, delighted in

> this mixture [which] produces somewhat perfectly singular ... The ivy creeping along gothic arches, and forming a verdant lattice across the dismantled case-ments; bushes starting through the chasms of the rifted tower, and wild flowers embracing its battlements; and the fantastic strokes of nature working upon patterns of art, which all the refinement of magnificence cannot imitate.[65]

Rooker and many of his contemporaries would have been dismayed by the state of these ruins in the twentieth century, not because of their dilapidation – on the contrary, their architecture often appears remarkably similar to that represented two centuries ago – but because of their clinical bleakness, the absence of vegetation, the levelling of the ground, and the trim lawns mown closely so that archaeologists can mark out the sites of vanished walls and columns (compare figs. 33 and 34). The aesthetic cult of ruins is today almost entirely defunct. In its place is a demand for (or at least the provision of) 'intelligibility'.[66] Another twentieth-century watch-word is 'access' – which means that car parks may be sited immediately beside an ancient monument. At Tintern Abbey, a striking case in point, the conspicuous car park and the modern exhibition building intrude upon the prospect of the Abbey from the south-east, a view favoured by both Rooker (fig. 35) and Dayes (fig. 36).

These two issues, concerning vegetation and adjacent buildings, had already generated controversy at Tintern. In the first case, the Duke of Beaufort had cleared some of the undergrowth from the ruins, turfed the ground and arranged for regular mowing. Samuel Ireland disliked the 'smooth and trim manner in which the ground is kept', finding it out of

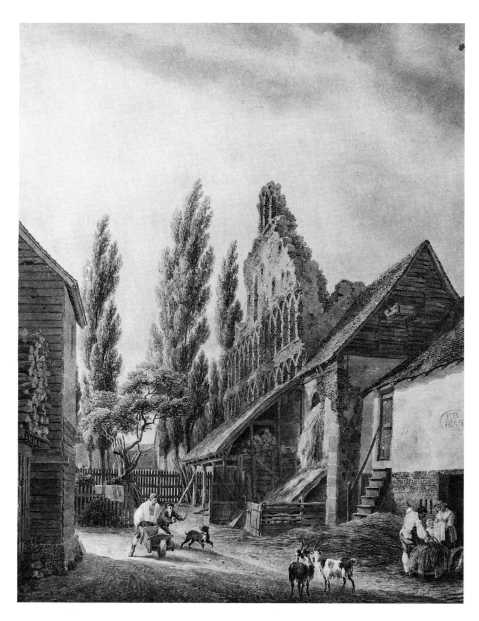

FIG. 38 *St Botolph's Priory, Colchester*
Colchester and Essex Museum

keeping with the irregularity of the ruins, although other visitors were less censorious.[67] All tourists, however, admired the moss and lichen, ivy and maidenhair which were allowed to cluster around the masonry until the twentieth century. The second debate concerned the modern buildings which stood near to the Abbey, especially on the river side. Gilpin thought that these 'shabby houses' spoilt the view from the Wye, but Ireland disagreed, claiming that they lent additional magnificence to the Abbey.[68] Since both Rooker and Dayes show the neighbouring houses clearly in their views of Tintern, they implicitly take the side of Ireland, although neither artist was much concerned with magnificence; for both men, the small cottages contributed to the Picturesque effect of the whole, together with the boats, figures and animals. (Rooker's seems to be the earlier view, since the left-hand cottage had itself become a ruin by the time of Dayes's visit.[69])

Many of the small buildings which clustered around ancient ruins were used for agricultural purposes, and the ruins themselves were often exploited by farmers as casual storage or temporary shelter for animals. If the owner of the site did not himself convert a part of the ruins into a farmhouse or a shooting-box, he generally allowed a tenant farmer to erect lean-to sheds against the once-hallowed walls. At the time of the Dissolution of the Monasteries, the commissioners of Henry VIII were well aware of the agricultural potential of the buildings they were intent on destroying: one agent recorded his orders

> to pull down to the grownde all the walls of the Churches, stepulls, cloysters, fraterys, dorters, chapter housys, with all other howsys, saving them that be necessary for a farmer.[70]

How, then was the Picturesque tourist to respond to these accretions? To the antiquarian they were regrettable, fit to be mentioned only as an ironic reflection on the theme of *sic transit gloria mundi*: 'Against the Remains of this Gateway two miserable cottages have been patched up – one of them, such is the vicissitude of worldly grandeur, an Ale-house!'[71] Likewise William Gilpin, with his dislike of 'vulgarisms':

> The transmutations of time are often ludicrous. Monmouth castle was formerly the palace of a king; and the birthplace of a mighty prince: it is now converted into a yard for fatting ducks.[72]

As we have seen, however, other recorders of the Picturesque did not share Gilpin's distaste for lowly buildings, and the draughtsman of the 1790s was not necessarily obliged to exclude them. The option most frequently followed was to adopt a viewpoint from which such buildings were unob-

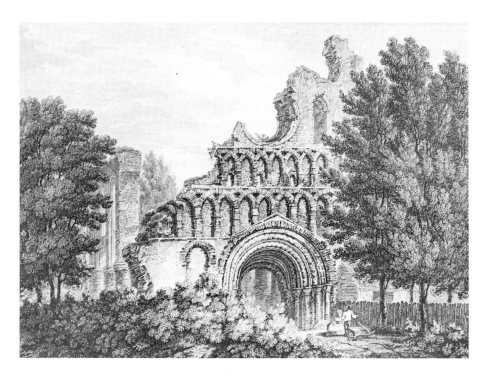

FIG. 39 W. Byrne after T. Hearne, *St Botolph's Priory, Colchester* Private collection

FIG. 40 Edward Dayes, *St Botolph's Priory, Colchester* Courtauld Institute Galleries

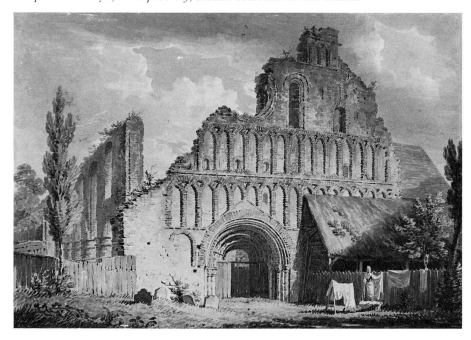

trusive, and if further disguise were required, to manipulate foliage, shade or figures accordingly. Rooker, on the other hand, often adopted the opposite course, taking up a position which made a feature of the cottage or barn at the expense of the antiquity.

Rooker clearly regarded farmyards *per se* as potentially Picturesque – witness the *Farmyard near Thetford* (fig. 37), with its varieties of surface and incident. At Bury St Edmunds a farmyard had been created in what were formerly the precincts of St Botolph's Chapel, but in Rooker's picture (**5**) there is no reason to discern any but the mildest irony. At another building dedicated to St Botolph, the Norman priory at Colchester, Rooker's predilection for rustic paraphernalia is again evident (fig. 38). The west façade of the Priory was of considerable antiquarian interest, with its tiers of small arches incorporating Roman brick, and half of the perimeter of a circular window above; the round-headed arches interlace to create an impression of pointed arches beneath the points of intersection – a pattern 'from which the idea of a pointed arch is thought by some to have been conceived'.[73] One may compare Rooker's drawing with Thomas Hearne's view engraved for Byrne's *Antiquities of Great Britain* (fig. 39), which highlights these arches and the massive portals with zigzag mouldings. Hearne includes a good measure of foliage, not merely for Picturesque contrast but also to screen the more recent farm buildings which had been added to the southern wall, and to conceal much of the lean-to shed at the right of the entrance. For the same purpose Edward Dayes's watercolour (fig. 40) incorporates a dark shadow which falls across the shed, and further diverts the spectator's attention by placing a demure launderess in front of it.[74] Rooker's view is taken from a point fifty yards to the south, from which the Priory façade appears at an acute angle and occupies only a fraction of the picture space. The great doorway is completely hidden by the lean-to shed, which now forms the centre of the picture. We are shown the logs inside the shed, another woodpile opposite, and the barn and pigsty built against the south wall of the ruin. But if Rooker relegates the ancient Priory to the background, he does allow the barn at right the dignity of its date, 'E.B.1695', inscribed on the plaster above the open door.

An extreme example of this tendency can be seen in *Stack building near Kenilworth* (fig. 41). Rooker made a number of studies of Kenilworth Castle, many of them more conventional, and some of them with figures playing hide-and-seek in the ruins. In this view, however, the castle is no more than a dim and distant silhouette, and Rooker's interest is focused entirely on the process of erecting the stacks, which are seen at three different stages of construction.

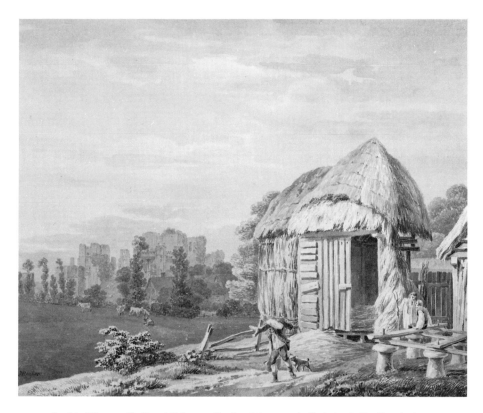

FIG. 41 *Stack building near Kenilworth* Private collection (photograph: Sotheby & Co., London)

FIG. 42 *Interior of the Abbot's Kitchen, Glastonbury* Tate Gallery

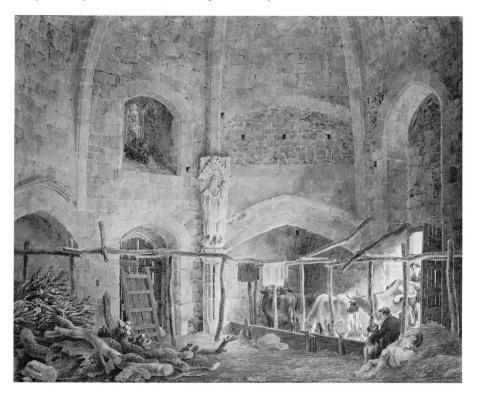

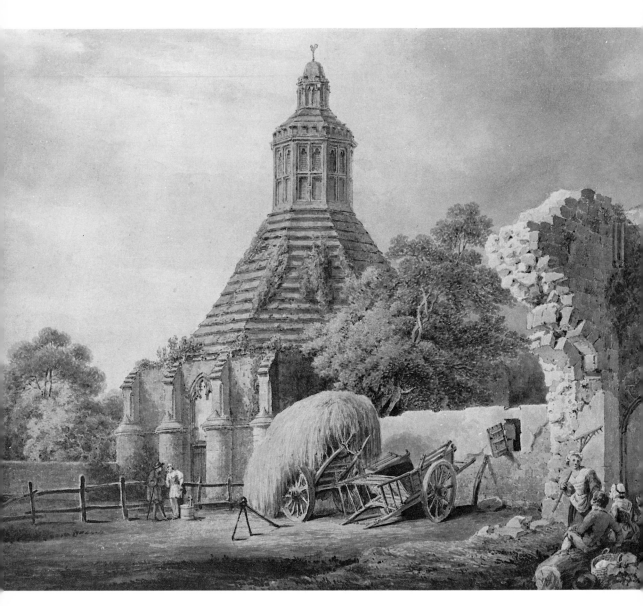

FIG. 43 *The Abbot's Kitchen, Glastonbury* Yale Center for British Art

At Glastonbury Abbey Rooker shows farm animals actually inside the monastic buildings: a part of the Abbot's Kitchen has been turned into a cattle stall, with the aid of a framework of stakes and planks (fig. 42). When William Stukeley visited the site in the 1720s he had found 'barbarous havock', for the tenant of the ruins was stripping the cut stone from St Joseph's Chapel, 'and the squared stones were laid up by lots in the abbot's kitchen: the rest goes to paving yards and stalls for cattle, or the highway'. Stukeley made the interesting observation that some of the buyers had superstitious fears about re-using materials from the monastery in a dwelling house, but were quite prepared to use them for stables and out-houses. St Mary's Chapel had itself been taken over by farmers, its original roof removed and replaced by 'a sorry wooden one ... thatched with stubble to make it serve as a stable: the manger lies upon the altar and niche where they put the holy water.'[75] Rooker's picture of the exterior of the Abbot's Kitchen (fig. 43) emphasizes the rustic accretions of tree, wall, creeper, and hay-wagons; a version of this picture[76] adds a further three or four hayricks between the fence and the kitchen. His interior view, in which a sculptured ecclesiastic looks down upon placid cows and a labourer sleeping in the hay, comes even closer to the state of affairs described by Stukeley, but a gentle irony replaces the antiquary's bitter disapproval.

THE 'HORRID ALP' SUBDUED

Rooker's antipathy to the Sublime extends to his treatment of mountains, or, rather, his avoidance of them. Few topographical artists of his time can have been so little affected by the enthusiasm for mountain scenery which is closely associated with the Romantic movement. Soaring peaks and fathomless chasms were either omitted from Rooker's itinerary or represented in a manner which played down their extreme qualities. Here again his attitude was contrary to that of Gilpin, who confessed that 'I always had a predilection for the North of England, & wished to lay my bones under a mountain'.[77] Rooker failed to visit Gilpin's Lake District, and travelled mostly in the south, where Sublime subjects were relatively scarce.

Wookey Hole in Somerset was certainly such a subject, and Rooker's view of the cliff here is perhaps his closest approximation to the Sublime ideal (see **18**). Nearby is the Avon Gorge with St Vincent's Rocks, which for many years had inspired awe in travellers: John Evelyn called it a 'horrid Alp', and judged that its precipice was 'equal to anything of that nature I have seen in the most confragose cataracts of the Alps'.[78] This is not the impression given by Rooker's view (fig. 44), a composition which

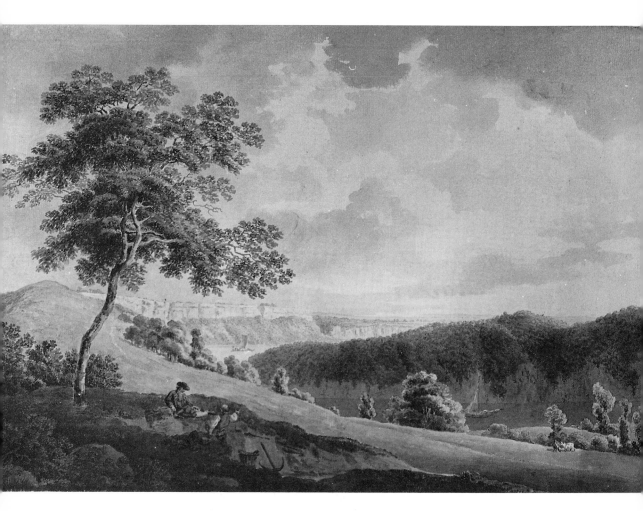

FIG. 44 *Avon Gorge, Bristol, with St Vincent's Cliffs* Norfolk Museums Service

FIG. 45 *The Vale of Llangollen, with Castel Dinas Bran* Courtauld Institute Galleries

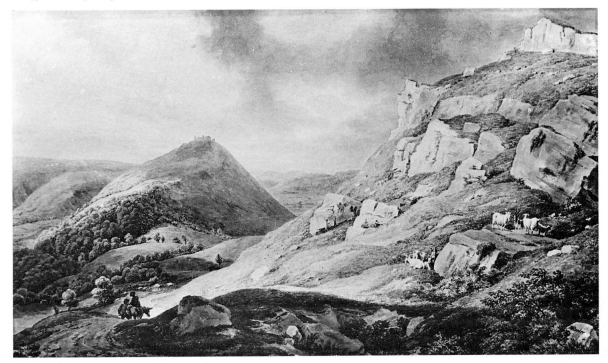

emphasizes the horizontal sweeps and curves of the river banks. The sheer cliffs of St Vincent's Rocks, which were drawn by Paul Sandby and by Nicholas Pocock from immediately below,[79] appear in the misty distance of Rooker's picture.

Wales offers a multitude of opportunities for the painting of mountains, but Rooker largely ignored them. A rare exception is *The Vale of Llangollen, with Castel Dinas Bran* (fig. 45), which is as bleak and rugged a landscape as Rooker ever painted. The scene is almost bereft of architecture – the castle remains on their distant hill were (and are) so battered by man and elements that they may almost be mistaken at a distance for craggy frag-ments of rock. The hill itself is a geological oddity, created by glaciers which gouged out the adjacent valleys, leaving a limestone outcrop fairly described by Thomas Pennant as 'a vast conoid hill, steeply sloped on every side'.[80] Nevertheless, artists invariably exaggerated its steepness. Rooker has done so in this instance, and again in his view of Dinas Bran from the west of Llangollen Bridge, although in neither is the distortion so marked as in Richard Wilson's several views of the subject.[81]

A more characteristic image of the Welsh countryside as conceived by Rooker is *Pontypridd Bridge* (fig. 46). This slender bridge over the river Taff,

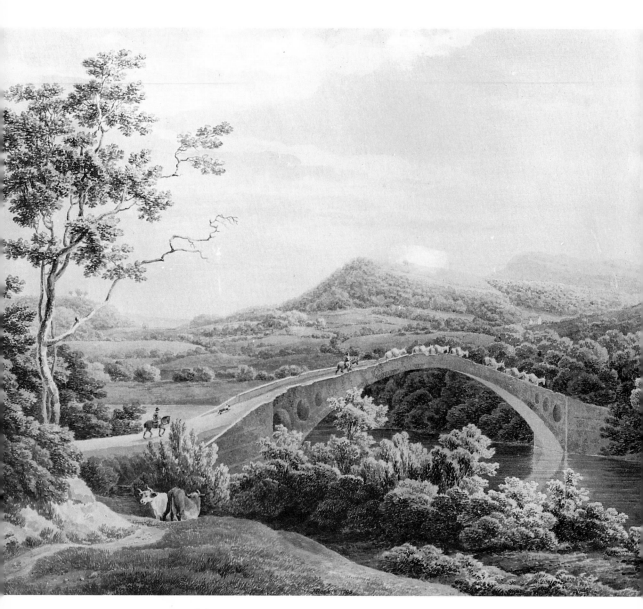

FIG. 46 *Pontypridd Bridge* National Museum of Wales, Cardiff

in what was to become a well populated mining valley, was celebrated for its huge span and for its ingenious structure: it was completed in the mid-1750s by William Edwards, a self-taught Welsh stonemason who, after several collapses, bored three conspicuous holes at each end of the bridge, thereby ensuring that the abutments would not be heavy enough to spring the crown. The result was a tenuously elegant arch, which was said to rise from the banks 'like a rainbow'.[82] Rooker has also paid close attention to the terrain, however, and here his watercolour, which is dated 1792, invites comparison with Richard Wilson's earlier view, now known only in its engraved form (fig. 47). The latter surely does not represent, as has recently been claimed, 'an Arcadian paradise' or 'a gentleman's utopia',[83] but a bleak and rugged landscape which emphasizes the steep crag at left and the rapids beside the rocky outcrop below the bridge. Even allowing for changes of vegetation between Wilson's visit and Rooker's, much of the difference between the two pictures must lie in the personalities and per-

FIG. 47 P.C. Canot after Richard Wilson, *The Bridge at Pontypridd* (engraving), published 1775
The Royal Pavilion, Art Gallery & Museums, Brighton

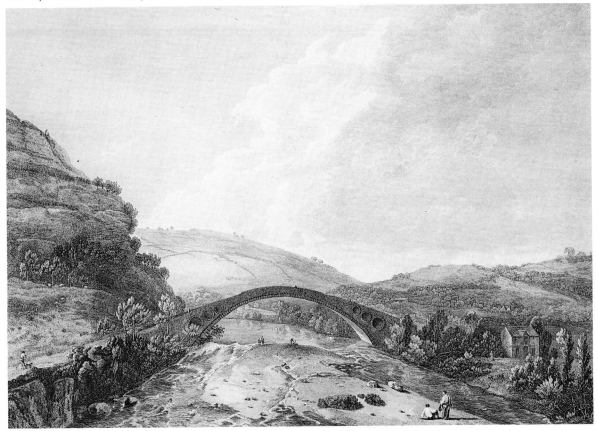

sonal concerns of the two artists. Rooker has adopted a sketching-point which avoids the cliff and conceals every stony surface with luxuriant foliage. There is no evidence of rapids in Rooker's gentle pastoral, and instead of the sheep dotted on Wilson's steep hillside he places cows in a grassy foreground. The bridge itself is domesticated by a troop of pack-horses proceeding across the arch.

If Wilson's view corresponds with a literary tradition which tended to exaggerate the savage wildness of the Welsh countryside, Rooker's is that of an amiable and comfortable tourist – one such as the Hon. John Byng, who on a 'remarkably fine' day in August 1787 had his post-chaise driven to within fifty yards of the bridge. He and his companion admired the landscape and the bridge, 'dispensed due praise', and then walked to the falls nearby where they sat on the broad rocks in the river ('parties are sometimes form'd to drink their wine and tea upon these flat rocks') before retiring to the ale-house.[84]

Rooker's drawing of the Iron Bridge at Coalbrookdale (fig. 9) may be seen in the same light. It has been suggested that Rooker here presents a misleadingly artificial view of Coalbrookdale since he does not depict the factories and foundries of the valley;[85] the only traces of industry are the chimneys of the lead-smelting works visible through the arch. It is of course possible that Abraham Darby III in commissioning the picture (see p. 36) stipulated that the industrial works be excluded; but in any case Rooker would no doubt have chosen a vantage-point which minimized the 'sublime', the 'romantic', the 'horror' and the 'terror' – to use the terms commonly employed by eighteenth-century visitors to the valley. Rooker ensures that the bridge occupies the width of his picture, allowing just enough room for a frame of vegetation and small portions of escarpment at either side. Other artists produced dramatic, distant views of the plunging valley and its steep cliffs,[86] but Rooker's subject is the bridge in every detail, down to the inscription on the inner arch. His approach is what might be expected in one professionally concerned with the mechanics of the stage, and in one who enjoyed the intricate patterns formed by the interplay of joists and beams, which he represented again at Dunwich (**17**) and in his own studio at the Haymarket (colour pl. V).

Notes

1. See Sir Richard Colt Hoare, quoted in Kenneth Woodbridge, *Landscape and Antiquity*, 1970, pp. 168–70; and William Coxe, *An Historical Tour through Monmouthshire*, 1801, p. 188.

2. Colt Hoare, op. cit., p. 169.

3. Squibb's Sale Catalogue, 29 April 1801, lots 109–70.

4. See John Harris, *The Artist and the Country House*, 1979, pp. 43, 252.

5. Arnold Houbraken, *De Groote Schouburgh ...*, 1718–21, quoted in the National Gallery, London, *Art in Seventeenth-Century Holland*, 1976, p. 52.

6. John Barrell, *The Dark Side of the Landscape*, Cambridge, 1980, p. 6.

7. ibid., pp. 82–3.

8. For clear statements of this distinction see Carl P. Barbier, *William Gilpin*, Oxford, 1963, p. 144 and n. 3.

9. David Solkin, *Richard Wilson*, Tate Gallery, 1982, p. 99.

10. W. Gilpin, *Observations on the River Wye ...*, 1782, p. 36.

11. *Iliad*, Bk 22, l. 154–6 (Lines 202–4 in Pope's version). See *Sir Uvedale Price on the Picturesque*, ed. T.D. Lauder, 1842, p. 407. Pope's text gives 'e'er', but 'ere' was clearly his (and Homer's) meaning.

12. Thomas Rees, *The Beauties of England and Wales*, vol. XVIII, 1815, p. 631.

13. Compare the later and more reverent view of the Clarendon Press by Thomas Malton the Younger, engraved in 1802 for Malton's *Views of Oxford* (the original illustrated in Leger Galleries' catalogue Nov.–Dec. 1982, no. 19).

14. From 'The world as object', 1953, reprinted in *Barthes: Selected Writings*, ed. Susan Sontag, 1983, p. 63.

15. Andrew Wilton, *Turner and the Sublime*, 1980, p. 68. For an interpretation of Turner's figures, and their disturbing indistinctness, see Karl Kroeber, 'Romantic historicism: the temporal sublime', in *Images of Romanticism*, ed. K. Kroeber and W. Walling, Yale, 1978, p. 155.

16. Byron, *Childe Harold's Pilgrimage*, Canto II, verse X.

17. See Stuart Piggott, *Antiquity Depicted: Aspects of Archaeological Illustration*, 1978, pp. 25 ff.

18. See Graham Parry, *Hollar's England*, 1980, p. 35 and n.

19. Bodleian Library, MS. Aubrey 17, f. 20. Two of the drawings are dated 1670.

20. John Harris, op. cit., p. 11 and pl. 29.

21. Bodleian Library, MS. Aubrey 2, 177v.; quoted in Michael Hunter, *John Aubrey and the Realm of Learning*, 1975, p. 68.

22. W. Stukeley, *Itinerarium Curiosum*, 2nd ed., 1776, p. 152. Stukeley's surviving drawings are listed in Stuart Piggott, *William Stukeley: An Eighteenth Century Antiquary*, 1950, appendix D.

23. Letter from Richard Gough to the *Gentleman's Magazine*, LVIII, 1788 (pt 2), p. 689.

24. *Life of Anthony Wood*, ed. Llewellyn Powys, 1961, p. 77.

25. Quoted in Piggott, op. cit., pp. 25, 62.

26. *The Correspondence of Thomas Gray*, ed. P. Toynbee and L. Whibley (Oxford, 1971), vol. 2, p. 791, note 1.

27. *The Topographer*, vol. I, 1789, pp. iii–iv, and vol. II, 1790, p. i.

28. See *The Auto-Biography of John Britton, FSA ...*, 1850, and J. Mordaunt Crook, 'John Britton', in *Concerning Architecture*, ed. J. Summerson, 1968, pp. 104–10.

29. See Joan Evans, *A History of the Society of Antiquaries*, Oxford, 1956, pp. 72 and n., 121, 160.

30. Schnebbelie's watercolour, signed and dated April 1789, is preserved in the Library of the Society of Antiquaries.

31. See Susan Legouix, *Images of China: William Alexander*, 1980, p. 92.

32. Turner's drawing was sold at Sotheby's on 16 March 1978, lot 177 (illd.). A watercolour by Turner of Winchester Cross, in the Whitworth Art Gallery, Manchester, is inscribed *made by Mr Turner for Mr Alexan ... in 1796*. (See Andrew Wilton, *The Life and Work of J.M.W. Turner*, 1979, cat. no. 164.)

33. See Evans, op. cit., p. 121.

34. Other interpretations of this subject are Edward Dayes's sketch of 1792 (V & A D217-1904), which presents a somewhat fattened Cross as a picturesque object; and a view by Thomas Rowlandson (Christie's 18 November 1980, lot 110, illd.) in which the Cross appears, faint and slender, sandwiched between two inn-signs, as a background to a vivid coaching scene.

35. *England Displayed*, 1769, vol. I, p. iii.

36. *The Antiquarian Repertory*, vol. 1, 1775, p. iii.

37. William Combe, *The Tour of Dr Syntax in Search of the Picturesque*, 1812, Canto IX.

38. See Barbier, op. cit., pp. 112–13. See also W. Gilpin, *Remarks on Forest Scenery*, 1791, vol. 1, pp. 265–6.

39. See Barbier, op. cit., p. 53.

40. Letter on 24 January 1788, quoted in Barbier, op. cit., p. 137.

41. See Barbara Maria Stafford, 'Toward Romantic landscape perception . . .', *Art Quarterly*, NS 1, no. 1, 1978, pp. 89–124.

42. Rev. Arthur Inigo Suckling, *The History of Antiquities of the County of Suffolk*, vol. 2, 1848, p. 445.

43. See Barbier, op. cit., p. 52.

44. A view by Rooker of the Hall was sold at Sotheby's on 13 March 1980 (lot 113, illd.), as *The ruins of a castle on the Welsh Marches*.

45. Hon. John Byng, in *The Torrington Diaries*, ed. C. Bruyn Andrews, 1934, vol. I, p. 284; Francis Grose, *The Antiquities of England and Wales*, vol. 4, 1776.

46. Letter to Gilpin of 8 January 1784, quoted Barbier, op. cit., p. 71.

47. *The Topographer*, V, August 1789, p. 301.

48. W. Gilpin, *Remarks on Forest Scenery*, 1791, vol. I, pp. 267–8.

49. ibid., pp. 62, 227.

50. See Barbier, op. cit., p. 126.

51. Lauder (ed.), op. cit., p. 154.

52. ibid., p. 84. For scaffolding see Rooker's *North Gate, Yarmouth*, illustrated in P. Conner, *Michael Angelo Rooker in East Anglia*, The Old Water Colour Society's Club, vol. 57, 1982, p. 50.

53. Lauder (ed.), op. cit., p. 395.

54. See Price's letter of 2 February 1795 to Lady Beaumont (p. 6), in the Coleorton Papers, Pierpont Morgan Library, MA 1581.

55. Squibb's sale catalogue, 29 April 1801, lot 5.

56. For the affinity between Price and Gainsborough see John Hayes, *The Landscape Paintings of Thomas Gainsborough*, 1982, vol. 1, pp. 94, 163, 280.

57. Combe, op. cit., Canto XIV.

58. John Aubrey quotes Sir John Suckling to this effect: 'And as in prospects wee are there pleased most, /Where something keeps the eie from being lost, / And leaves us roome to guesse.' For this and other early reactions to ruins see Margaret Aston, 'English ruins and English history: the Dissolution and the sense of the past', *Journal of the Warburg and Courtauld Institutes*, 36, 1973, pp. 231–55.

59. J. Aikin, *Letters from a Father to his Son . . .*, 1793, p. 265.

60. ibid., pp. 264, 269–70.

61. Letter to Martha Blount describing a visit of 1734, ed. George S. Rousseau, 'A new Pope letter', *Philological Quarterly*, 45, 1966, p. 415.

62. Letter to Richard Bentley of 18 September 1755, in *The Yale Edition of Horace Walpole's Correspondence*, ed. W. S. Lewis, vol. 35, 1973, p. 251.

63. See *England Displayed*, 1769, vol. I, p. iv: 'An affecting scene! but pregnant with lessons of instruction . . .'

64. See Francis Grose, *The Antiquarian Repertory*, vol. III, 1779, p. 241: 'The View being in nature greatly obscured by trees, these are here supposed to be cut down, and only their stumps remaining.'

65. Aikin, op. cit., p. 266.

66. See Michael W. Thompson, *Ruins: Their Preservation and Display*, 1981, a reasoned apology for current attitudes.

67. Samuel Ireland, *Picturesque View on the River Wye*, 1797, pp. 136–7; William Gilpin, *Observations on the River Wye . . .* 1782, pp. 33–5; William Coxe, *An Historical Tour through Monmouthshire*, 1801, ch. 36.

68. Ireland, op. cit., p. 133; Gilpin, op. cit., p. 33.

69. Dayes's picture is dated 1794, but other watercolours by Dayes of Tintern Abbey are variously dated 1792, 1795 and 1796. His view of the west end of the Abbey, sold at Sotheby's, 17 November 1983 (lot 122, illd.), makes a prominent feature of the cottages on this side of the ruins.

70. Letter from John Freeman to Thomas Cromwell, August 1539, quoted in Aston, op. cit., p. 238.

71. Francis Grose, *The Antiquities of England and Wales*, vol. 4, 1776, text to *The Bishop's Castle, Llandaff*.

72. W. Gilpin, *Observations on the River Wye . . .*, 1782, p. 27.

73. *The Beauties of England and Wales*, ed. J. Britton and E.W. Brayley, vol. 5, 1803, p. 316.

74. See also a smaller sketch of this view by Dayes, inscribed 'Sketchd. 1791', with a lighter shadow and no launderess, sold at Christie's, 24 March 1981, lot 4 (illd.). In several other cases Dayes, like Rooker, gives prominence to cottages and farm buildings.

75. W. Stukeley, *Itinerarium Curiosum*, 2nd ed., 1776, Iter VI, p. 152.

76. Newall Sale, Christie's 13–14 December 1979 (lot 63, illd.). A distant view of the Abbot's Kitchen, dated 1794, was sold as one of a pair at Christie's, 20 June 1978 (lot 41).

77. Letter to William Mason, quoted in Barbier, op. cit., p. 55.

78. *Diary*, entry for 27 June 1654.

79. Sandby's view was engraved for the *Virtuosi's Museum* in 1780; for Pocock see Jennifer Gill, *The Bristol Scene*, 1973, and Sotheby's sale of 10 July 1980, lot 112 (illd.). Other views by Rooker of Avon Gorge, seen from the river, were sold at Sotheby's on 15 July 1976 (lot 125, pair).

80. T. Pennant, *A Tour of Wales in 1773*, 1778, p. 279.

81. Rooker's watercolour formerly in the possession of the Leger Galleries, London; see also W.G. Constable, *Richard Wilson*, 1953, cat. nos. 36 a–c, and David Solkin, *Richard Wilson*, 1982, cat. nos. 132–3.

82. Thomas Rees, *The Beauties of England and Wales*, vol. XVIII, 1815, p. 639.

83. Solkin, op. cit., pp. 98–9 and cat. no. 121.

84. *The Torrington Diaries*, ed. C. Bruyn Andrews, 1934, vol. I, pp. 284–6.

85. See Francis Klingender, *Art and the Industrial Revolution*, rev. ed., 1968, p. 88.

86. See Stuart Smith, *A View from the Iron Bridge*, 1979, cat. nos. 26–30.

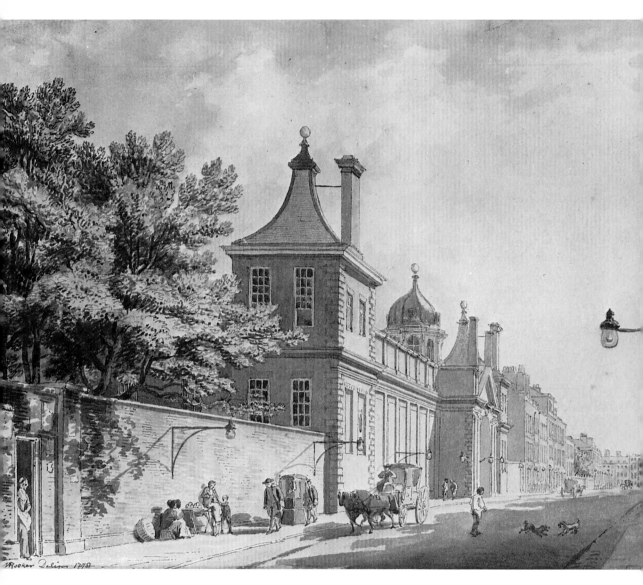

FIG. 48 *The porch of Montagu House* British Museum

III The city scene

Urban scenes are not common in Rooker's work. Most of those which survive refer to the cities of Oxford or London, and in both cases there are examples from his early life which show his style in process of development. His spectacular watercolour of the *North front of Westminster Hall, in Palace Yard* (colour pl. IV) is already highly accomplished, but the stonework is not picked out with that peculiar sharpness and assurance which characterizes his later years. The brickwork is conveyed, in some areas, by short, dark, horizontal strokes with a fine brush. In other areas, however, the bricks are suggested by slightly thicker strokes of colour, set against the 'mortar' of lightly-washed paper – the mannerism typical of Rooker's mature style. The picture is dated, but the final digit has been cut off at the right-hand margin of the paper, leaving '177-'. A date early in the 1770s is indicated by the crested carriage near the left, which is almost identical with that in Rooker's *Magdalen College with the old bridge* (fig. 62), engraved in 1771; on the other hand the portly clerical figure in the right foreground reappears in a book illustration of 1780 (**24**).

Rooker would have sketched this view with his back to the Thames and Westminster Bridge, looking south-west from the site on which Big Ben was erected nearly a century later. The low shuttered building in the left foreground, partly obscuring the entrance to Westminster Hall, is the Exchequer Coffee House; another coffee-house, Oliver's, stands on the other side of the gateway, and immediately beyond it is the Royal Oak Tavern with its sign at roof level. The low, double-gabled structure at the far right is the Coach and Horses Tavern. These taverns and coffee-houses clung, it must have seemed, like parasites to the venerable flank of Westminster Palace: they were frequented by lawyers, their clients and 'witnesses', many of them available for hire. Two figures in legal wigs and gowns are discernible among the small groups in Rooker's picture.

Above the Court of the Exchequer (the medieval range behind the Royal Oak) appear Westminster Abbey's western towers, built only 1735-40, and still perhaps regarded as one of the novelties of this prospect. The tower with its standard aloft is that of St Margaret's Church, rebuilt at the same time. There are near-contemporary views from much the same standpoint;[1] Rooker's detailed watercolour, however, more clearly shows the dilapidated state of the facing-stones and niches in the north front of Westminster Hall before the drastic 'restoration' of 1820. By that time the coffee-houses and other post-medieval additions had been removed.

Rooker's early manner of representing brickwork can again be seen in fig. 48, *The porch of Montagu House*, dated 1778. Here some outlines are

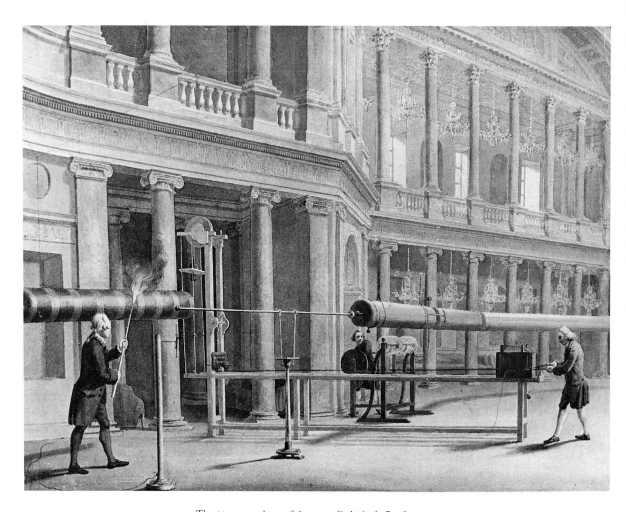

FIG. 49 *The apparatus and part of the great cylinder in the Pantheon*
Private collection

drawn with pen and ink, which is unusual in Rooker's work, for he generally drew even the finest lines with the tip of a brush. The subject had a particular significance to Rooker, since between 1774 and 1792 he gave his address as 'opposite the Museum, Great Russell Street, Blooms-bury'. In 1759 Montagu House had been opened to the public as the first British Museum; the present British Museum was erected on the same site. Montagu House was more commonly sketched from the gardens to the north, especially when the gardens were in use as a military camp. Rooker, however, has tackled the more difficult view of the south front, looking eastwards down Great Russell Street. The narrow angle has not prevented him from picking out the distinctive features of the roofline, a Jacobean ogee dome flanked by concave roofs in the French manner.

A view of the apparatus and part of the great cylinder in the Pantheon (fig. 49), which belongs to the same period, is a unique record of a remarkable occasion. The scene is the interior of the Pantheon in Oxford Street, de-signed by James Wyatt as a distant relative of the Pantheon in Rome. It had opened to great acclaim on 27 January 1772: 'the most astonishing and perfect piece of architecture that can possibly be conceived' (Horace Walpole); 'the Pantheon in point of ennui and magnificence is the wonder of the eighteenth century and the British Empire' (Edward Gibbon). The Rotunda or Great Room, flanked by the composition columns of 'Gallo antico' pictured by Rooker, was used for fêtes, masquerades, concerts, theatrical events and special exhibitions; Lunardi's balloon was displayed here, suspended from the dome, after his celebrated ascent of 22 September 1784. The spectacle on this occasion was an experiment conducted by Benjamin Wilson the portrait painter, here acting in his capacity as scientist. The Fellows of the Royal Society and the members of the Board of Ordnance assembled in the Rotunda to see Wilson operate his 'great cylinder' to simulate the effects of a thunderstorm, and to conduct fifty different experiments with the aid of his apparatus.

The event which gave rise to this project was a natural thunderstorm in May 1777, in which the gunpowder magazine at Purfleet was struck by lightning and damaged, despite the sharply pointed lightning conductors which had been set up on the magazine shortly before. Wilson had already claimed that pointed conductors were scarcely effective; now, with the encouragement of George III, he set out to prove his case. To create an electrical storm he used lengths of coiled wire and a foil-covered cylinder 155 feet long, which curved around the room like a horseshoe, suspended from silk lines. The great cylinder could be linked to a smaller cylinder of brass, which appears at the left of Rooker's view. An obvious problem was

FIG. 50 *The Manor of Marylebone as a school* (sketch) British Museum

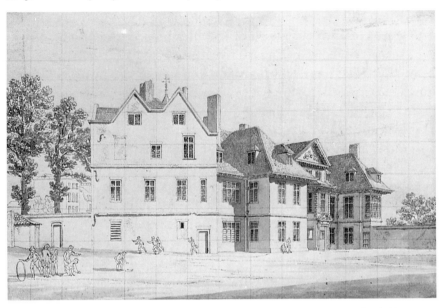

FIG. 51 *The Manor of Marylebone as a school* (finished version) Fitzwilliam Museum, Cambridge

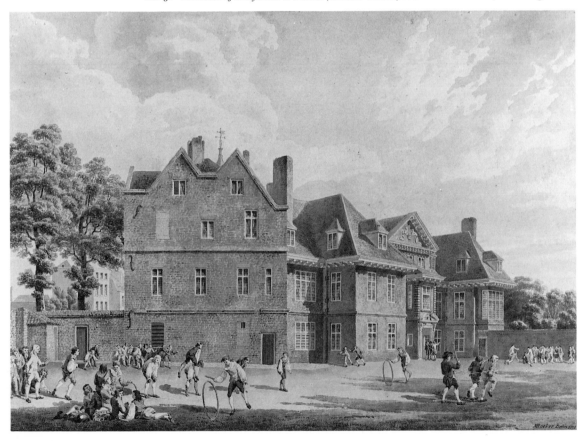

that thunderclouds move, whereas Wilson's apparatus could not; to over-
come this, he built a scale model of the Board-house at Purfleet, which
could be moved at controlled speeds along a grooved wooden runway. As
Rooker's drawing shows, the metal drainpipes and cisterns at Purfleet were
carefully replicated on the model, and the spike of the lightning conductor
is just visible above the roof. A small interval was left in the model's piping,
so that a stream of light might be visible when the model approached the
artificial thundercloud.

By varying his parameters Wilson concluded that round-headed conduc-
tors were more efficient than pointed, and that they should project a much
shorter distance above the roof than the ten feet recommended by Benjamin
Franklin. In one experiment Wilson sponged down the model to simulate
rain; in others the apparatus was made to fire gunpowder. Wyatt was on
hand to assist, and presumably Rooker was present with his sketchbook. It
is hard to imagine that any other artist of the time could have drawn the
electrical equipment with sufficient delicacy and precision to satisfy Wilson.
The latter's paper to the Royal Society, for which Rooker's drawing was
engraved as the frontispiece, is not only detailed (with measurements to a
twelfth of an inch) but elegantly expressed with touches of wit and without
self-importance. Rooker's view is the pictorial counterpart of Wilson's text
– understated, unpretentious, but with every component exactly in its
place.[2]

In January 1792 the Pantheon burnt down, allowing William Marlow
and J.M.W. Turner to sketch its ruins. A casualty of the preceding year
was the Manor or Palace of Marylebone, which was drawn by Rooker in
the last year of its existence. This splendid building, in which foreign
dignitaries were formerly entertained, had now become a school. Small
boys bowled their hoops in the courtyard which was once the preserve of
ambassadors' carriages – precisely the sort of circumstance which Rooker
appreciated; his finished watercolour (fig. 51) includes fifty-odd pupils en-
gaged in leapfrog or marbles, or imitating a coach and pair, in what must
have been their last term at the Rev. Mr Fountayne's fashionable academy.
In the background can be seen a part of the urban development which was
rapidly bringing the former Marylebone Park within the boundaries of
London.

Rooker's preliminary drawings of the Manor (figs. 50 and 52) are dis-
cussed by the antiquary and topographical artist John Thomas Smith, who
refers in his *Book for a Rainy Day* (1845) to several views of Marylebone
Park and Manor:

but the most interesting, and I must consider the most correct, are four drawings

made by Michael Angelo Rooker, formerly in my possession, but now in the illustrated copy of Pennant's London in the British Museum ... The first drawing is a view of the principal and original front of the palace, or manor-house, with other buildings open to the play-ground; it was immediately within the wall on the east side of the road, then standing upon the site of the present Devonshire Mews. This house consisted of an immense body and two wings, a projecting porch in the front, and an enormously deep dormer roof, supported by numerous cantalivers [*sic*], in the centre of which there was within a very bold pediment, a shield surmounted by foliage with labels below it.[3]

The garden front of Marylebone Manor is depicted in every detail. At right is the attractive clock tower (just visible in the front view also); each section of drainpipe is itemized, and a sash-window is plainly a recent addition beneath the second gable. Of the earlier version which he once owned, Smith comments that

in the midst of some shrubs stands a tall lusty gentleman dressed in black, with a white Busby-wig, and a three-cornered hat, possibly intended for the figure of the Rev. Mr Fountayne, as he is directing the gardener to distribute some plants.

If so, the authoritative figure in the finished watercolour (fig. 53) may represent Mrs Fountayne, who according to Smith was 'a vain dashing woman, extremely fond of appearing at Court, for which purpose, as was generally known, she borrowed Lady Harrington's jewels'. Apparently she contrived that the expenses of her carriage were borne by her pupils' wealthy parents. A notable difference between the two versions lies in the kitchen garden, which has flourished miraculously in the finished picture – perhaps a tribute on the artist's part to the superior gardening skills of Mrs Fountayne.

The Painted Chamber, Westminster (fig. 54) is not a Picturesque subject, in any conventional sense. Built in the twelfth century as a part of the Royal Palace of Westminster, the Painted Chamber took its name from the remarkable wall-paintings applied in the time of Henry III, who had his State Bed in this chamber. In 1725 most of the adjoining Cotton House was pulled down, and a massive buttress had to be erected to support the north-east corner of the Painted Chamber: perhaps it was this extraordinary feature, attributed by a later generation to Inigo Jones,[4] which recommended the view to Rooker.

The date of Rooker's watercolour is something of a puzzle. He exhibited two views of this subject at the Society of Artists very early in his career, but the architectural evidence points to a much later date. A drawing by John Carter of the Painted Chamber in 1788[5] shows a gothic two-light

FIG. 52 *The Manor of Marylebone, garden front* (sketch) British Museum

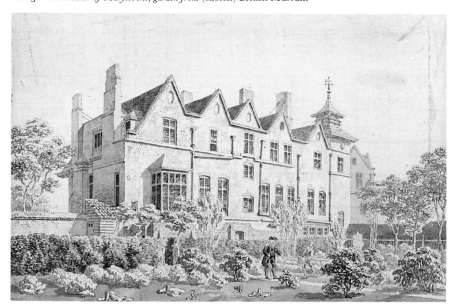

FIG. 53 *The Manor of Marylebone, garden front* (finished version) Fitzwilliam Museum, Cambridge

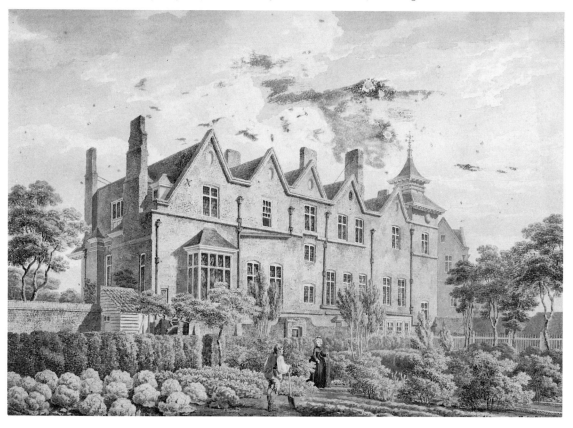

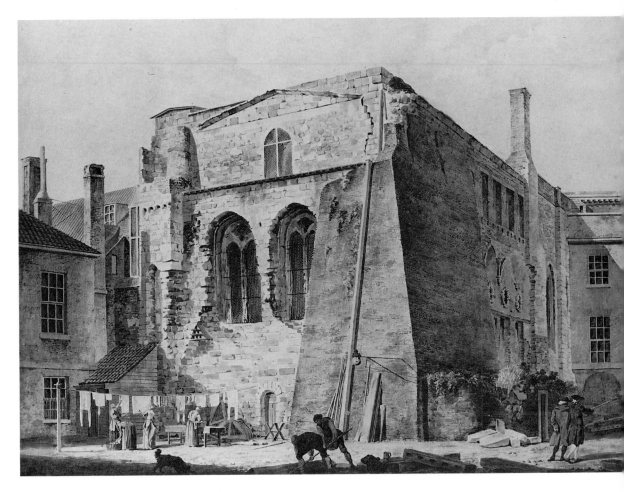

FIG. 54 *The Painted Chamber, Westminster*
Private collection, formerly with Spink & Son

window still in place in the east gable, whereas in Rooker's picture this window has been replaced by a makeshift affair of thin wooden battens. New cracks are visible above the buttress, lending credibility to the architect's opinion in 1789 that the Chamber was 'incapable of Useful Repair and Improvement'.[5] Nevertheless, the building was altered and refitted in 1800 (losing the lozenge-shaped lights in the heads of the two principal east windows, which can be seen in Rooker's view), and accommodated the House of Lords after the great fire of 1834.

The London-based draughtsman was not restricted to street scenes or views of grand buildings. The lodges and cottages in Hyde Park were favourite sketching subjects in the late eighteenth century, for here, within half-an-hour's walk of Westminster or Charing Cross, were eminently Picturesque buildings in a rural setting. The Cake House (sometimes called the Cheesecake House) was a particularly suitable subject, as it offered several gables and roofs at different levels, and was approached by a small bridge over a pond.

In 1801 the Cake House could be described as 'certainly antient'.[7] In the seventeenth century, as 'Price's Refreshment Lodge', the cottage had served pastries to the soldiers, promenaders and spectators who gathered at the 'Ring' nearby; for many years it was fashionable to come on from the playhouse to watch the racing and trick riding around this dusty track. In the early eighteenth century the lodge was known as the Cake House, and was so described by Jonathan Swift as he recorded the death of the Duke of Hamilton: the Duke had been wounded in a duel, and was helped towards the Cake House, but died on the grass before he could reach it.[8] The inaptly-named Serpentine River passed a few yards to the south of the cottage, whose site is marked on Rocque's plan of Hyde Park in 1748, half way between the bridge and the lake's eastern limit. The Cake House was finally removed in 1835.

Two alternative viewpoints presented themselves to the watercolourist. The first was from the south-east, exploiting the bridge, the pond and its ragged fringes; the second was from the north-east, at a greater distance, allowing the Serpentine to be seen in the background. The first option was adopted by Paul Sandby, Hearne and Rooker, all within a couple of years, and the resulting watercolours enable us to make a direct comparison of their styles. Sandby's view (fig. 55), dated on the mount '1797', is one of his most pleasant and least stilted compositions, which after his death was bought by Colnaghi for the Prince of Wales. It retains an open and airy atmosphere by underplaying the extent of the foliage and including the ride at right, although this meant joining a separate piece of paper to the

FIG. 55 Paul Sandby, *The Cake House, Hyde Park* By gracious permission of HM the Queen

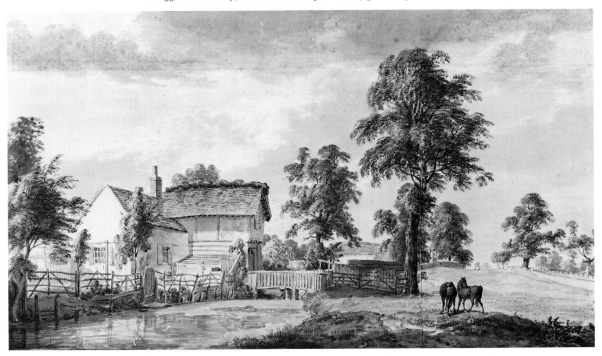

FIG. 56 Thomas Hearne, *The Cake House, Hyde Park* Private collection

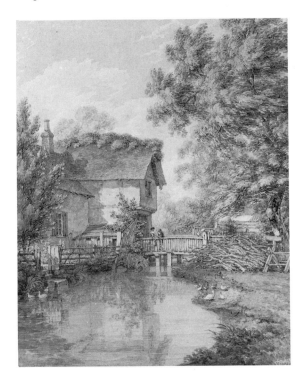

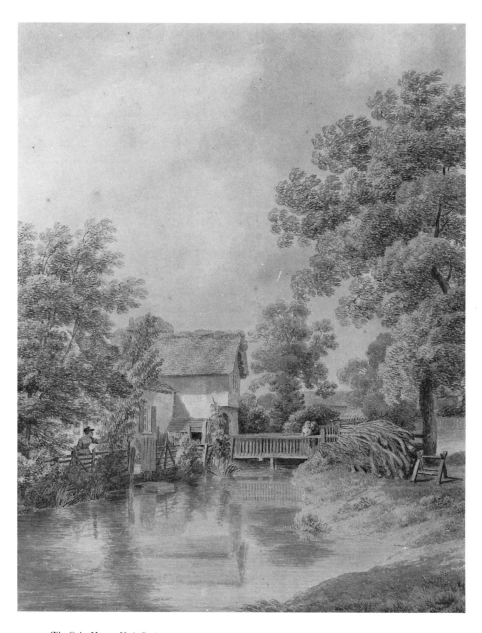

FIG. 57 *The Cake House, Hyde Park*
Private collection; formerly
with the Fine Art Society, London

main sheet.[9] The views taken by Hearne and Rooker give a more enclosed effect to the Cake House, emphasizing the overhanging branches, the reeds by the fence and the vegetation along the ridge of the roof. Hearne's picture (fig. 56), dated '1798', is so similar in its content to Rooker's (fig. 57) – notably in the woodpile and the trestle at right – that we are bound to conclude that the two artists sketched the scene together, with Hearne positioned a yard or two to the right of Rooker. Figures and ducks would have been added later, in the artists' respective studios, as each produced his 'finished' watercolour.

The Oxford Almanack

For twenty years Rooker supplied the pictorial designs for the annual *Oxford Almanack*, and could therefore be considered the official artist of Oxford University. His talents were ideally suited to that Oxonian mentality which delights in antiquarian detail even to the point of pedantry, but whose obsession is relieved by a dry, self-mocking sense of humour. Perhaps for this reason, his designs for the *Oxford Almanack* established the format which prevailed until the twentieth century.

For the first ninety years of its existence (the first of the series was issued in 1674) the *Almanack* designs were subect to many fluctuations in pictorial and academic fashion, but allegory was the dominant principle. The last *Almanack* to carry an allegorical subject was that of 1765, drawn by John Miller, in which toga'd figures referred obliquely to such recent events as a solar eclipse, the marriage of Princess Augusta, and the publication of *Marmora Oxoniensia*. In 1766 Miller's design was topographical – a view of the Physic Gardens; allegorical figures were still in evidence, but greatly reduced in size. In the following year they disappeared entirely. For 1767 and 1768 J.B. Malchair supplied landscapes in which the spires of the city were seen distantly across trees and fields. In 1769 the Rookers were first called on to provide the *Almanack* heading, and their view of All Souls' quadrangle set the new pattern: a university institution (often a recently completed building) viewed usually from an oblique angle, with a sprinkling of active figures in the foreground. The twenty *Almanack* plates in which Rooker had a hand were all exterior views, as have been most of their successors, although in the year after Rooker's death J.M.W. Turner set a precedent for interior scenes. Rooker's formula was adopted not only in the *Almanacks* but in many of the Oxford views drawn in the early nineteenth century by Thomas Malton, J.C. Nattes, Joseph Skelton, J.C. Buckler and A.C. Pugin.

The *Almanack* for each year was printed in the preceding year. The 'Orders and Accounts' of the Clarendon Press, publishers of the *Almanack*, record that the engraver James Basire was required in 1796 to send a proof of next year's design to the Delegates of the Press before the long vacation.[10] The engraver would have begun his work earlier in the year, and the drawing from which he worked would have been executed at least two years before the year to which the *Almanack* referred; Rooker's drawings for the *Almanacks* of 1784 and 1786 are dated '1782' and '1784' respectively.

The Rookers were responsible for both drawing and engraving, and a degree of collaboration in each task is suggested by the inscription 'Edw. and Mich. Rooker del. & sculp.' beneath the plates from 1769 to 1775. After Edward's death in 1774 the younger Rooker undertook both tasks until 1788. Some sources claim that he gave up because he found engraving harmful to his eyesight; others that he simply did not enjoy engraving. According to the obituary in the *Gentleman's Magazine*, Rooker's appointment at the Haymarket Theatre in 1779 allowed him to give up all engraving except the annual plate of the *Oxford Almanack*: this is plausible, for Rooker received 50 guineas for each commission,[11] paid by William Jackson, to whom the Delegates subcontracted the production of the *Almanack* from 1768 until 1789.[12] It seems that since Rooker's contract was with Jackson rather than the Delegates he was not obliged to surrender his drawings to the latter, as were his successors Daniel Harris, Edward Dayes and J.M.W. Turner; the result is that his *Almanack* drawings are now scattered among public and private collections. Eleven have come to light at the time of writing.[13]

The dominating characteristics of Rooker's *Almanack* designs are their attention to detail – in representing, for example, the elaborate tracery in the east window of Merton College chapel (fig. 58), and even the seventeenth-century sundial below, with a shadow cast on to the painted grid by a bullet fixed in the other angle of the buttress; and, secondly, a concern to present glimpses of university landmarks at the margins and corners of the principal subject. Thus his view of the Clarendon Building (fig. 59), then the Printing House, includes a part of the Bodleian Library on the left, with the cupola of the Radcliffe Library just visible beside the Tower of the Five Orders. Further left, at the end of Catte Street, is a fraction of St Mary's Church, and on the right the Sheldonian Theatre appears, still in possession of the oval windows which it lost when the lantern was enlarged in 1838.

Several of Rooker's *Almanack* designs celebrated recent structures, such as the elegant Palladian library built for Exeter College in 1778 (fig. 60);

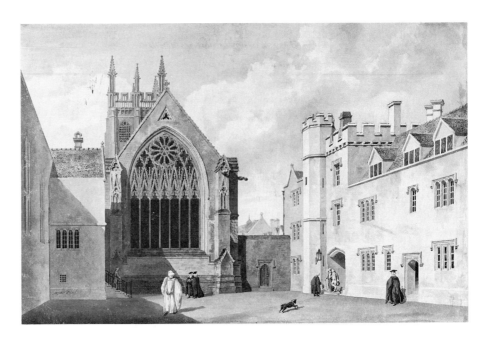

FIG. 58 *Merton College*
(design for the 1788 *Almanack*) Fitzwilliam Museum, Cambridge

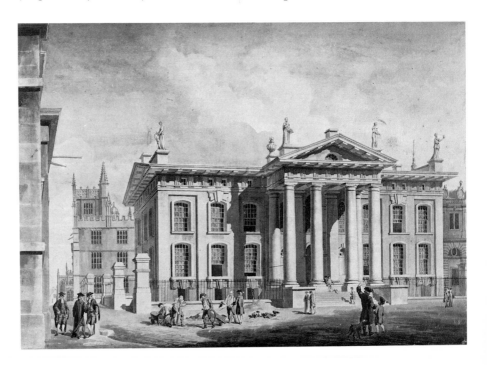

FIG. 59 *The Clarendon Building*
(design for the 1774 *Almanack*) Fitzwilliam Museum, Cambridge

for three-quarters of a century it formed a pleasant contrast with the creeper-covered Selden Wing of the Bodleian Library, until Oxford's recurrent obsession with Gothic led to a new college library in Sir George Gilbert Scott's version of that style. The Queen's College (fig. 61) had radically altered the view along Oxford High Street in the later years of the eighteenth century, and a travel volume of 1776 could describe the college as 'one entire piece of well-executed modern architecture'.[14] The *Oxford Almanack* for 1762 carried an elevation of the new quadrangle facing a vast imaginary piazza; Rooker's view brings the college back to contemporary life, picturing the frontage along the gentle curve of the High Street, where its baroque ostentation is balanced by the happy mixture of seventeenth- and eighteenth-century houses beyond.

At Magdalen College Bridge (fig. 62), on the other hand, Rooker (or Jackson) evidently wanted to record the view before it was altered. In 1770 one of the arches of the old bridge gave way, and an Act of Parliament was passed to allow the bridge to be removed. The removal occurred in 1772. By 1779 a new bridge was in place, designed by John Gwynn, Edward Rooker's former associate. This is an early drawing, which dates from the period in which Edward Rooker had a hand in production; it lacks the distinctive clarity of M.A. Rooker's later designs, and has been attributed to other artists,[15] but there can be little doubt that the drawing was executed by one or both of the Rookers.

North-west view of Friar Bacon's study (fig. 63) is another record of a threatened structure. The hexagonal tower was traditionally supposed to have been the study or observatory of Friar Bacon, the eminent philosopher of the late thirteenth century. According to legend, Bacon had so constructed the tower that it would fall when a man more learned than himself should pass under it. The university apparently failed to produce such a scholar, for the tower stood until it was dismantled in the spring of 1779 as a part of the rebuilding of the South Bridge. John Byng, visiting Oxford in June 1781, regretted this demolition 'which the hurry of modern taste occasion'd'.[16] For Rooker the scene offered a near-perfect combination of elements: the antique building, the river and craft, local inhabitants in picturesque garb, a carpenter's yard stocked with unevenly-cut timber, and a diversity of building surfaces – brick, stone, barge-boarding and stucco. Rooker was by no means the first to sketch this view, but it brought him a measure of success, as is indicated by the fact that he painted at least three versions in oils, one of which was exhibited at the Royal Academy in 1779 (no. 270).

His frontal view of the Fellows' Building at Corpus Christi College (fig.

64) is a departure from the current convention which required that country-house façades be drawn from an oblique angle. In views of Oxford quadrangles, however, the artist could incorporate two or more ranges, one full-face and the others at an angle (fig. 58); in the view at Corpus Christi, the left-hand wall acts as a substitute for the range of a quadrangle. This wall was removed shortly after Rooker's view was taken, yielding a view from the east of Christ Church Cathedral and Tom Tower; Turner's *Almanack* design for 1811, which was drawn seven or eight years before that date, shows the garden without the wall or the railings, and with creeper beginning to make its way up the façade. The Fellows' Building is thoroughly formal in style – 'much admired for its chaste style in architecture'[17] – and Rooker has used every available device to disrupt the regularity of the classical frontage: the shadow of the tree at left, the sash windows opened to varying extents (see also fig. 59), and the spire of St Mary's Church, whose summit is allowed just to appear above the balustrade (a device borrowed by Daniel Harris in his *Almanack* design for 1791). The heap of youthful figures in the foreground of the drawing was perhaps regarded as too frivolous for the *Oxford Almanack*, for they are banished from the engraving, and replaced by a pair of dignified horses.

Gardens and foliage play a conspicuous part in several of Rooker's *Almanack* views, and in the design for 1783 (fig. 65) the college buildings of St John's and Trinity are entirely upstaged by the trees and shrubs of St John's College gardens. This was appropriate in that 'the gardens of this College may be considered as the best specimen of modern gardening in Oxford, the beauty of which must be universally acknowledged'.[18] It is an unconventional composition, divided fairly sharply between architectural backdrop and luxuriant foreground, and reminding us that Rooker had joined the staff of the Haymarket Theatre very shortly before this drawing was executed.

The deflationary rôle of Rooker's figures, which has been discussed in chapter 2, is again evident in his Oxford views, where an undergraduates' punting party, or a road-mending crew, or an unruly dog worrying some other creature, provides a foil to the reverently-delineated architecture. Thomas Rowlandson took this process a step further in the watercolours[19] which he based on the *Oxford Almanack* designs. In Rowlandson's adaptations, the human activity has been intensified and burlesqued: boats full of mortar-boarded figures race past Friar Bacon's study (fig. 66), a funeral passes in pomp through the Front Quadrangle at Merton, and Rooker's road-menders reappear at All Souls', intent on harassing a fat and elderly scholar. In some of Rowlandson's series the scene approaches chaos: a

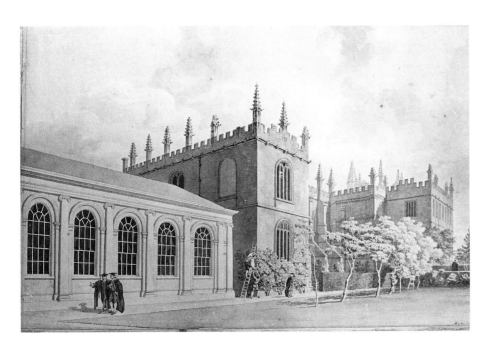

FIG. 60 *The Libraries and Schools, from Exeter College gardens*
(design for the 1786 *Almanack*) Private collection

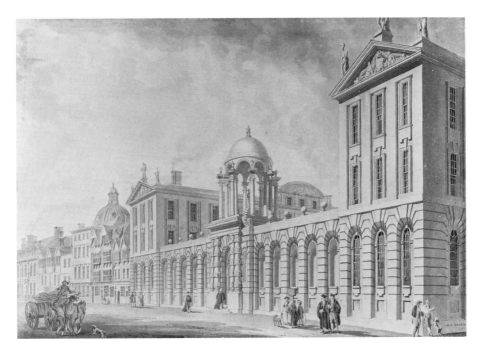

FIG. 61 *The Queen's College*
(design for the 1775 *Almanack*) Ashmolean Museum, Oxford

FIG. 62 *Magdalen College with the old bridge*
(design for the 1771 *Almanack*) Birmingham Museums and Art Gallery

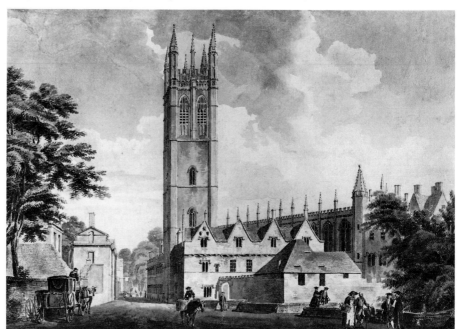

fist-fight is in progress outside Christ Church, while an undergraduate vomits in a corner, and at Magdalen a dog has upturned a milkmaid, causing a hod-carrier up a ladder to tip his bricks on to the man below. For much of their comic effect these drawings depend on their reference to the decorous 'official' versions of each scene. It is as if Rowlandson has liberated the figures in Rooker's designs, and allowed them to run riot – as they had at least half a mind to do already.

ROOKER AND TURNER

Rooker's *Almanack* design of Friar Bacon's study provided the basis for one of J.M.W. Turner's two earliest dated drawings.[20] It was copied crudely but closely in 1787 by the twelve-year-old prodigy, who unlike Rooker used pen-and-ink outlines and a little white bodycolour mixed with the blue watercolour. When twelve years later Turner gained a commission to supply drawings himself for the *Oxford Almanack*, he must have been fully conscious of the precedent established by Rooker's twenty years of *Almanack* design. A proof engraving of the *Almanack* for 1811, a view of Christ Church Cathedral with a distant glimpse of Tom Tower, has inscribed on the back, in Turner's hand, a memorandum to the engraver: 'Tom is not like. Get Daye's [*sic*] or Rooker's or Delamotte's to look at . . .'[21]

FIG. 63 *North-west view of Friar Bacon's study*
(design for the 1780 *Almanack*) Ashmolean Museum

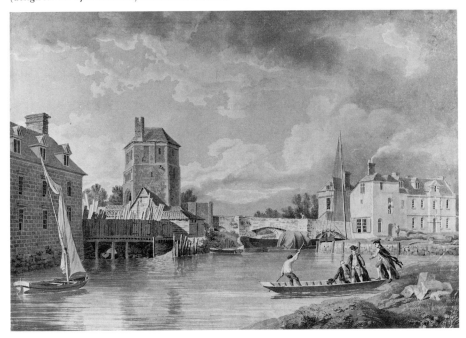

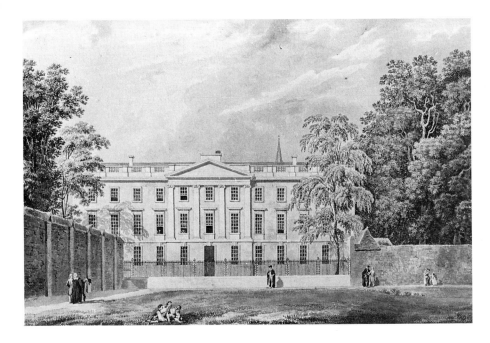

FIG. 64 *Corpus Christi College from the fields*
(design for the 1784 *Almanack*) Private collection

FIG. 65 *St John's College from the garden*
(design for the 1783 *Almanack*) Private collection

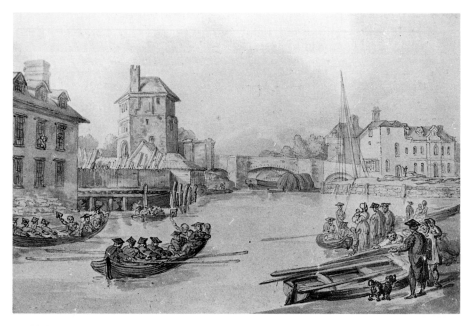

FIG. 66 Thomas Rowlandson, *Boat racing at Friar Bacon's study*
Worcester College JCR

In more general terms, Rooker's influence on the young Turner was less significant than that of Dayes, Hearne and Cozens, with whom Turner worked at Thomas Monro's school in the mid-1790s; Rooker is sometimes said to have been a member of the Monro circle, but there is no reliable evidence of it. There is some Rooker-like sketching of foliage among the small early Turner drawings in the British Museum, and Turner's views of antiquities taken in the years 1792–5 are often reminiscent of Rooker's compositions, but Rooker was only one of a dozen watercolour artists whose work Turner was studying in this decade. By the time of Rooker's death Turner had joined Rooker in the rank of Associate of the Royal Academy, and had far outstripped him in range and reputation. Nevertheless, the author of the great *Fifth plague of Egypt* (RA 1800) bought a number of small pencil sketches by Rooker at the Rooker Sale of April–May 1801. Some of these presumably correspond with Turner's record of '16 Sketches by Rooker' in his 'Woodcock Shooting Sketch-book'.[22] One detailed drawing by Rooker from Turner's collection, *The Chapter House at Margam*, remains in the Turner Bequest because Ruskin, when cataloguing the bequeathed material after Turner's death, mistook it for an example of Turner's early work, and it was exhibited as such for some years in the National Gallery.[23] Had Ruskin not attributed it to Turner, the drawing would have gone to the artist's descendants (under the settlement of his disputed will), as did at least 17 other drawings by Rooker; 14 of these were finally bought from the collection of C.M.W. Turner via Colnaghi's by the National Museum of Wales in 1946. All of these (and also the Margam drawing) are identifiable by the auction lot and day numbers which are pencilled on each sketch and which correspond with the Rooker Sale catalogues. They are slight on-the-spot sketches, some in pencil only and others with the addition of half-a-dozen small washed-in areas of varying density. It is interesting that Turner should have acquired these working drawings out of the many works available at the sale: no doubt he felt that he might still profit from Rooker's example in the basic organization of a composition in terms of light and shade, rather than in the detailed finishing of Rooker's exhibition watercolours.

Notes

1. An oil painting attributed to John Paul in the possession of the RICS (illustrated in Penelope Hunting, *Royal Westminster*, 1981, pp. 138–9), and the related engraving by Boydell (illustrated in Hugh Phillips, *Mid-Georgian London*, 1964, p. 18).

2. Benjamin Wilson, *An Account of the Experiments made at the Pantheon, on the Nature and Use of Conductors ... Read at the Meetings of the Royal Society*, 1778. See also A.T. Bolton, 'The Pantheon in the Oxford Road', *London Topographical Record*, XIII, 1923, pp. 55–67.

3. J.T. Smith, *Book for a Rainy Day*, 1845, pp. 33–4. The 'four drawings' include two interior views of the Manor, sketched in pencil, which are also in vol. V of Pennant's *London*, BM. The exterior views were often copied by other artists and students; a copy of the finished version by J. Ellwood is reproduced in Ann Saunders, *Regent's Park*, revised ed., 1981, pl. 2. The 'Rooker' drawing referred to in the text (p. 22) is also a copy.

4. Society of Antiquaries, *Vetusta Monumenta*, V, 1835, p. 5.

5. See *Architectural History*, 9, 1966, fig. 114.

6. Quoted in *The History of the King's Works*, VI, ed. J.M. Crook and M.H. Port, 1973, p. 512. See also vol. I of this series, pp. 494–9, and vol. V, pp. 396–9; also the *Gentleman's Magazine*, 1819, II, pp. 389–92.

7. *Gentleman's Magazine*, May 1801, p. 401.

8. *Journal to Stella*, entry for 15 November 1712.

9. A. Paul Oppé, *Sandby Drawings at Windsor Castle*, 1947, cat. no. 184. The second of the two tempting prospects outlined above was adopted in a gouache by Paul Sandby (illustrated as pl. 71 in Oppé, op.cit.), and in an anonymous engraving published in the *Gentleman's Magazine* for May 1801 (opp. p. 401). Two further watercolours (by Hearne and by J.T. Serres), representing the Cake House in the early nineteenth century, are illustrated in Neville Braybrooke, *London Green*, 1959, figs. XVI and XVII.

10. 'Orders and Accounts of the Delegates of the Press', MS vol. II, 1795–1810, p. 14.

11. Edward Edwards, *Anecdotes of Painters*, 1808, p. 266.

12. 'Orders and Accounts', vol. I, 1758–94, p. 69.

13. Ten of these are mentioned in Helen Mary Petter, *The Oxford Almanacks*, 1974, which also provides an excellent catalogue and history of the *Almanack*; in addition, Birmingham City Art Gallery holds the drawing for 1771 (see n. 15).

14. *A New Display of the Beauties of England*, 3rd ed., 1776, vol. I, p. 250.

15. *English Watercolours and Drawings: The J. Leslie Wright Bequest*, Birmingham Museums and Art Gallery, 1980, p. 36.

16. *The Torrington Diaries*, ed. C. Bruyn Andrews, 1934, vol. I, p. 5.

17. Joseph Skelton, *Oxonia Antiqua Restaurata*, 1823, vol. 2, opp. pl. 84.

18. Ibid., opp. pl. 83.

19. The series referred to is in the possession of the Junior Common Room of Worcester College, Oxford; others are reproduced in A. Hamilton Gibbs, *Rowlandson's Oxford*, 1911.

20. T.B. 1-A: A. Wilton, *The Life and Work of J.M.W. Turner*, 1979, cat. no. 5 (as 'after a drawing probably by Dayes'). See also A.J. Finberg, *The Life of Turner, R.A.*, Oxford, 1939, p. 14.

21. See W.G. Rawlinson, *The Engraved Work of J.M.W. Turner*, vol. 1, 1908, p. 19; and Petter, *op. cit.*, pp. 85–6.

22. T.B. cxxix (1810–12); see A.J. Finberg, *The National Gallery: A Complete Inventory of the Drawings of the Turner Bequest*, 1909, vol. I, pp. 361–2.

23. T.B. ccclxx-A; see Finberg, op. cit., vol. II, p. 1221, and Finberg, 'Some of the doubtful drawings in the Turner Bequest at the National Gallery', *Annual of the Walpole Society*, vol. II, 1912–13, p. 128.

IV Book illustrations

Rooker was born a little later than the English novel itself, according to most estimates, but just in time to meet the demand for illustrated editions of the young literary form. The decade of his birth marked the establishment of the new genre, with the publication of Richardson's *Pamela* and *Clarissa*, Fielding's *Shamela*, *Joseph Andrews*, *Jonathan Wild* and *Tom Jones*, Cleland's *Fanny Hill* and Smollett's *Roderick Random*. In the same decade the first circulating libraries were set up in London – at least half a dozen were operating by 1750 – thereby creating a wider reading public for books of this kind.

Rooker's art was well suited to portraying the domestic details which (as several literary critics complained) were a prominent feature of these early novels. Rooker had perhaps a particular affinity with Henry Fielding, who had begun his career in the theatre (in fact the very theatre in which Rooker was later employed). Fielding's theatrical experience seems to be reflected in the many moments of discovery or dénouement in his novels – moments which also lent themselves to graphic illustration. Fielding's novels, moreover, were considered to be especially English in their fondness for mock-heroic, lively characterization and 'thorough Insight into Low-life';[1] by contrast, the more genteel and sentimental manners of Richardson's works appealed more strongly abroad. Gravelot's delicate illustrations to *Pamela* (1742) still appear more appropriate to their subject than do the same artist's designs for the first French edition of *Tom Jones* (1750).

Rooker supplied illustrations as frontispieces to 11 of the 12 volumes of Fielding's *Works* published by Cadell in November 1783. (The remaining frontispiece is Hogarth's well known portrait of the author, which appears in the first volume of the set.) The Victoria and Albert Museum holds six of the drawings (**19-24**). All 11 scenes could be described as moments of confrontation, some of them passionate and most of them humorous. The frontispiece to the second volume, for example, illustrates a scene in *The Life and Death of Tom Thumb the Great* (performed at the Haymarket in 1730) in which Tom and his troops, having conquered the Picts, brings back the captive Queen of the Giants – the only one of her race short enough to pass through the gates of Tom's castle. In general Rooker gives emphasis to the incidental features of the scene which reinforce the tone of the episode: the shallow sophistication of Mrs Midnight's milieu (in the farce *Miss Lucy in Town*) is indicated by paintings of amorous exchange and a chinoiserie screen (**22**). It is impossible to be certain that the artist was given an entirely free hand in selecting the subject of his frontispieces, but only Rooker would have contrived to include a wheelbarrow and a garden roller in an illustration to *Tristram Shandy*,[2] or chosen to represent

A Voyage to Lisbon with a barn scene, in which he could portray the planks and bolts which he favoured (**23**). According to Fielding's text, the barn is merely 'lined on both sides with wheaten straw', but Rooker has interpreted this as a haystack looming above the diners.

The rococo manner in book illustration, introduced into Britain by Gravelot and evident in the work of his collaborator Francis Hayman, was wearing thin by the last quarter of the century; in the case of Rooker's 30 frontispieces designed for Colman's edition (1778) of Beaumont and Fletcher's plays, it survives only in the elaborate frames which are decorated with swags, trophies and conventional motifs related to the theme of the play in question (figs. 67-9). In the printed version Rooker's designs are not easily distinguished from those of Wale and Barralet, who also contributed to the edition, but in Rooker's preparatory drawings we can appreciate his virtuosity at a near-miniature scale. The designs are often

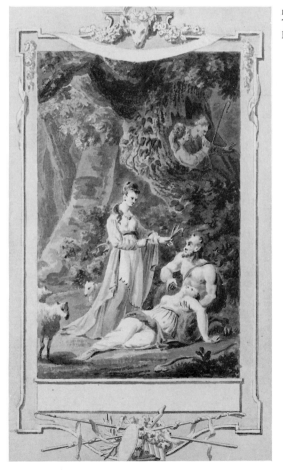

FIG. 67 *Frontispiece to*
The Faithful Shepherdess
British Museum

overloaded with incident: the frontispiece to *The Prophetess* contains, in an area of less than five inches by three, the mortal protagonists, the Roman legions behind them, and a bank of 'the grossest clouds' which hide from the mortals' view (but not from ours) the prophetess and her niece in a chariot drawn by a fire-breathing dragon.

The illustration of scenes from a play presents the artist with a peculiar problem. Is he or she to depict the scene as it would appear on stage, or as it would appear in reality (or, in the case of gods and dragons, in the realm of the imagination)? In general Rooker and his contemporaries took the second course.[3] His frontispiece to Fletcher's pastoral *The Faithful Shepherdess* (fig. 67) depicts a shepherd and shepherdess dallying in a hollow tree, unseen by the characters who occupy a sloping bank in the foreground. On stage the two groups would have been situated on either side of the stage, but the upright format of the published illustration requires the artist to

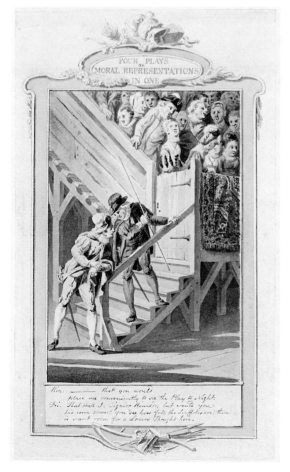

FIG. 68 *Frontispiece to*
Four Plays, or Moral Representations
in One
Yale Center for British Art

place one above the other. Moreover he has embellished the scene with sheep – who are not, of course, called for in the text – ambling around the participants.

The two apparent exceptions to Rooker's treatment of episodes from plays as genre pictures are both theatrical curiosities. One of these is his frontispiece to a production entitled *Four Plays, or Moral Representations in One* (fig. 68), which depicts a part of the seating in the theatre. The picture refers to the introductory scene which precedes the four allegorical pieces: one courtier is promising to find a seat for another in the already crowded gallery or 'scaffold' before the guests of honour (the King and Queen of Portugal) arrive and the drama proper begins. Here again, however, the situation is portrayed as it would be imagined, rather than on the stage as it would be acted. The second and most interesting case is his frontispiece to *The Knight of the Burning Pestle* (fig. 69). Here it is clear that the action

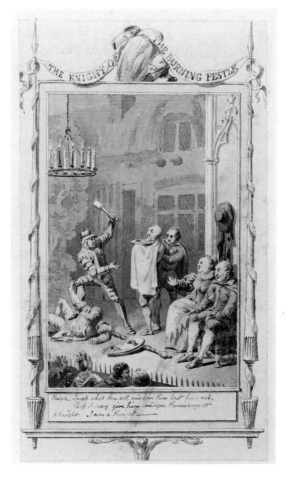

FIG. 69 *Frontispiece to*
The Knight of the Burning Pestle
British Museum

is taking place on stage, since the edge of the stage and the front row of the audience appear in the picture, for reasons which are to be found in the plot. A theatregoing grocer, described as 'Citizen', comes up on to the stage with his wife during the prologue, demanding to see a play in which the tradespeople of the City of London are represented. He insists that his apprentice Ralph be allowed to portray a grocer in heroic style; and so Ralph is allowed to take the part of a 'Grocer-Errant', wearing a suit of armour and armed with a pestle. In the course of the play Ralph performs various misdirected deeds of valour, and finally returns from battle with a forked arrow through his head: 'I die! fly, fly, my soul, to Grocer's Hall!...'

In the scene represented by Rooker, Citizen and his wife still remain on stage, encouraging Ralph. The text does not specify scenery, but to point up the contrived nature of the action, Rooker has introduced a set which is thoroughly incongruous. The backdrop shows the barber's shop; the flat beside Ralph takes the form of a substantial tree, which is quite out of place; and the opposite flat is a fragment of Gothick arcade, belonging perhaps to an abbey scene in some entirely different play. The effect is a neat reversal of the stage-designer's quest for verisimilitude, for the wings in this picture are intended to look as artificial as possible. The 'tree' wing is made to appear two-dimensional (most noticeably in the original drawing, but also in the engraving), whereas the trees in Rooker's other frontispieces are treated in a more naturalistic fashion; and the Gothick wing is given an extra touch of absurdity by Ralph's hat and coat which have been hung on it. Inconsistencies in stage scenery were not uncommon in the productions of the time, but they would have been caused by a shortage of suitable scenes, or perhaps by a scene-changer's failing to remove a flat at the right moment.[4] In the context of *The Knight of the Burning Pestle*, the bizarre setting is obviously deliberate and satirical, as befits the theme of the play.

NOTES

1. 'Essay on Mr Fielding's new species of writing', 1751, quoted in Ronald Paulson and Thomas Lockwood (eds.), *Henry Fielding: The Critical Heritage*, 1969, p. 14.
2. Private collection; signed and dated 1775; engraved for *The Life of Tristram Shandy*, 1778, vol. IV, p. 109.
3. See Allardyce Nicoll, *The Garrick Stage: Theatres and Audiences in the Eighteenth Century*, Manchester, 1980, ch. 5.
4. The Roman scenes in a production by Kemble of *Coriolanus*, for example, included terracing which was recognizable as Bond Street and Hanover Square in London (Allardyce Nicoll, *A History of English Theatre 1660–1900*, 1923–59, vol. 3, p. 35). Throughout a cottage scene in *Bombastes Furioso* (1822) a 'palace' wing was left on stage (see Richard Southern, *Changeable Scenery*, 1952, p. 311). Both these examples are quoted in Bamber Gascoigne's *World Theatre*, 1968, which also draws attention to Rooker's frontispiece and its doubly deceptive nature (pp. 192 ff.).

V Scene-painter at the Haymarket

In 1779 Rooker was appointed scene-painter at the Theatre Royal, Haymarket. For an artist of 33 this must have been an attractively secure post; for its part, the theatre was gaining an ARA of nine years' standing, whom a reviewer could already describe as 'that celebrated artist Mr Rooker'.[1]

Built in 1720, the Haymarket had become notable in the 1730s through the satirical plays of Henry Fielding, who was for two years its manager. By Rooker's day it had achieved the official status of a Theatre Royal, in virtue of a royal patent granted to its proprietor Samuel Foote in 1766. In 1776 George Colman the elder took over Foote's interest in the Haymarket, and in the next few years made several enlargements and improvements, among which may be counted the appointment of Rooker. Unlike the other two Theatres Royal of Covent Garden and Drury Lane, which generally operated from September to June, the Haymarket's patent allowed it to open only in the summer (with the exception of occasional winter performances given by special permission of the Lord Chancellor). The summer fare at the Haymarket tended to be lighter than that of its rivals: most of its productions were melodramas, comedies and comic operas, few of which have been performed since the eighteenth century. So the works on which Rooker lavished his talents bore such titles as *The Gnome, or Harlequin Underground*, and *The Baron Kinkvervankotsdorspraken-gatchdern*.[2]

One work of this kind, produced early in Rooker's career at the Haymarket, seems to have given rise to an attractive little myth which is often related in histories of English watercolours: the notion that he italianized his name, calling himself Signior Rookerini, to make himself more acceptable in a theatrical milieu. It is true that some of the leading scene-designers of the eighteenth century had come to Britain from Italy (Amiconi, Servandoni, Cipriani, Novosielski, Marinari), often to work in the field of opera, but their prestige can scarcely be held responsible for such an absurdity as 'Rookerini'. The origin of the story lies no doubt in a 'ballet tragi-comique' entitled *Medea and Jason*, by 'Signior Novestris' (George Colman the elder). In this ballet, produced at the Haymarket in 1781, Creon is given the character of Punch, Medea that of Mother Shipton, and Jason that of Pierrot; and in keeping with the burlesque idiom, the production's tailor was billed as 'Signior Walkerino', and the scene-painter as 'Signior Rookereschi'.[3] The italianized name seems to have been used only for this one production, and was garbled still further as the story was passed on. Nevertheless, it was remembered – perhaps because it sat so comically on the unflamboyant little Englishman.

Rooker would have been familiar with the London theatrical world

through his father, who first appeared on the London stage when Michael was two years old (see p. 17). Possibly as a young man Rooker already had ambitions as a stage designer: the playwright James Boaden remembered watching him at a performance of Garrick's *Jubilee* (Drury Lane, 1769) 'while with a rapid pencil he freely, but adequately, sketched the procession'.[4] Shortly before Rooker was engaged at the Haymarket he was employed on another project of the elder Colman's, which might be regarded as a trial in miniature of his capabilities: providing illustrations (see p. 118) for Colman's edition of *The Dramatick Works of Beaumont and Fletcher* (1778), one of whose plays Colman adapted and produced in the same year.

The Haymarket seated 1500 spectators, and was thus not small by modern standards (fig. 70). It was, however, considerably smaller than the great theatres of Covent Garden and Drury Lane, which grew still larger at each rebuilding; the King's Opera House, Haymarket, also held over 3000, so that the Theatre Royal in the same street was often known by contrast as the Little Theatre, Haymarket. The compact size of this theatre gave it acoustic advantages over its neighbours, in which Macbeth's dying speech could not be heard by the audience until half a minute after his death – or so the proprietor of the Little Theatre claimed.[5]

In economic terms, however, the Haymarket was less well placed. It could not afford to maintain as many employees on its payroll, and while Covent Garden and Drury Lane regularly employed several scene-painters, such an arrangement was exceptional at the Haymarket. Only near the beginning and near the end of Rooker's employment are the names of other scene-painters recorded there: James Canter in 1780, John Alefounder (who probably did no more than supply a portrait) in 1783, and in 1795 Gaetano Marinari, a well known Italian artist who worked for several of the London theatres.[6] Few of the Haymarket's accounts survive, but for one season (1793) there is a record of weekly salaries paid to the theatre's company and staff. This provides a clear indication of the regard in which Rooker was held. He received £15 10s per week, more than was paid to any of the 58 actors and actresses in the Haymarket's company, most of whom received less than £5 per week. Dr Samuel Arnold, Composer to the theatre, received £7 15s, as did the celebrated actor William Barrymore. Only John Philip Kemble of the Drury Lane company, who appeared at the Haymarket for the last six weeks of the summer season, was paid at a rate comparable with Rooker's.[7]

The accounts for Drury Lane and Covent Garden during this period show that a scene-painter in these theatres might expect to begin at two or

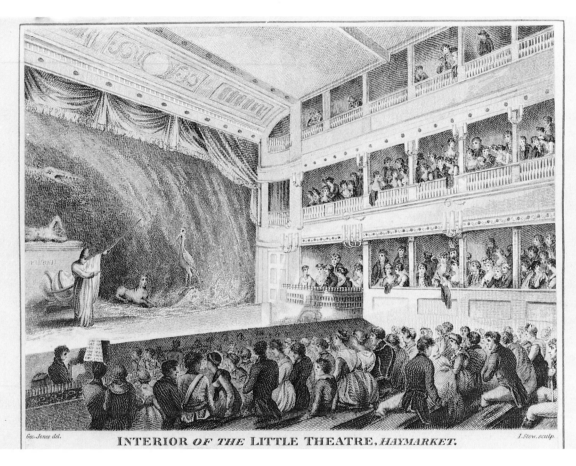

INTERIOR *OF THE* LITTLE THEATRE, *HAYMARKET.*

FIG. 70 *The Haymarket Theatre in 1815*
(J. Stow after G. Jones) Guildhall Library

three guineas a week, and rise to five or six. A few artists at the top of the profession earned more: in the 1770s de Loutherbourg was receiving about £10 a week, a salary unprecedented at Drury Lane, and in exceptional seasons Servandoni, Novosielski and Thomas Greenwood senior were paid in the region of £20 a week. It was to Rooker's disadvantage that the Haymarket played only a short summer season, whereas his rivals at the winter theatres would be paid for six to eight months a year. On the other hand he remained in employment at the Haymarket for nearly two decades, an unusually long run, and it is not surprising to learn that, from his work at the theatre, he 'enjoyed a sufficiency equal to his wishes'.[8]

Rooker would perhaps have had one or two assistants, paid by the day, to size his canvases and prepare his paints. He does not, however, appear to have followed the practice of other theatres in delegating the execution of his designs to junior artists.[9] The bills for several Haymarket productions state that the scenery was 'designed and painted by Rooker' and in all probability the figure depicted in his watercolour (colour pl. V), hard at work on a large canvas in the theatre's scene room, represents Rooker himself. He would also have been responsible for the machinery and stage effects which were often elaborate, especially in the pantomimes and burlesques: thunder and lightning, disappearances through trap-doors, or airborne entrances for deities in triumphal cars. For the musical entertainment *Rule Britannia*, first performed on 18 August 1794, Rooker's spectacular illusions seem to have been the principal attraction. At the end of the first act came

> A Grand View of the British Fleet and the French Prizes entering Portsmouth, and an appropriate Procession. The Piece to conclude with a representation of the Town, &c. of Portsmouth, as illuminated on the glorious occasion. With a Transparency of Earl Howe.

Much of Rooker's work must have involved reconstituting stock scenery for new purposes. Two nights after *Rule Britannia*, the Haymarket staged a musical farce entitled *Britain's Glory; or, a Trip to Portsmouth*, which concluded with a scene of the Grand Naval Review held there in honour of King George III. 'Portsmouth' and 'the British Fleet' would have been unravelled again, but altered to suit the new occasion. Two documents in the British Museum, apparently in Rooker's own hand, offer further clues as to what the scene-painter's job entailed.[10] One of these is a list giving the expenses incurred each year in the painting of scenes at the Haymarket from 1779 to 1789. These vary from £222 3s od to £316 8s 8d, but the fluctuations do not coincide with new productions; 1783, for example, was one of the more expensive years, despite the fact that Rooker was not called

on to design any fresh production during this season. The other document contains a calculation of the total value of the Haymarket's scenery at the beginning of the 1788 season. The final valuation, £1093 11s 3½d, is arrived at as follows. 'Scenes now in use but painted before 1779' account for only £75. Of the scenes produced since then (that is, since Rooker's arrival), one-third is written off 'for work destroy'd'. Of the remainder, a quarter is valued at its original cost, 'being as good as new', and the other three-quarters is valued at half its original cost, as being 'on an Average, half as good as new'. This suggests that a typical painted scene was likely to last for half a dozen years;[11] and the two documents taken together indicate that most of the scene-painter's time and materials were expended in adapting, refreshing and replacing stock scenery.

To judge from the scattered pieces of theatre criticism which survive, Rooker's stage sets were highly regarded by theatregoers. The *Lady's Magazine* was a consistent admirer, describing *Separate Maintenance*, 1779, one of the productions of Rooker's first season, as 'ornamented with a most elegant scene, in which Lady Newbery gave her fete ...'[12] The same periodical considered the scenery of *Harlequin Teague; or, The Giant's Causeway*, 1782, to be 'excellent, beyond all praise; if Rooker has not earned a reputation before, it would establish him a lasting one'.[13] This pantomime (by John O'Keeffe and George Colman the elder) must have been a taxing production for Rooker, since it required transformations from an Italian warehouse to a pigsty, from Drury Lane Theatre to a 'puff shop', and from a smithy to Ranelagh Gardens, as well as scenes of the Giant's Causeway and of London from Highgate Ponds. In *The Surrender of Calais*, 1791, a melodrama by the younger Colman,

> the new scenery by Rooker affords undeniable evidence of the superior powers of his pencil; particularly the view of the English Camp without the walls of Calais, which forms a striking *coup d'oeil* – nothing can be more beautiful or picturesque.[14]

Other critics compared the Haymarket's sets favourably with those at the two principal playhouses. The 'camp in St James's Park' which concluded the elder Colman's afterpiece *The Genius of Nonsense*, 1780, was said to be 'perhaps as accurate and masterly a spectacle as ever appeared on the more extensive theatres of Covent Garden and Drury Lane';[15] and we are told that in the scenery for *The Mountaineers*, 1793, a semi-historical drama set by Colman the younger in medieval Granada, 'the distinctions of situation, time, costume, and architecture, so rarely attended to by the painters at the winter theatres, are here observed with critical exactness'.[16] If Rooker could not match de Loutherbourg's daring experiments in atmo-

sphere and illumination, he was eminently able to meet the critical de-
mand, voiced with increasing confidence in the last three decades of the
century, for 'accuracy' and authenticity in all the stage properties. It was
only during Rooker's adult life that period costume became an accepted
convention in historical plays, while stage scenery was scrutinized for ar-
chitectural solecisms which would have passed unnoticed a generation be-
fore. A piece by Colman the younger performed at Drury Lane in 1799,
entitled *Feudal Times; or, the Banquet Gallery*, was criticized for its indeter-
minate architecture and even for its nonsensical title, on the grounds that
banquets were not held in galleries in feudal times.[17] William Capon,
however, who designed scenes for John Kemble at Drury Lane and Covent
Garden, was praised for his historical accuracy, and is said to have 'worked
as if he had been on oath'.[18] Two of his designs for medieval street scenes
survive: they lack the charm of Rooker's drawing, but they belong to the
same tradition of attempting to recreate the past in faithful detail, a tra-
dition which culminated in the 1850s in the productions of Charles Kean.

A symptom of this movement was the increasing tendency, in the course
of the eighteenth century, for artists to combine the professions of topo-
graphy and scene-painting. George Lambert, Alexander Nasmyth, Charles
Cotton, Nicholas Dall, Edward Edwards, Thomas Malton the younger,
John Inigo Richards and (most influentially) Philip de Loutherbourg all
worked regularly in both spheres, and it was well known that Canaletto,
the most highly regarded topographical artist of the time, had begun his
career painting for the theatre. In the early Georgian era a scene-painter
was more likely to have come from the ranks of decorative artists, but a
century later the relationship between theatre and topography was taken
for granted: a survey of 'the Rise and Progress of Scene-Painting in Eng-
land' undertaken in 1831 declared that 'Rooker was well qualified for this
appointment [at the Haymarket], as he was decidedly the best topograph-
ical artist that England had yet produced'. And the survey closes with a
reference to 'our two ingenious and highly talented contemporaries Stan-
field and Roberts, whose splendid scenery is so topographically and locally
true...'[19]

An observation by the latter artist, David Roberts, may have a bearing
on Rooker's situation. Before winning a reputation for his topographical
work, the young Roberts was employed as a scene-painter at several
theatres in Scotland and in London, where for three years he worked
alongside (and overtook) Rooker's former colleague Marinari. In 1820
Roberts secured a post at the Theatre Royal, Edinburgh: 'I went on paint-
ing on a small scale', he wrote, 'which I found of immense advantage to

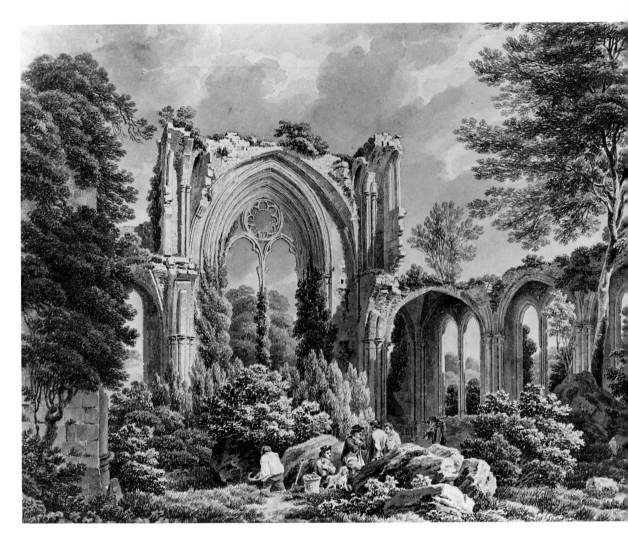

FIG. 71 *Netley Abbey* Graves Art Gallery, Sheffield

me as a scene-painter, in teaching me composition, light and shadow, and, above all, aerial perspective.'[20] Rooker, too, operated on two very different scales; the artist whose topographical watercolours were more minutely detailed than any others of his generation was also a successful painter of drop-scenes several hundred square feet in area, which had to be bold and distinct enough to make an impact at the furthest extremity of the auditorium. Today this seems a remarkable achievement, but at the time it was scarcely remarked upon[21] – an omission which is in itself a commentary on contemporary tastes in scenic art.

It is also possible that the theatre created an interest in certain locations, and a market for views of them. Rooker's watercolour composition of Netley Abbey, showing the east end of the presbytery with its delicate cusped circle (fig. 71), survives in several versions:[22] one of these, a preparatory sketch, is dated 'Oct. 7. 1794'. It may be no coincidence that an 'operatic farce' entitled *Netley Abbey* was first produced in the same year, opening at Covent Garden on 10 April 1794. The play included a scene of the Abbey by moonlight, during which it transpired that a fortune in India Bonds and Exchequer Bills had been hidden in a recess among the ruins. In the printed script the author acknowledged the outstanding beauty and fidelity of the abbey scene, which was the work of Rooker's rival in scene-painting, John Inigo Richards. We can imagine that Richards's triumph prompted Rooker to go and sketch the celebrated ruin himself: fig. 71 is certainly one of Rooker's most theatrical compositions, with its gloomy clouds and dark areas of shadow, in keeping with Thomas Gray's belief that Netley 'ought to be visited only in the dusk of the evening'.[23]

In 1795, the year in which one of Rooker's views of Netley Abbey was displayed at the Royal Academy, another effusion on the subject – *Netley Abbey, a Gothic Story* – was published anonymously. In this melodrama set in the thirteenth century, the young hero, disguised as a strolling minstrel, discovers the Abbey's secret: a fair lady imprisoned in a 'subterraneous cell' by her murderous uncle. The author of this very successful romance was none other than the Reverend Richard Warner, a fact which illustrates the readiness of both visual and literary artists to cater for widely differing tastes. Just as topographical writers like Warner could apply their skills to a more popular market, so could Rooker and Richards (and, in the next generation, Augustus Welby Pugin) provide backdrops to burlesques as well as satisfy the demands of antiquarians and connoisseurs.

Although the grand theatres of London and the provinces could offer the greatest rewards to the scene-painter, there were also many private theatres

capable of securing his services for a short season. 'Since the theatrical resignation of Roscius [i.e. Garrick] the rage for dramatic entertainments in private families has increased astonishingly', observed the *London Post* of 5 November 1776; 'scarce a man of rank but either has or pretends to have his petit théâtre, in the decoration of which the utmost taste and expense are lavished'.[24] Rooker was fortunate in that the peak of his career coincided with that of the vogue for amateur theatricals in the 1780s. Such productions were frequently social events, accompanied by dancing or dining, and although the actors were generally amateurs, the accoutrements of the theatre were often of a high standard. Professional designers from the patent theatres might be brought in to create the scenery; alternatively a fashionable and sociable artist without previous experience of the stage would be asked to try his hand – as were Benjamin Wilson (by the Delavals), John Downman (by the Duke of Richmond) and Paul Sandby (by Sir Watkin Williams Wynn).[25]

Rooker, who belonged of course to the first category, was employed at Blenheim by the 4th Duke of Marlborough. At first the family productions took place in a converted room in the palace, but their success led the Duke to convert a conservatory into an elegant theatre seating some two hundred people. Several short seasons were performed by the Duke's family and friends in 1787, dutifully praised by the newspapers, who also admired Rooker's scenery. For the following year 'several beautiful scenes by Rooker [were] added to the former suite',[26] and a future Prime Minister (Lord Liverpool) joined the cast; for the 1789 season the theatre was enlarged, and scenes by James Roberts and Thomas Greenwood were added to Rooker's. But the events of 1789 in France did not encourage aristocratic revelry, and this was the last year in which plays were performed in the theatre at Blenheim.

It was also an eventful year for the Haymarket. The health of the elder Colman had been deteriorating, and in 1789 he was officially declared a lunatic, leaving debts estimated at £7000. His son took over as proprietor, but the court which had charge of the debts granted him a mere £200 a year, together with an allowance for supporting his father. This seems to have been an effective political manoeuvre on the part of the court; unlike the pro-Government Covent Garden, and the pro-Opposition Drury Lane, the Haymarket had preserved a broadly neutral stance during the elder Colman's reign, and his confinement to an asylum allowed the Government a means of putting pressure on the new proprietor. In order to have his salary increased (as it was, in 1792), Colman the younger was obliged to make a public proclamation of his loyalty to the Administration.[27]

FIG. 72 *Design for* The Battle of Hexham Yale Center for British Art

FIG. 73 *Design for a fortress scene* Paul Mellon Collection, Upperville, Va.

Despite these financial difficulties, the younger Colman was meanwhile winning a reputation as a playwright. Rooker was associated with the young man's first four major successes: *Inkle and Yarico*, 1787; *The Battle of Hexham*, 1789; *The Surrender of Calais*, 1791; and *The Mountaineers*, 1793. All but the first consisted of a historical framework upholstered with sentiment, comedy and songs tenuously related to the plot. *The Battle of Hexham*, which did much to create a fashion for such musical history, had the additional advantage of a popular theme, for its sympathetic portrayal of Henry VI and Queen Margaret was seen as a patriotic compliment to the reigning monarch. Rooker's scenes, which were well received, included Hexham forest by moonlight, a robbers' cavern, and a view of Henry VI's camp for which Rooker's watercolour has survived (fig. 72). In his 'Advertisement' to the published play Colman claimed that he had not attempted to imitate Shakespeare, but had nevertheless 'aimed at some antiquity of style' in his language. Rooker's design represents a similar compromise, giving a respectably medieval impression without attempting any archaeological detail which might prevent the scene being used, as it possibly was, for King Edward III's camp in Colman's next play *The Surrender of Calais*, of 1791.

In 1792 Colman and his employees were seen to be operating in harmony, and *The Diary* of 17 September referred to Colman's 'gentlemanly behaviour to his Company behind the scenes'.[28] In 1793–4 the Haymarket enjoyed a winter season. While Drury Lane was rebuilding, Colman rented their patent and managed the Drury Lane company at his own theatre, retaining Rooker as scene-painter. The following summer season saw three new productions, all designed by Rooker, but this busy year marks a turning-point in the artist's fortunes, and to some extent in Colman's. The year began inauspiciously when, on 3 February, 15 people were killed at the Haymarket: the theatregoers who had crowded at the pit entrance to see the royal party which was attending the theatre, broke through the barriers and were thrown down a steep staircase. Some blame was naturally attached to Colman, despite his denial that the structure of the Haymarket was defective. Productions of his own plays in the next few years were less successful than before; he made some unnecessary enemies, and failed to pay off his debts. One wonders how Rooker reacted to Colman's founding a 'Property Club' in 1797, in which a theatrical coterie of both sexes met backstage among the properties and scenery, while the press hinted heavily at irregular goings-on.[29]

After 1794 Rooker's activities were evidently phased out. For the launching of *Zorinski* in 1795 the designers were stated to be 'Rooker, Marinari, &c.'; for *The Italian Monk*, 1797, the scenes were credited to 'Marinari,

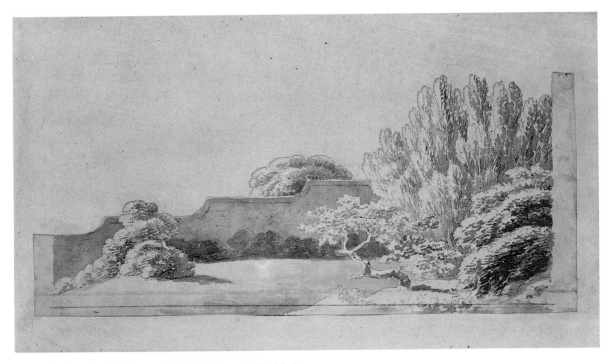

FIG. 74 *Garden wall and bushes: scene design* Yale Center for British Art

FIG. 75 *Design for a garden scene* British Museum

&c.'; and although Rooker remained on the list of the Haymarket's employees until 1800, he worked on no other new productions. The elder Colman, who had taken him up in the 1770s, had finally died in August 1794, and his son may have felt less inclined to maintain his expensive designer. Precisely when and how Rooker lost his job is not clear. Edward Edwards believed that his leaving 'was occasioned by his refusing to join in the liquidation of the manager's debts'.[30] Hakewill's obituary states, more guardedly, that Colman dismissed his scene-painter 'in order to lessen the expences of the house' —

> This event taking place unexpectedly, and a considerable sum of money due to him being at the same time involved in a chancery-suit, added to the pressure of the times, preyed upon his mind, and brought on a dejection of spirits from which he never recovered.[31]

At the auction of Rooker's possessions held in the month after his death, over a hundred of his stage designs were disposed of, and yet no more than a handful can be traced today; his contemporaries' work in the theatre has fared equally badly. There is no body of eighteenth-century stage designs to compare with the Chatsworth collection of Inigo Jones's drawings for masques at the Stuart court. Many such drawings were probably discarded once the flats or drops were completed, or else were consumed in the fires which were a constant threat to every Georgian theatre. Those which survived would have lost some of their interest as the plays which occasioned them were forgotten, and potential collectors may have been further deterred by the grids of squares commonly superimposed on a design which was to be redrawn on a larger scale.

The few which remain are therefore of particular interest. *A fortress with cannon* (fig. 73) is squared into 24 divisions, perhaps corresponding with the stage of the Haymarket Theatre which was 24 feet wide. *Garden wall and bushes* (fig. 74) would, in its enlarged form, have been used upstage in a variety of different productions, and seems suited to discreet rendezvous and conversations overheard from behind the low wall. *A garden scene* (fig. 75), on the other hand, may have been used for a backdrop: it is entirely conventional in its conception, as can be seen by comparison with a similar design by Sir James Thornhill, for *Arsinoë* at Drury Lane in 1705, which also consists of a formal garden enclosure with arbours and urns flanking a central fountain.[32]

There is one outstanding record, however, of Rooker's years at the Haymarket. This is his finished watercolour of a scene-painter – surely Rooker himself – standing, dwarfed by the machinery of his profession, in the

corner of his lofty studio (colour pl. V). The scene-painter is shown at work on a landscape flat or backdrop held within a painting-frame, which could be moved up or down through a slot in the floor – an arrangement which was not adopted on the continent until the following century. To reach the upper part of a drop or flat, the artist would stand on the 'painting bridge' which is seen in its uppermost position, 12 or 13 feet above the ground; this, too, could be winched up and down. The framework on the extreme left seems to be another painting-bridge, in a lowered position, placed presumably against a painting-frame just out of the picture. The stove would have been used for boiling water in which to melt the painter's size. The two long rolls of fabric slung below the roof are evidently drop-scenes or act-drops, which could be rolled down to form scenes at the back or front of the stage.

The artist is wearing protective clothing in the form of an old coat and turned-up baggy trousers, with a hat to keep any splashes of distemper away from his wig. His painting wrist is supported by a padded mahlstick, in the traditional manner of artists when working on detailed passages with a short brush; it is interesting to see Rooker using a mahlstick even for stage scenery.

This is the only known view of such a room in a British theatre in the eighteenth century, and indeed no other such views are recorded before the 1870s.[33] As a composition the watercolour is no less remarkable. It is difficult to think of any equivalent, before the twentieth century, to this geometrical forest of vertical and horizontal lines overlaid with the massive diagonals of the principal beams. There is no discernible trace of pen or pencil. The incidentals are painted with typically devotional care: the rows of pots, some containing paint already mixed, the bolts, ropes and cog-wheels, and the dog, patient but unappreciative of the work of art beside him.

Of all the animals in Rooker's work, dogs appear most frequently. Usually these are active, running or at least trotting, and often threatening to cause a commotion; generally they are of the ragged, not to say mongrel, variety favoured by connoisseurs of the Picturesque ('among dogs, the Pomeranian and the rough water dog are more picturesque than the smooth spaniel or greyhound').[34] The animal shown here is a little more aristocratic, however. Is it simply a portrait of Rooker's own dog? Modern critics warn against such a literal-minded interpretation; one authority doubts whether there are any 'real, as opposed to iconographical, dogs represented in eighteenth-century English art'.[35] Yet none of the proposed categories of allusion seems to fit here: the scene-painter's dog represents

neither the social status of the sportsman, nor the staunchness of John Bull, nor the 'cynical' satirist, nor even the carnal appetites of the male sex.[36] This is a demure, detached and dignified creature, a silent rebuke to those academics who persist in seeking metaphors in improbable places.

A very similar dog appears in Rooker's frontispiece to Beaumont and Fletcher's *Love's Pilgrimage* (British Museum), drawn in the 1770s, which may lead us to suppose, purely from considerations of the canine life-span, that the present picture was executed no later than 1790.

NOTES

1. *The Lady's Magazine*, September 1779, p. 486.
2. *The London Stage 1660–1800*, ed. C.B. Hogan, 1962 etc., pt 5, vol. 1, p. 441, and vol. 2, p. 1080.
3. Enthoven Collection: 1782, Victoria & Albert Museum. Variants in subsequent newspaper announcements were 'Rookerelski' and 'Rookerelschi'. The name 'Rookerini' is first attributed to Rooker in Edward Edwards, *Anecdotes of Painting*, 1808, p. 266.
4. J. Boaden, *Memoirs of the Life of John Philip Kemble, Esq.*, 1825, vol. 2, p. 295.
5. Hogan (ed.), op. cit., pt 5, vol. 3, p. 1677.
6. For the season of 1800 Marinari and Rooker were joined by 'S. Whitmore'.
7. Enthoven Collection: 1783, Victoria & Albert Museum. Kemble was paid £150 for the season.
8. *Gentleman's Magazine*, LXXI, May 1801, p. 480. For a fuller discussion of scene-painters' wages see Sybil Rosenfeld, *Georgian Scene Painters and Scene Painting*, 1981.
9. At Covent Garden, for example, 'a copy of the drama is put into the hands of the artist who is to plan the scenes (Richards, an RA and highly distinguished, had the office at this time); he considers upon it, makes models in card-paper, and gives orders to the painters. The author is often brought into the scene-room to give his opinion on the progress of their work'. (*Recollections of the Life of John O'Keeffe*, 1826, vol. II, p. 39).
10. Rooker documents, Dept of Prints and Drawings, British Museum.
11. In Rooker's time new sets were produced much more frequently than had been the case in the previous generation. Tate Wilkinson's *Memoirs*, 1790, observe that 'now frequently we have new scenery to almost every piece. It was very uncommon formerly for new plays to have more than what we term stock scenery:— There is one scene at Covent Garden used from 1747 to

this day ...' (vol. 4, p. 92, quoted in Rosenfeld, op. cit., p. 12).
12. *Lady's Magazine*, September 1779, p. 486. This and the following four references are given in Sybil Rosenfeld and Edward Croft-Murray, 'A checklist of scene painters working in Great Britain and Ireland in the 18th Century', *Theatre Notebook*, vols. 19–20, 1964–6, pp. 144–5.
13. ibid., August 1782, p. 39.
14. ibid., August 1791, p. 425.
15. *Biographia Dramatica*, 1812, II, p. 261.
16. *Thespian Magazine*, September 1793, p. 214. The scenes in question included the marketplace in Granada, a Moorish garden, the wild 'Sierra de Ronda' and an Andalusian inn.
17. *Gentleman's Magazine*, February 1799, pp. 113–6; June 1799, pp. 468–72; November 1799, pp. 935–8.
18. Boaden, op. cit., pp. 295, 101–2. Boaden's adaptation of *The Italian Monk* was first performed at the Haymarket in 1797, with designs by Rooker and Marinari.
19. *Magazine of the Fine Arts*, 1831, p. 325.
20. Quoted in James Ballantine, *The Life of David Roberts, R.A.*, Edinburgh, 1866, p. 19.
21. For the remarks of 'Antony Pasquin' on the scene-painter's *petite* mind' see p. 139. The memoirs of the landscape artist Thomas Jones cast an interesting sidelight on a difference between scene-painting and easel-painting. In 1773 Jones prepared some scenery for Oldfield Bowles's private theatre at North Aston, Oxfordshire; 'but not being accustomed to what is called *painting in Distemper*, that is to say with size and water instead of Oil, the whole was done with Oil & Spirits of Turpentine the fumes of which ... affected my head, breast, stomach & nerves in such a manner that I thought I should have died – I was advised to go a hunting ...' (*Journal of the Walpole Society*, XXXII, 1946–8, p. 29).

22. The sketch was sold at Christie's on 16 November 1965 (lot 174); finished versions are at the Graves Art Gallery, Sheffield (illustrated here) and at Birmingham City Art Gallery. An upright view by Rooker of the east window at Netley was formerly in the possession of Anthony Reed Esq.; it was engraved by 'J. Powell' in 1800.

23. Letter to James Brown, October 1764, in *The Correspondence of Thomas Gray*, ed. Paget Toynbee and Leonard Whibley, Oxford, 1935, vol. 2, p. 843. The tradition of Netley Abbey by moonlight is maintained in *The Beauties of England and Wales*, vi, 1805 (two engravings after Dayes); and after Constable's honeymoon visit to the site in 1816 he worked up a watercolour on the not unexpected subject of *Moonlight at Netley Abbey*.

24. Quoted in Sybil Rosenfeld, *Temples of Thespis*, 1978, p. 11.

25. See Rosenfeld, ibid. The author adds that the scene-painting was occasionally entrusted to 'a talented member of the *Corps Dramatique*' (p. 169).

26. *Public Advertiser*, 22 January 1788, quoted in Rosenfeld, op. cit., p. 114.

27. See Lucyle Werkmeister, *A Newspaper History of England 1792–1793*, Lincoln, USA, 1967, pp. 42 ff., 93.

28. Quoted in Jeremy F. Bagster-Collins, *George Colman the Younger, 1762–1836*, New York, 1946, p. 64.

29. ibid, pp. 111–12.

30. Edward Edwards, *Anecdotes of Painters*, 1808, p. 266.

31. *Gentleman's Magazine*, LXXI, May 1801, p. 480.

32. See Graham Barlow, 'Sir James Thornhill and the Theatre Royal, Drury Lane, 1705', in *The Eighteenth-Century Stage*, ed. K. Richards and P. Thomson, 1972, pl. 3.

33. See Sybil Rosenfeld, 'A Georgian scene-painter at work', *British Museum Quarterly*, XXIV, 1969, nos. 1–2, pp. 33–6; and Rosenfeld, 1981, pp. 10–11.

34. *Sir Uvedale Price on the Picturesque*, ed. T.D. Lauder, 1842, p. 85.

35. Ronald Paulson, *Popular and Polite Art in the Age of Hogarth and Fielding*, Notre Dame, Indiana, 1979, p. 60.

36. ibid., pp. 49–63.

VI Rooker & the critics

Rooker's lifetime saw the beginnings in England of a new literary genre: criticism of contemporary art. In France the genre was already in evidence in the 1740s, and was firmly established by Diderot's regular reviews of the biennial *Salons* in the 1760s. In Britain no critics of comparable stature emerged until the nineteenth century, but in the years following the Royal Academy's foundation several newspapers (notably the *Morning Post*) began to consider its exhibitions. One of the first identifiable reviewers was John Williams, who entered the Royal Academy Schools in 1773 and tried to make his way as a portrait painter before turning to journalism in 1784. He opposed himself to Tory policies, composed theatrical satires lampooning actors and artists, and published a virulent attack on the Prince of Wales's entourage, using the pseudonym 'Anthony Pasquin'; Macaulay spoke for many of his contemporaries in describing Williams as a polecat.[1]

In 1794, 1796 and 1797 Williams published reviews of the current Academy exhibitions, further antagonizing most of the artists represented. His tastes in painting, unlike his political attitudes, were generally conservative. He favoured broad landscape effects with 'a superior glow of harmony', and the autumnal tints of Claude and his followers. His critiques are witty, often at the expense of the artists concerned, and sometimes adopt a tone of moral outrage worthy of Ruskin's 'Academy Notes' half a century later. He was no doubt acquainted with Rooker, either at the Academy Schools or at the theatre, for he was an active theatrical critic; in 1792 two of Rooker's colleagues, the actors Wathen and Barrymore, physically attacked Williams after seeing him at the Haymarket Theatre. Whether for personal or aesthetic reasons, the 'Critical Guides' contained a succession of increasingly hostile comments on Rooker's exhibits. In his survey of the 1794 exhibition Williams devoted most of his attention to the oil paintings, allowing less than a page to 'drawings', among which he admired the work of Paul Sandby and William Hodges, but 'Mr. M. A. Rooker's drawings are Nature rather too tenderly represented'.[2] In 1796 Rooker had no fewer than 12 watercolours in display, but Williams found these

> below his character: they are executed with such ignorance of effect, and such offending littleness of manner, that they seem rather the works of a boarding-school spinster, than a veteran '*Associate!*'[3]

Williams also disliked the 'spotty' and 'scattered' manner of William Alexander's views of China; Dayes's *Warwick Castle*, however, he admired. In 1797 Williams turned the full force of his scorn on to Rooker, whose work was denounced, improbably enough, as an example of artistic vanity:

No. 711, 721, 722 and 748, are tinted Drawings by M. A. Rooker, A. This

gentleman was recently employed as the Scene Painter to the Little Theatre in the Hay-market, from whence he was discarded to make room for one more insufficient, and as he has been a scene Painter, we are not a little amazed at the *petite* properties of his mind, which are more analogous to the pursuits of a Lady than a masculine professor; these drawings are among the worst we have seen from the same source. We are truly surprised that Mr. Rooker should have practised so long, and not have made a greater progress in his art, than appears to us: there is the same neatness of pencilling, the same faintness of tone, the same absence of spirit and due effect, and the same want of knowledge in the anatomy of his figures, as there was in his first professional advances in life: it is not possible that any person could have practised so long, with so little success, who was not very vain, and that vanity forces a rejection of proper study; the advantages of humility in every stage of life, are incalculable ... vanity and nobleness are like two buckets in a well, the raising of one produces the consequent depression of the other.[4]

'*Petite*' was a damning epithet at a time when watercolourists were striving for public recognition of their art, and measuring their achievements directly against those of oil painters. A manual of the time advises students to use large brushes, for 'very small camel's hair pencils [i.e. brushes] will in time give the student a *petite* manner';[5] and even Claude could be criticized for painting nature's littlenesses instead of achieving the 'breadth' of Richard Wilson.[6]

Two of Rooker's fellow artists left brief appraisals of Rooker. Edward Edwards, who had been a fellow student of Rooker's at the Royal Academy Schools, offered routine praise of his artistic merits,[7] but the 'Professional Sketches' composed by Edward Dayes are more revealing. Dayes's view of Rooker must be read in the light of his own situation – his financial straits at the time of writing, and his failure to gain access to the ranks of the Royal Academy, or to find adequate employment for his considerable talents. Within three years of composing the following entry, Dayes's bitter disappointment had led him to commit suicide. His style appears to have owed more than a little to Rooker; he may have seen Rooker's career as a reflection of his own, and therefore to have exaggerated Rooker's difficulties.

Poor Michael! dejected and broken in spirit, for want of due encouragement, drooped into eternity the last day of February, 1801, aged about fifty-seven. The ingratitude of a friend, to whom he had lent a sum of money, and the neglect of an undiscerning public, broke the heart of this highly deserving and meritorious artist. The hand of folly is profuse in the purchase of old pictures; but the performances of living artists, however deserving, are too frequently treated with contempt. While the wealthy and ignorant are suffered to dictate in matters of art, the professor will be left to suffer; and ultimately the dignity

of science will sink into obscurity and contempt, from its being rendered sub-
servient to little minds . . .

He has left some admirable specimens of engraving, as well as his father: but
his chief delight was drawing, in which, for taste and execution, he stands
unrivalled. He appears to have founded his manner on that of Paul Sandby;
and though more dashing style at present prevails, it is less true, and unques-
tionably more artificial.[8]

As Dayes saw all too clearly, the taste of the time was inimical to the
careful technique practised by Rooker and himself; more galling still, it
favoured the 'flashy' effects of Turner, whom he condemned with a series
of back-handed compliments, and Girtin, with whom Dayes had quarrelled
notoriously when he was Girtin's master. Had Rooker and Dayes lived on
for another decade into the nineteenth century, they would have found
fashion in watercolour departing even further from their own ideals. Paul
Sandby's manner had likewise become outmoded well before his death in
1809, and Farington's reactions to Sandby's posthumous sale of work would
have applied also to Rooker:

I could not but sensibly feel the great difference between His works and those
of Artists who now practise in Water Colour. – His drawings so divided in
parts, so scattered in effect, – detail prevailing over general arrangement.[9]

Sandby's death prompted similar observations from his son (Thomas Paul
Sandby), who complained that the self-appointed connoisseurs of his own
day – 'not professional men though, thank God!' – preferred

an undefined wild rumble-tumble (or anything else you please) of penciling
[*sic*] to a just representation; which work they call *bold*, and spirited sketching;
and aptly it is named, for *bold* must be the doers, *bolder* the admirers.[10]

By the 1830s it was possible to take a more detached view of the achieve-
ments of the early watercolourists. 'A Historical Sketch of Painting in
Water-Colours' published in Arnold's *Library of the Fine Arts* in 1831 con-
ceived of the history of British watercolours as a process of steady improve-
ment towards a state of near-perfection in his own day 'which is the ad-
miration of all nations'.[11] The author's patriotic pride allowed him to be
generous to the pioneers of the art. As he saw it, Paul Sandby had made
the decisive innovation in 'going to nature for his prototype'; the art was
then advanced in successive steps by Rooker, Hearne, John Cozens, Girtin
and Turner. Sandby outlined his topographical subjects in pen and ink,
and then added tints, 'with characteristic touch, and occasionally with
pictorial taste'. Rooker's contribution was to develop the potential of the

watercolour medium itself. In place of the generalized tinting employed by
Sandby, Rooker showed that watercolours

> carefully applied in the representation of the localities of tint in brick, stone,
> timber, tile, and plaster, were capable of being wrought into works much more
> worthy of competing with pictures than his predecessors had conceived, or had
> even considered to be possible.[12]

With greater perceptiveness than many of his successors, this historian
thus fastened on the fact that Rooker occupied a pivotal position in the
development of British watercolour art – a point at which colour, trans-
parent watercolour applied with the brush, superseded drawn outline as
the dominant element. In December 1832 the same periodical (and, it
seems, the same author) returned to the theme of 'local colour':

> Rooker having at length made the valuable discovery, others now pursued the
> same sensible mode of practice, and it was found that roads and paths were not
> necessarily to be tinted red gravel colour, nor posts and rails washed with a
> weak tint of orange; neither were tiles and chimneys to be coloured with the
> fiery red of chimney pots, nor trees with an unbroken mixture of Prussian-blue
> and gamboge. On the contrary, timber was made to look old, either as seen in
> reality on the boarding of a barn or a park paling, with the tiled roof of that
> russet tone in which time mantles antiquity, whether it be a work of art, as in
> ancient buildings, or of nature, as on the body and spreading branches of an
> oak, a beech, or that 'painters' own tree' as Gainsborough used to say, 'the
> ash'.[13]

Subsequent authors have added little to our appreciation of Rooker's
work and art. Too often Rooker, Hearne, Pars, the Maltons, Dayes and
other able contemporaries have been dismissed as a group of like-minded
toilers in the mundane task of 'topography'. Richard and Samuel Red-
grave, authors of the influential handbook *A Century of British Painters*, 1866,
effectively equated topography with a lack of individuality or aesthetic
appeal, writing of 'the humbler art of the topographer', 'the meagre truth-
fulness of the topographer', 'the tamer manner of the topographers', and
– the phrase that recurs so often in the literature of watercolour – 'mere
topography'. To the topographer, 'truth of rendering was of more value
than art of beauty'; his or her task was 'the exact transcript of local objects
... simple literal truth is all that is required of the topographer'.[14] These
latter remarks were removed from the second (1890) edition of the book,
but the conception of the topographer as 'a merely literal transcriber of
nature'[15] survived in the writing of the 1890s and beyond.[16]

In recent times we have become aware that there is no 'simple literal
truth' such as the Redgraves proposed; it is as much of a chimera as the

'atomic proposition' promulgated by Bertrand Russell and Ludwig Wittgenstein. Each topographer has his own vision and preoccupations which give his work a particular identity – although that identity may not be obvious on first inspection. In this respect the most discriminating commentator of the twentieth century has been Cecil Hughes, who in 1913 remarked on the clear difference between Hearne's antiquarian tendency and Rooker's interest in relating ancient remains to the life of his own time. Hughes describes the sense of affection which permeates much of Rooker's work:

> Hearne's more austere ideals led him possibly to conceptions of greater dignity, but Rooker is the more lovable. His drawing of buildings is clean and accurate, and his treatment of the irregular faces of old brick or stone walls is a thing of delicious and restful profusion. His figures, whether of people or of animals, are charming in their individual grace, and in their grouping, and they are always full of life and of an evident reason for existence. As a topographer of the actual facts of his own time, I place him far ahead of any of his contemporaries. They could draw, let us say, Sir Roger de Coverley's country seat, and make it recognizable by Sir Roger, and, from that fact, interesting to you. Rooker could do this too. He could make you feel quite certain – more certain than the others could make you – that Sir Roger lived there. But he could do more. He could jeopardize the tenth commandment. He could make you want to live there yourself. Topography, I think, can be submitted to no higher test than that.[17]

Notes

1. See R.W. Lightbown's introduction to 'Antony Pasquin', *Memories of the Royal Academicians* and *An Authentic History of Painting in Ireland*, Oxford, 1970. For Williams's lawsuit involving Farington see the latter's *Diary*, 24 November and 8 December 1797. Farington reports that the foreman of the jury in this case (which Williams lost) was William Tyler – an RA who dined regularly with Farington, Rooker and the other members of the Academy Club.

2. 'Anthony Pasquin', *A Liberal Critique on the Present Exhibition of the Royal Academy . . .*, 1794, p. 36.

3. 'Anthony Pasquin', *A Critical Guide to the Exhibition of the Royal Academy for 1796 . . .*, 1796, p. 27.

4. 'Anthony Pasquin', *A Critical Guide to the Present Exhibition at the Royal Academy for 1797*, 1797, pp. 21–2. This passage appears also in 'Anthony Pasquin', *The Royal Academy; or, A Touchstone to the Present Exhibition*, 1797, an enlarged version of Williams's criticism published in the *Morning Post*.

5. James Roberts, *Introductory Lessons . . . for Painting in Water-Colours*, 1809, p. 26; see also p. 15.

6. Thomas Wright, *Some Account of the Life of Richard Wilson, Esq., R.A.*, 1824, p. 63. See also Gilpin's criticism of 'littleness' in the drawings of John 'Warwick' Smith (letter of 26 January 1789, quoted in Carl P. Barbier, *William Gilpin*, 1963, p. 151).

7. Edward Edwards, *Anecdotes of Painting*, 1808, p. 266.

8. 'Professional Sketches on Modern Artists', in *The Works of the Late Edward Dayes*, 1805, pp. 347–8.

9. *Diary*, 2 May 1811.

10. See A. Paul Oppé, 'The memoir of Paul Sandby by his son', *Burlington Magazine*, LXXXVIII, 1946, p. 147.

11. *Library of the Fine Arts*, vol. 1, 1831, no. 5, p. 403.

12. ibid., p. 405.

13. *Magazine of the Fine Arts* (continuation of *Library of the Fine Arts*), vol. I, no. 2, December 1832, p. 125.

14. Richard and Samuel Redgrave, *A Century of Painters of the English School*, 1866, vol. I, pp. 371–83.

15. Gilbert Redgrave, *A History of Water-colour Painting in England*, 1892, p. 10.

16. See also John Lewis Roget, *History of the Old Water-Colour Society*, 1891, vol. I, ch. III; and W. Cosmo Monkhouse, *The Earlier English Water-Colour Painters*, 1890. Roget's detailed and generally useful work strangely describes Rooker's drawing as 'decided and vigorous' and claims that the artist's 'manners somewhat rough' were reflected in his style (p. 42) – a Ruskinian judgement patently misapplied in the case of Rooker. Monkhouse offers a sympathetic critique of Rooker's work, but can scarcely bring himself to distinguish between the other topographers of the time: 'the method of these early men was so much alike, the scope of their art so much the same . . .' (p. 28).

17. Cecil E. Hughes, *Early English Water-Colours*, 1913, pp. 23–4 (reprinted 1929 and 1950).

I *The Bunch of Grapes Inn, Hurst*
Paul Mellon Collection, Upperville, Va.

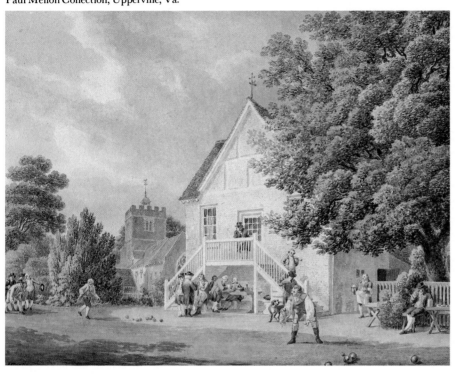

II *Queen Eleanor's Cross, Waltham* Sotheby & Co., London

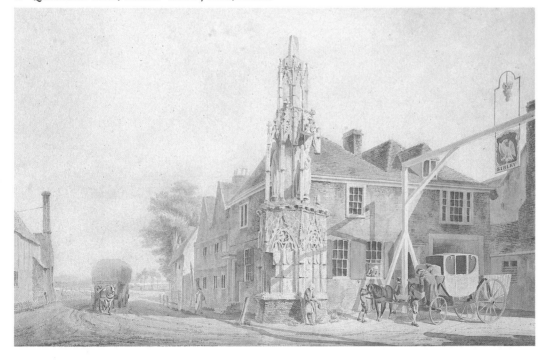

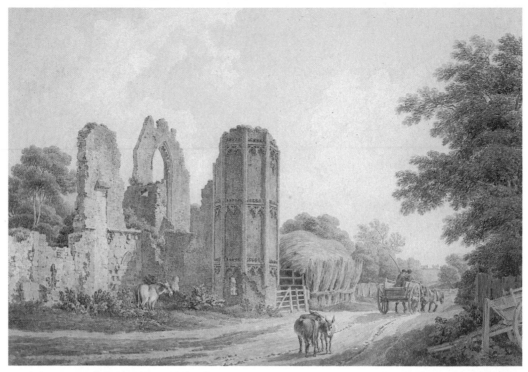

III *Leiston Abbey* Coll. Anthony and Alison Reed

IV *North front of Westminster Hall, in Palace Yard*
Private collection; photograph courtesy William Drummond, Esq.

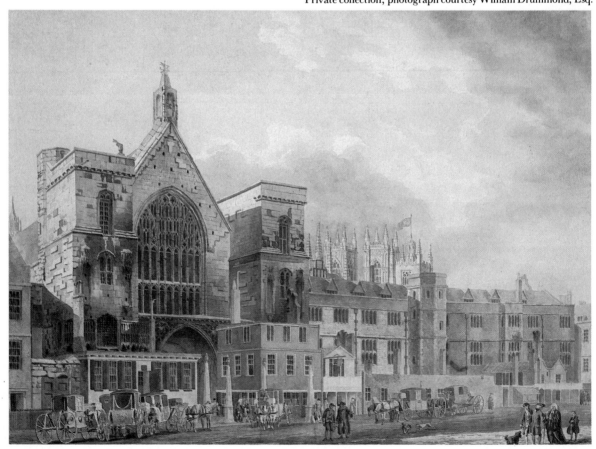

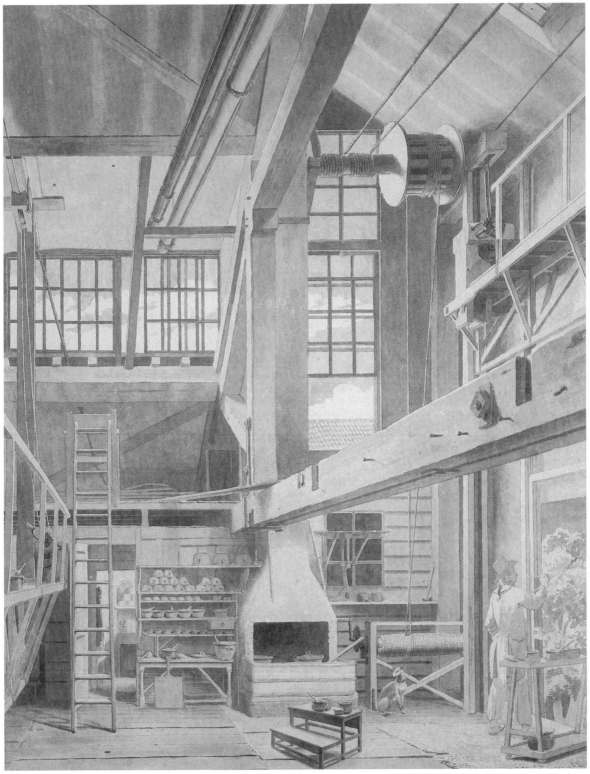

V *A scene-painter in his studio* British Museum

Catalogue **3** *A countryhouse in a wooded setting*

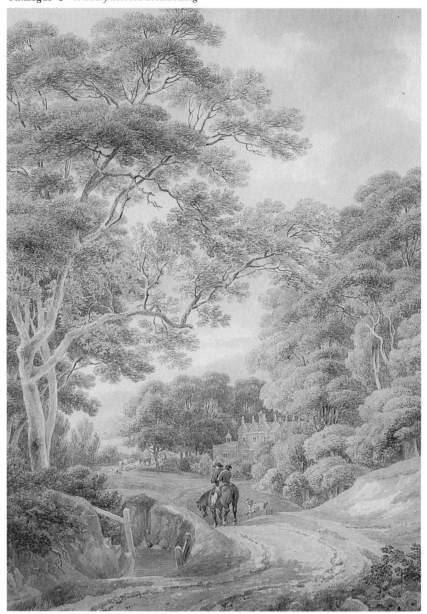

Catalogue **4** *Ruins of St Botolph's Priority, Colchester, from the south-east*

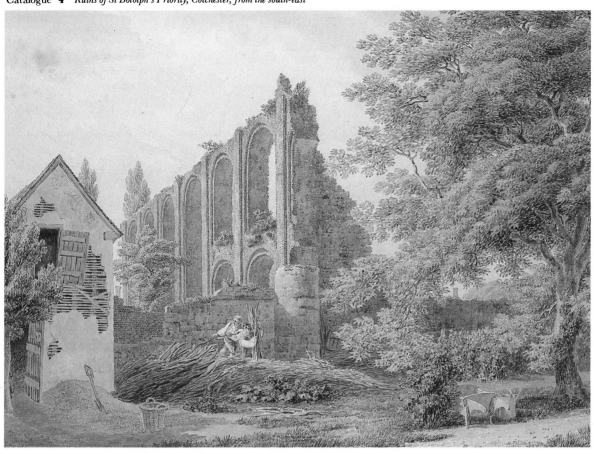

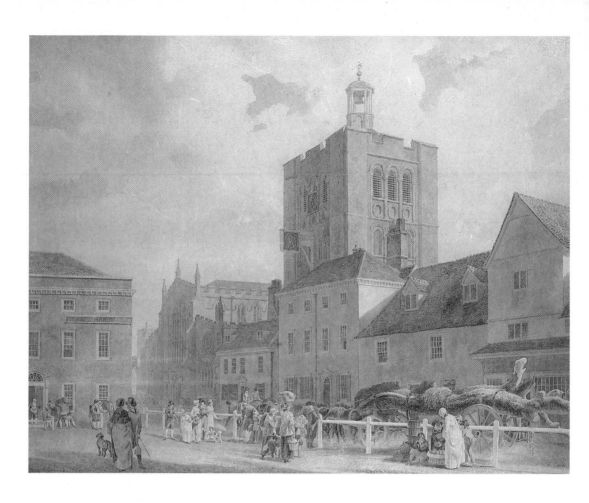

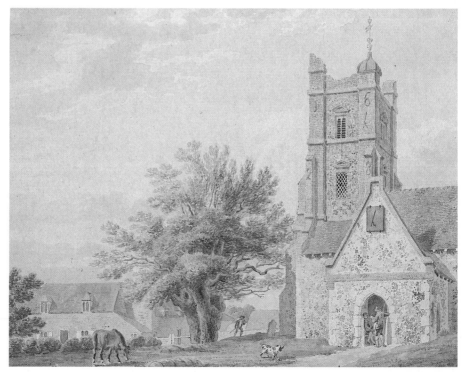

Catalogue **11** *Bury St Edmunds: the Norman Tower, St James's Church and Six Bells Inn, with figures and a timber waggon*

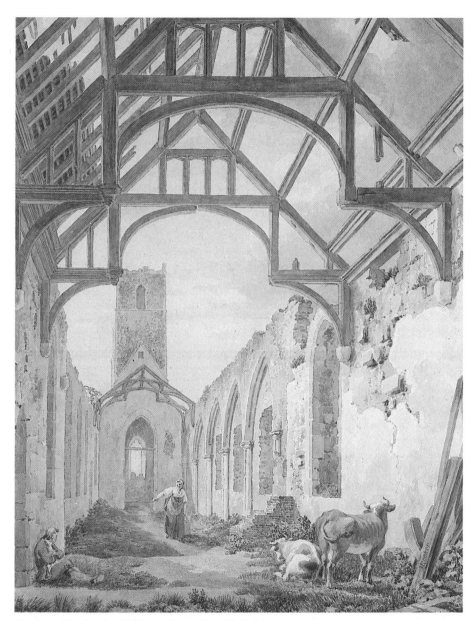

Catalogue **17** *Interior of All Saints' Church, Dunwich, Suffolk*

Catalogue **16** *St Nicholas's Church, Ringwould, Kent*

Catalogue **18** *Wookey Hole, near Wells, Somerset*

Catalogue of
Michael Angelo Rooker's
watercolours
in the collection of the
Victoria & Albert Museum

Catalogue

Sizes are given in inches and centimetres, height before width

1
Abbot's Bridge, Bury St Edmunds

Pencil and watercolour; $14\frac{5}{8} \times 18\frac{1}{2}$ ($37\cdot3 \times 46\cdot8$) Inscribed on back in pencil, in an early hand (not the artist's): *Abbott's bridge/ St Edmundsbury. 1795*, and in pencil below, *£2.2.0*.
FA 447
CONDITION: Very faded
PROV: See below. Two 'finished drawings' of Abbot's Bridge were sold at the Rooker Sale on 1 May 1801 (lots 45 and 46)
EXH: Perhaps RA 1798, no. 630

The medieval bridge spanning the River Lark seen from the south-west, with a distant prospect above it of St James's Church and the Norman Tower.

While depicting three of Bury's celebrated medieval antiquities in the centre of his picture, Rooker's viewpoint allows him to include vernacular elements – timbered houses at left, farmers' carts, the Fox Inn at right; when Rooker's view was borrowed for an antiquarian publication, the Rev. Richard Yates's *History ... of St Edmund's Bury*, these latter features were omitted. In the first (1805) editions of this work the author acknowledged that 'the Honourable Mr. Nassau, who purchased most of the drawings and sketches taken from the Abbey of Bury by the late Mr. Rooker, generously permitted my Brother to collate his drawings with those of the same subject

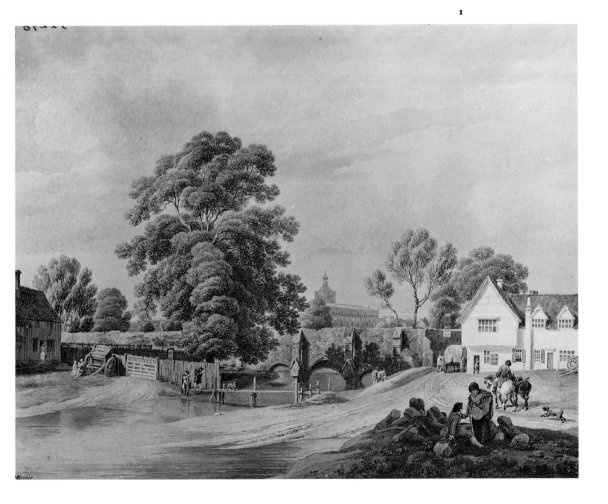

2

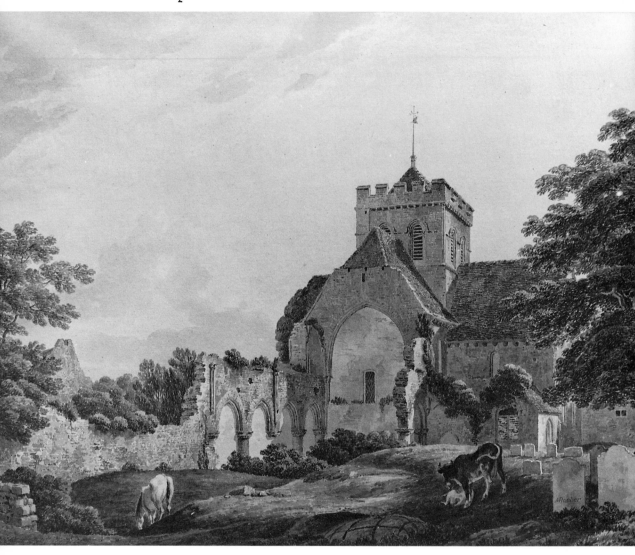

by that ingenious and accurate Artist' (pp. xi–xii). The 'collated' drawings were in fact redrawn by William Yates with slight alterations, and credited to Yates in the engraved versions. Some of these, including the present view, appeared only in the enlarged second (1843) edition of the *History*: the central portion of Rooker's 'Abbot's Bridge' is redrawn and reproduced opposite p. 45.

The RIBA Drawings Collection holds a volume of drawings for the *History* which may well be by William Yates. One of the drawings (numbered '13') bears the false signature 'Rooker Del.', and it is likely that some or all were copied from Rooker's originals. Further watercolours by Rooker which were clearly utilized by the Yates brothers are in Birmingham City Art Gallery (*West front of the Abbey Gate*) and the Paul Mellon Collection, Yale Center for British Art (*Market square with Moyses Hall*); also four of the other views of Bury exhibited here.

Rooker's 'List of Sketches' (see Appendix 1) records that he sketched this bridge on 1 and 2 August 1796. This seems to have been Rooker's only visit to the region; he exhibited 12 East Anglian subjects at the Royal Academy in the years 1797 to 1800, but none in previous years. The date '1795' inscribed on the reverse of this picture has been added by a hand other than Rooker's.

2
Boxgrove Priory Church, near Chichester

Pencil and watercolour; 11 × 14¾ (27·7 × 37·3) Signed (on tombstone): *MARooker* (MAR in monogram)
1726–1871
CONDITION: Slightly faded; some discoloration
PROV: A finished drawing of *Box Grove Priory* was sold at the Rooker Sale on 1 May 1801 (lot 65) William Smith gift, 1871
EXH: International Exhibitions Federation, USA, 1966–7

LIT: Samuel Redgrave, *A Descriptive Catalogue of the Historical Collection of Water-Colour Paintings at the South Kensington Museum*, 1876, p. 184. Adrian Bury, *Two Centuries of British Water-Colour Painting*, 1950, p. 37.

The church and tower seen from the churchyard to the west.

From most angles Boxgrove Priory Church appears whole and self-contained, but Rooker has selected the one aspect which is ruinous, and which indicates the true extent of the medieval church. Before the Dissolution, a long nave ran eastwards from the crossing, and a few remnants of its piers and arches can be seen in Rooker's watercolour. The ruined masonry survives to this day, but the graveyard has been levelled, the east wall has been resurfaced with modern stone and flint, and a bogus east window has been added.

3
A country house in a wooded setting

Pencil and watercolour; 14 × 10⅛ (35·6 × 25·6)
1727–1871
(See colour plate between pp. 144 and 145)
CONDITION: Faded
PROV: William Smith gift, 1871
LIT: Samuel Redgrave, *A Descriptive Catalogue . . .*, 1876, p. 184. Luke Herrmann, *British Landscape Painting of the Eighteenth Century*, 1973, p. 45. John Murdoch, *Forty-two British watercolours from the Victoria and Albert Museum*, 1977, no. 12 (with ill. facing)

A country house with shaped gables and castellated stable block at left is just visible among the luxuriant foliage which surrounds it; two figures approach on horseback.

This drawing has traditionally been entitled *Godinton, near Ashford Kent* (see lit.), but as the present owner of the house confirms, Rooker's view does not represent Godinton at any stage in its history. Rooker executed few country-house views,

and although the present example adopts the angled viewpoint fashionable at the time, it makes no attempt to aggrandize the house, which is dwarfed and all but obscured by the towering trees nearby. The anti-heroic tone is maintained in the figures: in place of fashionable strollers Rooker has added two men astride a single horse, which ambles reluctantly towards the house.

4
Ruins of St Botolph's Priory, Colchester, from the south-east

Pencil and watercolour; 10½ × 14⅜ (26·5 × 36·6) Signed *MARooker* (MAR in monogram)
(See colour plate between pp. 144 and 145)
CONDITION: Slightly faded; foxing in upper areas
PROV: A 'finished drawing' of this subject was sold at the Rooker Sale on 30 April 1801 (lot 58). According to the Rooker papers (BM) it was bought in and allocated to 'Mr. Papworth'. William Smith gift, 1871
EXH: Perhaps RA 1799, no. 854
LIT: Alexander Finberg, 'The development of British landscape painting in water-colours', *Studio*, 1918 (Special Winter Number), p. 7. Patrick Conner, 'Michael Angelo Rooker in East Anglia', *The Old Water-Colour Society's Club Annual*, Volume 57, 1982, p. 51 and pl. xix

This delightful watercolour exhibits many of Rooker's distinctive qualities: a restricted but pleasing range of colours, the luminous effect of a placid summer's evening, virtuoso treatment of diverse building materials, and a scattering of incidental objects (spade, basket, wheelbarrow, watering-can) distributed like theatre properties in the foreground. Typically again, Rooker has chosen to allow the famous ruin of the priory church – the elegant brickwork arcade – to be upstaged by a ramshackle potting shed and a pile of brushwood set against the crumbling stone wall.

The shed in fact blocks the view of the inner façade of the west wall (see p. 81); Theodosius Forrest, drawing from a similar viewpoint some years earlier, evidently took up his sketching position a few yards further back, with the result that the outer edges of the west wall appear in Forrest's picture like a set of ghostly chimneys above the roof of the shed (see Iolo Williams, *Early English Water-Colours*, 1952, pl. 40). On the other hand Thomas Hearne, more concerned with the archaeologically significant than with the rustic Picturesque, banished all modern accretions from his drawings of St Botolph's by stationing himself over the stone wall and looking straight up the nave (illd. Sotheby's cat. 13 November 1980, lot 128). Today commercial buildings stand in the way of Rooker's prospect, but Hearne's can still be achieved.

Rooker's 'List of Sketches' (see Appendix 1) records that he sketched St Botolph's Priory on 21 July 1796.

5

Ruins of St Botolph's Chapel, Bury St Edmunds

Pencil and watercolour; 7 × 9 (17·8 × 22·8)
Signed *MARooker* (MAR in monogram)
1184–1875
CONDITION: Faded; small tears in the left and right margins
PROV: A finished drawing of *St Botolph's Chapel* was sold at the Rooker Sale on 1 May 1801 (lot 47). Bought 1875 from Hogarth & Sons
LIT: Conner, op. cit., p. 51

A ruined chapel adjoins farm buildings, forming a yard occupied by pigs, poultry and a seated figure.

This view has mistakenly been described as *St Botolph's Chapel, Colchester* in the V & A's published catalogues; versions in the City Art Gallery, Stoke-on-Trent, and in the Yale Center for British Art, New Haven, have been catalogued understandably enough as farmyard scenes. The gabled building is indeed a chapel, so ruined as to have reached that blend of the antique with the agricultural which Rooker prized. Exposed beams are visible through the lancet window; the chapel porch is now no more than a pile of propped-up straw.

Rooker's view was redrawn by William Yates and reproduced in Richard Yates, *History . . . of St Edmund's Bury*, 2nd ed., 1843, pp. 48–9, and was therefore probably

5

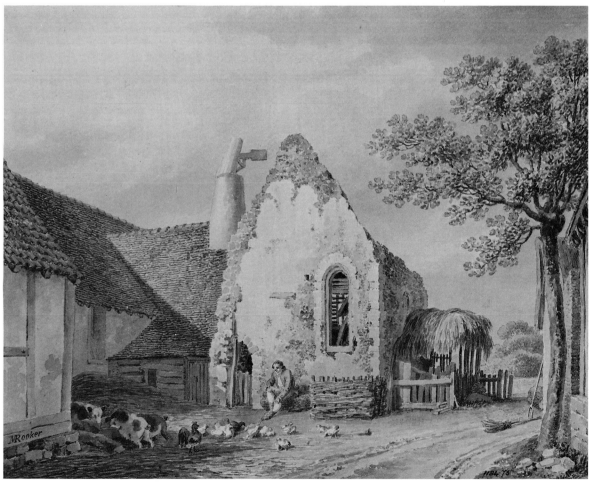

6

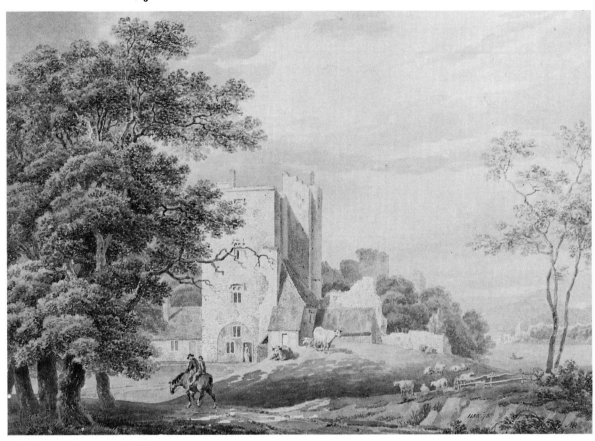

one of the group of Rooker's drawings of Bury which was bought by the bibliophile George Nassau (see cat. entry for *Abbot's Bridge*). Rooker's 'List of Sketches' (see Appendix 1) records that he sketched 'St. Botolphs Chapel, Southgate Street' on 10 August 1796. The chapel has long since disappeared, although its site can still be identified.

6
Saltwood Castle, near Hythe

Pencil and watercolour; 7 × 10 (17·6 × 25·3)
Signed in monogram *MAR*
1185–1875
CONDITION: Faded
PROV: Bought 1875 from Hogarth & Sons

The former residence of archbishops, and home of Thomas à Becket's murderer, was severely dilapidated at the end of the eighteenth century: the estate was tenanted

as a farm, with barns and sheds built out of the ruins, and the farmer's employees lodged in the upper rooms of the Keep. Rooker's view looks westward from within the bailey. The trees and stream in the foreground form a puzzling feature of the picture: either they are purely fictional – which would be untypical of Rooker's topographical work – or they are transposed from the outer (southern) side of the bailey, where a stream runs at a short distance from the walls. A sketch of Saltwood Castle was sold on the second day of the Rooker sale at Squibb's (lot 117).

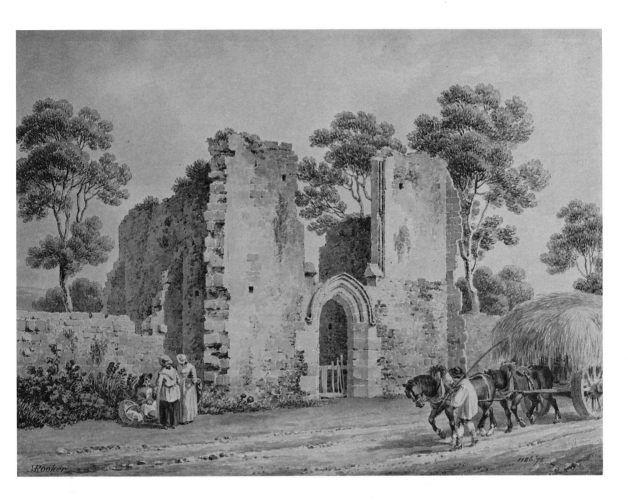

7
Old gateway, Bury St Edmunds

Pencil and watercolour; 6¾ × 8⅞ (17·2 × 22·5)
Signed *M.A. Rooker* (MAR in monogram)
1186–1875
CONDITION: Faded
PROV: Bought 1875 from Hogarth & Sons

A horse-drawn haycart passes a massive
ruined gatehouse flanked by high stone
walls.

The gateway represented was that of St
Saviour's Hospital, a twelfth-century
foundation outside the north gate of the
city. This view was copied by William
Yates and reproduced (with altered
staffage) in Richard Yates, *History . . . of St
Edmund's Bury*, 2nd ed., 1843, pp. 48–9.
Yates notes that the Hospital was once
notable, 'for it was here that a Parliament
assembled in 1446; and here it was that
Humphrey, the good Duke of Gloucester
was murdered'.

This view may coincide with that of
'The North Gate' recorded in Rooker's
'List of Sketches' on 9 August 1796 (see
Appendix 1).

8

8
Lord Cremorne's villa, Chelsea

Pencil and watercolour; 8⅜ × 10¾ (21·2 ×
27·3) Signed *MARooker* (*MAR* in
monogram)
1187–1875
CONDITION: Faded
PROV: Bought 1875 from Hogarth & Sons

In Rooker's day Chelsea was still a rural
village, entirely separate from the
metropolis of London. Chelsea Farm, the
riverside residence built for the 9th Earl of
Huntingdon, was bought in 1778 by
Thomas Dawson, Baron Dartrey, who in
1785 became Viscount Cremorne. Here
Lady Cremorne was often visited by Queen
Charlotte and her six daughters. Lord
Cremorne employed James Wyatt to
enlarge the house; in 1800 it appeared as
the 'white house' in Thomas Girtin's
celebrated view across the Thames (Tate
Gallery 4728).

This view is characteristic of Rooker in
that, despite its title, it does not present a
nobleman's residence set in its estate, nor
even a tastefully organized garden, but a
weed-strewn bank with a pair of overgrown
bushes, leading down to a featureless
stretch of the River Thames. The side view
of Lord Cremorne's villa could scarcely be
less flattering. Rooker's pleasure lies in the
varieties of foliage, the lamp-post, and
above all in the wooden palisade and
fences which sweep across the composition.

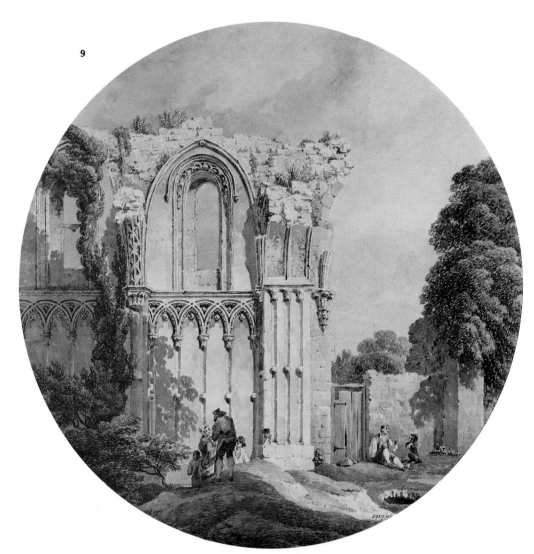

9

9
Part of the north wall of St Joseph's Chapel, Glastonbury

Pencil and watercolour; circular: diam. 11¾ (29·7) Signed *MARooker* (MAR in monogram)
2927–1876
CONDITION: Faded
PROV: A 'finished drawing' of St Joseph's Chapel, Glastonbury, was sold at the Rooker Sale on 1 May 1801 (lot 56); two other views of Glastonbury were sold in the preceding lot. William Smith Bequest, 1876
EXH: Perhaps RA 1795 (no. 574 or no. 578)

The two-storeyed wall of the roofless chapel, with two round-headed windows above an intersecting series of blank round-headed arches.

The ruins of Glastonbury Abbey were too stark and unmysterious for extreme Picturesque taste at the time of Rooker's visit. The uniformity of the meadowland on which the ruins stand, the shortage of 'good masses of ivy' and the lack of surrounding trees were all thought to 'detract much from their *interest* as well as beauty . . . The eye moreover is fatigued and disgusted at surveying a lengthened mass of stone wall with no resting-place, no

spot of green to repose on … (Rev.
Richard Warner, *A Walk through some of the
Western Counties of England*, 1800, pp. 23-4).
These words might serve as a manifesto for
Rooker himself. The same author made an
exception, however, of St Joseph's Chapel,
where natural vegetation 'just softens down
and corrects the light colour of the
materials of the building, without
obscuring its exquisite beauties'. Rooker
illustrates the 'course of *Saxon* [i.e.
Norman] arches; which *intersecting* each
other, form well-proportioned *Gothick* ones,
and perhaps point out the *origin* of this
much-disputed Stile' (ibid., p. 25).

Several other drawings by Rooker of
Glastonbury survive. A pair of upright
views of cattle wandering among the ruins
was sold at Christie's on 20 June 1978 (lots
40 and 41): both were dated 1794. Other
views show the ruins with sheep (National
Library of Wales), St Joseph's Chapel in
use as a hay-store (private collection), the
Abbot's Kitchen serving as a cowshed and
stickhouse (Tate Gallery – see fig. 42), and
haycarts outside the Abbot's Kitchen. The
latter subject exists in at least two versions,
one sold from the Newall Collection at
Christie's on 13 December 1979 (63), and
the other now in The Yale Center for
British Art (fig. 43).

10

**Ruined abbey near the water side,
with hills in the distance**

Pencil and watercolour; 8⅜ × 10¾ (21·2 ×
27·3)
50–1881 (E 5651–1910)
CONDITION: Some discoloration and foxing

At right an overgrown ruin, with a shallow
pointed arch springing from Norman
capitals, stands at the edge of a lake, with
wooded hills on the further shore.

This is evidently a *capriccio*, possibly a
preliminary sketch for a theatre scene. A
number of such imaginary views by Rooker
survive, incorporating classical, medieval or
modern buildings.

10

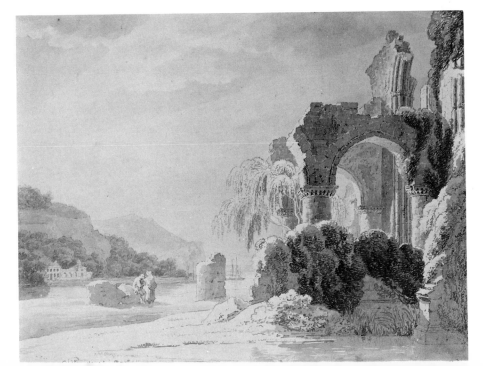

11

Bury St Edmunds: the Norman Tower, St James's Church and Six Bells Inn, with figures and a timber waggon

Pencil and watercolour: 14½ × 18⅛ (36·8 × 46·5) Signed *MARooker* (MAR in monogram)

51–1881

(See colour plate between pp. 144 and 145)

CONDITION: Faded

LIT: H. M. Cundall, *A History of Water Colour Painting*, 1908, p. 32. E. B. Lintott, *The Art of Water Colour Painting*, 1926, p. 212. Graham Reynolds, *An Introduction to English Water-Colour Painting* 1950, p. 15. Martin Hardie, *Water-Colour Painting in Britain*, vol. 1, 1966, p. 173 and pl. 179

The west end of St James's Church (now Cathedral) is seen at the south-west corner of Chequer Square; to its right the 'Norman Tower' (or St James's Gate Tower) rises behind two- and three-storeyed houses.

Rooker's view reflects that blend of medieval splendour with eighteenth-century elegance which is still so characteristic of Bury. The strolling gentlefolk represent the polite society which François de la Rochefoucauld enjoyed during his residence here in 1784; but Rooker gives greater prominence to the tradespeople, and especially to the huge gnarled tree-trunks lying on a juggernaut wagon pulled by four horses. The houses facing the square at right have since been removed, so that the Norman Tower (now without its cupola) gives directly on to Crown Street.

A smaller version of this watercolour was exhibited by Leger Galleries, 'English Watercolours', November 30–December 23 1983, no. 1, in which a fresh cast of figures appears in exactly the same setting. A phaeton here replaces the timber-wagon, but as if to offset this show of gentility Rooker has given prominence to a tradesman pushing a wheelbarrow. For the Picturesque qualities of timber-wagons see p. 72.

12

Newport on the Usk, Monmouthshire, with bridge and castle

Pencil and watercolour; 10 × 14 (25·4 × 35·6) Signed *MARooker* (MAR in monogram)

194–1890

CONDITION: Faded

PROV: A 'finished drawing' of the bridge at Newport-on-Usk was sold at the Rooker Sale on 30 April 1801 (lot 86). According to the Rooker papers (BM) it was bought in and allocated to 'Mr. Papworth'. Bought 1890 from Dr Percy

The wooden bridge over the Usk at Newport, with the ruined castle on the farther bank; in the foreground, figures bring barrels to a moored boat.

As a connoisseur of beams and planks, Rooker must have been well pleased with the elaborate piles carrying the bridge, whose floor consisted of planks loosely fastened so that the strain of passing carriages might not affect the bridge as a whole. Rooker may also have chosen this subject in the knowledge that this bridge was about to be dismantled, and superseded by a five-arch structure more in keeping with Newport's newly-gained eminence as the leading coal port in South Wales. If his view of the Iron Bridge at Coalbrookdale (fig. 9) hails the coming of the Industrial Revolution, the present picture celebrates the last days of a town which that revolution was soon to transform.

A pencil-and-wash study for this picture (*Newport on the Usk* (sketch), National Museum of Wales, Cardiff, **12A**) is of particular interest as an example of Rooker's working method: in this sketch from nature the artist has established the basic structure of the composition in terms of light and shade, leaving the foreground activity to be added later – probably in the studio. It is one of a group of five sketches sold on the second day of the Rooker Sale on 30 April 1801 (lot 119: 'Five – Usk Castle and Newport on Usk.') These were bought at the sale by J. M. W. Turner, and

are now divided between three public collections: the National Museum of Wales at Cardiff (three sketches), the National Library of Wales at Aberystwyth, and the National Gallery of Scotland. The latter sketch, *Part of the Castle at Newport on Usk*, remained in the Turner family collection until its sale at Sotheby's on 13 March 1980 (lot 127). See also Alexander Finberg, *A Complete Inventory of the Drawings of the Turner Bequest*, 1909, vol. 2, p. 1221, and Finberg, 'The historical collection of British water-colours at the Grafton Galleries', *Connoisseur*, 32, 1912, pp. 13–17.

12 A

12

13

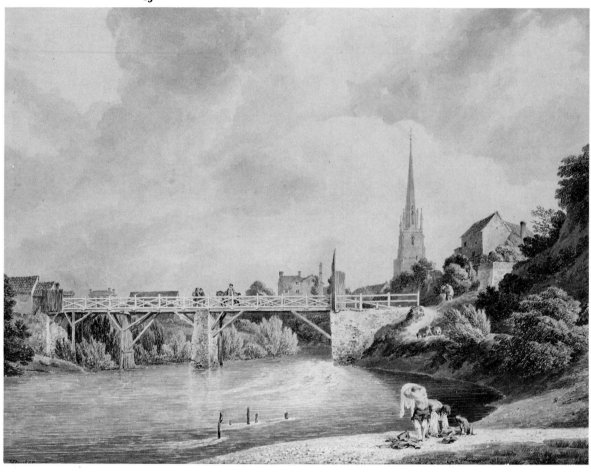

13
Bridge at Monmouth, with St Mary's Church in the background

Pencil and watercolour; $10\frac{3}{4} \times 14\frac{1}{2}$ ($27 \cdot 2 \times 36 \cdot 9$) Signed *MARooker* (MAR in monogram)
118–1892
CONDITION: Faded; some foxing
PROV: Bought 1892 from the Fine Art Society

The old wooden bridge ('Tibb's Bridge') across the River Monnow, with a steep bank at right, and the tower and spire of St Mary's Church in the right background.
 Monmouth came to the attention of Picturesque tourists in the 1770s, both as a centre for the Wye tour and on its own merits. 'Monmouth, a town I never heard mentioned, lies ... in a vale, that is the delight of my eyes and the very seat of pleasure,' wrote Thomas Gray in 1771 (quoted in William Gilpin, *Observations on the River Wye ...*, 1782, p. iii). The pleasures included castle ruins, wooded hills, the confluence of two rivers, and three bridges, of which the best known was the weighty structure over the Monnow at the lower end of the town, with its great bastion-gateway on the bridge itself, 'formerly a barrier against the Welsh' (Samuel Ireland, *Picturesque Views on the River Wye*, 1797, p. 104). This was duly drawn by Rooker, with pigs beneath the landward arch (formerly with Thomas Agnew and Sons). The wooden bridge shown here was altogether more precarious, with piers both of wood and of brick with a variety of *ad hoc* diagonal supports, all revealed in detail by Rooker. Although the prospect at this point was said to be 'peculiarly wild and romantic' (*The Beauties of England and Wales*, vol. XI, 1810, ed. J. Evans and J. Britton, p. 59), he again avoids the conventionally Picturesque: in place of the gliding white sails which Gilpin had admired on the river here (Gilpin, op. cit., p. 30), the artist supplies muscular little figures dressing after a bathe.

14

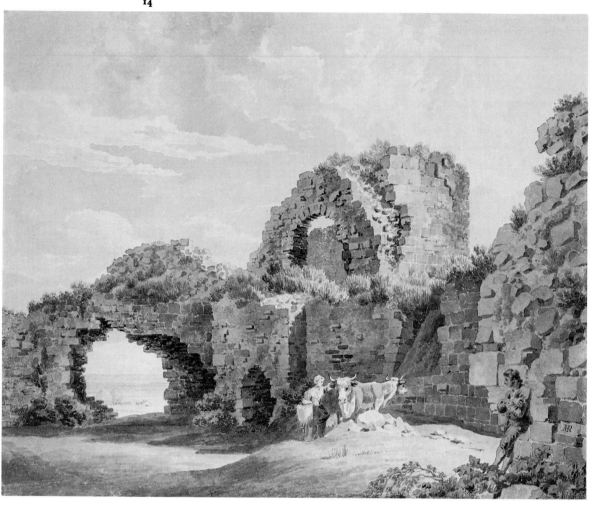

14
Ruins of Pevensey Castle

Pencil and watercolour; 9 × 11⅛ (22·9 × 28·3) Signed in monogram *MAR*
114-1894
CONDITION: Good
PROV: 'Two views of Pevensey Castle' were sold at the Rooker Sale on 1 May 1801 (lot 63). Given 1894 by J.E. Taylor

The South Tower seen from the inner bailey; through a large hole in the stonework at left can be seen a level landscape with hayricks.

The Norman castle at Pevensey had already been battered by storms and by combatants for 700 years when Rooker visited the place. For all its immensity and grandeur, Pevensey is not the most tractable of subjects for the artist. The ponderous blunted shapes and gaping apertures, in a windswept site largely bereft of vegetation, could not be regarded as Picturesque; there are no conventional compositions here. Rooker's views of Pevensey contrive to include distant points of reference - hayricks, church tower - as comforting reminders of civilization beyond the savage piles of ancient masonry.

A pair of related views of the Gate Tower at Pevensey by Rooker was sold at Sotheby's on 6 June 1972, one of them reappearing at Phillips & Son on 28 March 1983.

15

15
St Petronella's Chapel, Bury St Edmunds

Pencil and watercolour; $6\frac{7}{8} \times 8\frac{3}{4}$ ($17 \cdot 3 \times 22 \cdot 2$)
Signed *MARooker* (MAR in monogram)
D 416–99
CONDITION: Faded

The dilapidated chapel and neighbouring buildings are seen beyond a fence and brick wall in the foreground.

Typically, Rooker makes a feature of the gate, stile and wall, which were all removed when William Yates redrew the picture for Richard Yates's *History . . . of St Edmund's Bury* (unnumbered plate in 1805 ed.; opp. p. 49 in 1843 ed.). The chapel no longer survives, but the east window has been removed and set into the wall of St Nicholas in Eastgate Street. The chapel formed a part of St Petronella's Hospital near the South Gate; the projecting north window belonged to the refectory. In the words of Richard Yates, 'this Hospital, charmingly situated, was for the reception of leprous maidens, the original destination of St. James's Palace in London' (p. 49). Rooker sketched the chapel on 5 August 1796 (see Appendix 1).

A study for this watercolour is reproduced in Sotheby's catalogue of 15 March 1984 (lot 93).

16
St Nicholas's Church, Ringwould, Kent

Pencil and watercolour; $6 \times 7\frac{3}{4}$ ($15 \cdot 3 \times 19 \cdot 8$)
Signed in monogram *MAR*
D 417–99
(See colour plate between pp. 144 and 145)
CONDITION: Good

The church tower and porch at right are separated by a massive yew tree from two-storeyed houses at left.

Previously catalogued as *An unidentified church possibly in Suffolk*, this view was kindly identified by Dr John Newman. Some of the attractive features recorded by Rooker have since disappeared, including the ruined upper storey, the first two digits of the date '1628' picked out in iron on the buttresses, and the sundial on the porch gable. The little pediments above the windows have survived nineteenth-century

'restoration', however, and so has the cupola at the top of the tower. Rather than take the entire church as the subject of his picture, Rooker has admitted only the western end with its wealth of interesting detail.

17
Interior of All Saints' Church, Dunwich, Suffolk

Pencil and watercolour; $10\frac{3}{4} \times 8\frac{1}{4}$ ($27 \cdot 4 \times 21$)
Signed *MARooker* (MAR in monogram)
D 551–1905
(See colour plate between pp. 144 and 145)
CONDITION: Good
PROV: A 'finished drawing' of All Saints', Dunwich, was sold at the Rooker Sale on 1 May 1801 (lot 49).

A view westwards along the nave of the tower, which is seen through the largely ruined roof; evening sunlight.

The church is captured in the very process of decay: the beams in the right foreground have surely fallen only days before the artist's visit. The condition of the church offers Rooker a perfect opportunity to indulge his enthusiasm for exposed beams and the patterns formed by their intersection (see *A scene-painter in his studio*, colour pl. V). He catalogues with relish every aspect of ruin – decaying plaster, broken-off rafters, encroaching vegetation, and cattle happily installed in the chancel.

In Saxon times Dunwich had boasted a regal palace and an episcopal seat; in the middle ages it prospered as a trading port, with six churches and three chapels. One by one these succumbed to coastal erosion, until in 1754 only All Saints' Church was in operation, and even here the inside walls were 'infected with an incurable spreading leprosy' (see Rev. Alfred Inigo Suckling, *The History and Antiquities of the County of Suffolk*, vol. 2, 1848, p. 276). Some 20 years later it fell into disuse and was stripped of its bells and lead, thus initiating the decay recorded by Rooker in 1796. 'Dunwich is wasted, desolate and void,' complained the county historian in 1848. 'Its palaces and temples are no more . . .' (ibid., p. 229). It was not until 1919, however, that All Saints' tower finally went down the cliff.

This drawing no doubt corresponds with Rooker's diary entry at Dunwich on

5 September 1796 (see Appendix 1), 'Inside view of Church next the sea'. On the same day he sketched the ruins of the chapel of St James's Hospital, which still survive.

18
Wookey Hole, near Wells, Somerset

Pencil and watercolour; $14\frac{1}{2} \times 10\frac{3}{8}$ (36.5×26.4) Signed *MA Rooker* (MAR in monogram)
P 44–1921
(See colour plate between pp. 144 and 145)
CONDITION: Slightly faded; damage in sky repainted in bodycolour
PROV: A 'finished drawing' of Wookey Hole was sold at the Rooker Sale on 1 May 1801 (lot 57). Given 1921 by Victor Reinaecker, by whom bought in the same year at Walker's Galleries, 118 New Bond St, London
EXH: Perhaps RA 1800, no. 345
LIT: Christopher Hussey, *The Picturesque*, 1927, opp. p. 90; 1967 ed., pl. XIII, fig. 2

Overgrown cliffs at Wookey Hole, from whose base issues a rapid millstream.

The caves, cliff and river at Wookey Hole were a tourist curiosity long before the Picturesque movement – 'as Italy has *Virgil's Grotto*, and the *Sybil's* Cave by *Puteoli*, so England hath *Ocky-Hole* by *Wells* ...' (James Brome, *Travels over England, Scotland and Wales*, enlarged ed., 1707, preface. For early drawings of 'Ochie Hole' by Bernard Lens the elder see Iolo Williams, *Early English Water-Colours*, 1952, p. 18 and pl. 29). In the late years of the eighteenth century the cult of the Sublime refuelled the melodramatic hyperbole of the travel-writers: 'rocky steeps ... gloomy recess ... thundering torrent ... here a cavern opens its dire jaws' (Rev. Richard Warner, *A Walk through some of the Western Counties of England*, 1800, pp. 208–9). Yet Rooker is not overwhelmed by the Sublime aspects of the scene. His response has something in common with the reaction of John Keats to the waterfall at Ambleside, which he visited on a walking tour in 1818: 'What astonishes me more than any thing is the tone, the colouring, the slate, the stone, the moss, the rock-weed.' Both artist and poet acknowledge a sense of

magnitude and power, but the sensory detail of colour and texture impresses their minds more vividly.

Rooker probably visited this site in 1794: Robin Atthill's book *Old Mendip*, 1964, reproduces a drawing, clearly by Rooker, of 'Wookey Hole mill in 1794'. The mill remains, but the drawing cannot be traced.

Six illustrations for
The Works of Henry Fielding, 1783

Pencil and watercolour; $5\frac{1}{8} \times 2\frac{3}{4}$ (13×7) Each inscribed *MAR 1780* (MAR in monogram). The appropriate passage from Fielding's *Works* is inscribed on the back (now detached) of each drawing.
1717–1900 to 1722–1900
CONDITION: Faded, and spotted
PROV: H.S. Ashbee bequest 1900
EXH: A 'Design for a new edition of Fielding's works' was exhibited at the RA in 1780, no. 376
LIT: Martin Hardie, *Water-Colour Painting in Britain*, vol. 1, 1966, p. 153

19
Frontispiece to *The History of Tom Jones, A Foundling* (*Works*, vol. 9)

Book XVIII, ch. XII. In the penultimate chapter of the book, Sophia Western has at last agreed to marry Tom on any day that he chooses. Her father, who has been listening at the door, 'burst into the room, and with his hunting voice and phrase, cried out, "To her, boy, to her, go to her. – That's it, little honeys, O that's it".'

According to the text, Mr Western enters at the instant when Tom 'caught her in his arms, and kissed her with an ardour he had never ventured before'. Rooker has, however, drawn a less passionate exchange.

20
Frontispiece to *Amelia* (*Works*, vol. 10)

Book III, ch. VI. Captain Booth, stationed at Gibraltar, has received a musket-ball in the left leg, and shortly afterwards 'a violent contusion' from an exploding bomb. While he is still convalescent – bottles of medicine can be seen on the table and mantelpiece – his servant Atkinson bursts in with the news that Booth's wife Amelia has arrived.

19

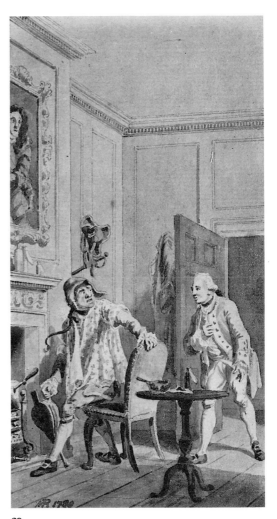

20

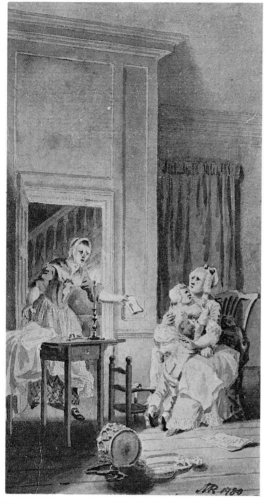

21

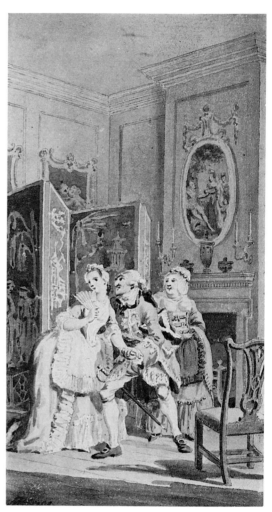

22

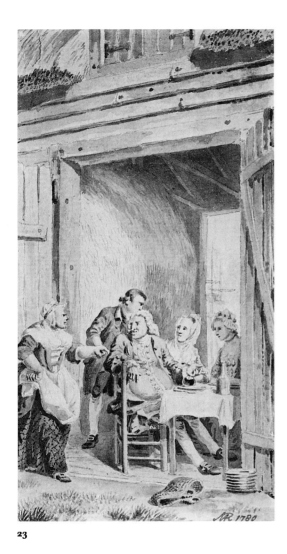

23

21
Frontispiece to *Amelia* (*Works*, vol. 11)

Book XI, ch. XI. Susan the maid comes in with a letter from Booth to Amelia, and is confronted with a 'melancholy, indeed frightful scene – a tearful Amelia, who has 'drunk a large bumper' of the wine she had been keeping for her husband, comforting her children. On the floor is another letter, challenging Booth to a duel.

22
Frontispiece to *Miss Lucy In Town* (*Works*, vol. 4)

Mrs Midnight, in the rear, introduces the philandering Zorobabel to the young Mrs Thomas, a 'country innocent' newly arrived in the city with aspirations to become a lady of fashion. Zorobabel at once seeks to take advantage of her: 'Nay, be not coy, my dear; if you will suffer me to kiss you, I will make you the finest of ladies; you shall have jewels equal to a woman of quality ...' (See p. 117.)

23
Frontispiece to *A Voyage To Lisbon* (*Works*, vol. 12)

Ch. VII, entry for 13 July 1754. The Fieldings, *en route* for Lisbon, put up at Ryde in the Isle of Wight, and dine in the driest accommodation available: 'a dry, warm, oaken-floored barn, lined on both sides with wheaten straw'. A hostile landlady explains to the long-suffering Fielding that there is no mutton available. The travellers' ship, immobilized by an adverse wind, can be seen beyond Fielding's wife and daughter. (See p. 118.)

24
Frontispiece to *A Journey From This World to the Next* (*Works*, vol. 5)

Ch. VII. At the gates of Elysium, a queue has formed of souls seeking admission. A family of four petitions Minos, the judge at the gates, saying that they have been starved to death through poverty. The parson of their parish vouches for them. ' "Very well," said Minos, "let the poor

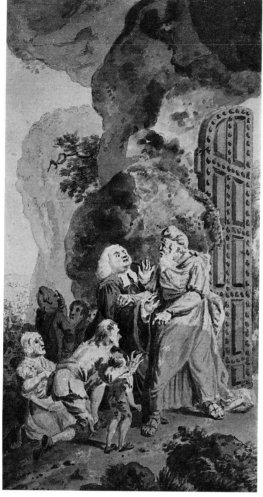

24

people pass." At which the parson was stepping forwards with a stately gait before them; but Minos caught hold of him and pulled him back, saying, "Not so fast, doctor . . ." '

Ex Cat.
Formerly attributed to Michael Angelo Rooker
The East End of Worcester Cathedral, with Edgar's Tower, from the north-east

Pencil and watercolour; 8¾ × 7¼ (22·2 × 18·5)
D 3–1902
CONDITION: Faded

The apse of the Cathedral with flying buttresses, partly obscured by a shop at right; beyond a high wall at left is the northern façade of the gateway known as Edgar's Tower.

Interest in Worcester Cathedral was stimulated by the investigation of the tomb of King John, which took place in the Cathedral on 17 July 1797: inside was found not only the coffin but the royal corpse as well (see Evans and Britton (eds.), op. cit., vol. XV, 1815, pp. 74–6). Joseph Powell's large watercolour in the Victoria & Albert Museum (1759–1871) is almost certainly the *West view of Worcester Cathedral* exhibited at the RA in the following year, together with a view of the east end. The present picture has affinities with Powell's *West View* (scraping out to give the effect of chimney smoke, and birds in the sky – neither of which is characteristic of Rooker) but in general the manner is not Powell's. The present cataloguer offers a tentative attribution to T. R. Underwood (see p. 66) on the basis of the treatment of the figures and stony foreground, the slightly awkward perspective, and the distinctive delineation of tracery, in which the delicate stonework is picked out by thin lines of dark shadowing (cf. fig. 26).

There is no other evidence that Rooker visited Worcester.

Ex Cat.

Rooker's tour of 1796

'List of Sketches abstracted from his diary By M. A. Rooker'
[MS in Rooker Papers, British Museum]

1796		numbers	1796		numbers
July 20th	Colchester Castle	1 & 2	Aug 12th	Thetford Abbey	28
July 21st	St. Botolphs priory	3 & 4	,,	,, Gate	29
July 22nd	St. John's Gate –		Aug 13th	2d View of Abbey	30
	called the G . . .	5	Aug 13th	Sluice with ruins of	
July 23rd	Coggleshall Church			the Cannons &	
	& part of town from			Cathedral	31
	window of		,,	The Canons & yard	32 &
	Wheatsheaf Inn	6		of White Hart Inn	33
July 25th	Castle Hedingham	7	Aug 16th	Castle Acre Priory –	34 &
July 26th	Little Hedingham			West Front of Do.	35
	from Clare	8	Aug 17th	3d. View of Do. –	36 &
July 27th	Another of Do.	9		View of the Castle	37
July 27th	Sketch of a Farm		Aug 18th	2d View of Castle	38
	Yard near Do.	10	Aug 20th	Norwich Castle	39
July 28th	Melford Hall	11	Aug 24th	Caistor Castle	40
July 28th	Kentwell Hall	12	Aug 25th	South Gate,	
July 30th	St. James' Gate,			Yarmouth North	41 &
	Bury	13		Gate	42
Aug 1st	The Monastery Do.	14	Aug 26th	Yarmouth Church	
,,	The Bridge Do.	15		from S.W.	43
Aug 2nd	Another Sketch of		Sept 1st	Rumburg Church	44
	do. with part of town	16	Sept 2nd	The Bridge at Mells	45
Aug 3rd	Hengrave Hall	17	,,	Blithburg Priory	46
Aug 4th	Abbey Gate two	18 &	Sept 3d	2d Sketch of Do.	47
	sketches	19	Sept 5th	The Hospital	
Aug 5th	St. Petronella's			Chapel, Dunwich	48
	Chapel	20	,,	Inside view of	
Aug 6th	St James Church	21		Church next the Sea	49
Aug 8th	Outside view of		,,	Outside view of	
	Abbey Gate from			Hospital Chapel	50
	house of Revd. Mr.		Sept 6th	Leiston Abbey	51
	Mills	22	Sept 7th	Do. South side	52
Aug 9th	The "Saxon"		Sept 8th	Do. East End	53
	Building in the		,,	Do. West Octagon	
	Butter Market	23		tower	54
Aug 9th	The North Gate	24	Sept 10th	Aldringham Church	55
Aug 10th	St. Botolphs Chapel,		Sept 12th	Oxford Castle	56
	Southgate Street	25	Sept 13th	Orford Church	57
,,	Ruins of Abbey from		Sept 16th	Framlingham Castle	
	Mrs. Davers orchard	26		from west	58
Aug 11th	Barnham Church		,,	Do. from north	59
	(ruins of)	27			

Works exhibited by Michael Angelo Rooker

Note: These entries are reproduced as they appear in the original catalogues of the Society of Artists and the Royal Academy, without any correction of inconsistencies in spelling or punctuation. The lists correspond in essentials with those reprinted in Algernon Graves, *The Society of Artists . . .*, 1907, and *The Royal Academy of Arts . . .* (8 vols.), 1905-6.

Society of Artists

1763 (188) Three views from nature

(Great Queen Street)

1765 (229) Two stained drawings from nature

1766 (145) A view of the horse guards, in water-colours

1767 (270) View of the Court of Claims, or Painted Chamber

(At Mr. Smith's, Long-acre)

1768 (276) A View of the Villa Adriana, from a picture of Mr. R. Wilson

†1768 (207) A View of the Court of Claims, or Painted Chamber; a stained drawing

(†: This drawing appeared in a special exhibition of 30 Sept. 1768 held in honour of the King of Denmark; otherwise the Society's exhibitions were held in April or early May.)

Royal Academy

(Queen's-court, Great Queen-street, Lindoln's-inn-fields)

1769 (96) A View of Liverpool; a stained drawing

 (97) A view of Liverpool across the River Mersey; a stained drawing

1770 (156) A view of Buildwas Priory, in the county of Salop.

1771 (166) A view of Merton College, in Oxford, kitcat

 (167)* Lilishall-abby, in the county of Salop, ditto

 (168) Part of Wenlock-abbey, in ditto.

1772 (218)* View of Temple-bar, on a May-day

 (219)* A landscape

 (220) Buildwas Priory in Shropshire

 (221)* A small ruin

1773 (254) Harewood House in the county of York, the seat of Edwin Lascelles, Esq.

(Opposite the Museum, Great Russel-Street, Bloomsbury)

1774 (239) A view of Harewood Castle, in the county of York, belonging to Edwin Lascelles, Esq.

 (240) A nobleman's seat

1775 (249) Portrait of an old oak

 (250) Waltham Cross a stained drawing

 (251) Entrance to Bayham Abbey, Kent a stained drawing

 (252) The rocks near Tunbridge Walks, Kent

1776 (259) A ruin

 (260) The cross isle of Bayham abbey, Sussex a stained drawing

 (261) A part of King's College chapel, Cambridge a stained drawing

 (262) Kirstall Abbey, Yorkshire a stained drawing

1778 (255)* View of St. Augustin's Gate, Canterbury

(256)* View of St. Mary's abbey,
York, its companion
(257)* View of the stone quarry at
Mount Sion, near
Liverpool
(258) Six stained drawings, being
part of a set of designs for a
new edition of the dramatic
works of Beaumont and
Fletcher
1779 (270) Friar Bacon's study at
Oxford
(271) The Castle-Hill at ditto
(272)* Godstowe Bridge, near
ditto
(273)* Lathorn Postern, at York
(274)* Westgate, Winchester
1780 (111) Hadley Park, with the urn
dedicated to Shenstone
(376) Design for a new edition of
Fielding's Works
1781 (239) The death of Hengo.
"*Destruction go with thy
coward soul, and heav'n direct
my hand.*" Vide Beaumont
and Fletcher's Bonduca
1786 (58) Landscape and ruins
(112) Landscape and Ruins

(53, Long Acre)
1789 (432) Goodrich castle,
Herefordshire
(453) Munow Bridge,
Monmouthshire
(584) Tintern Abbey,
Monmouthshire
(610) Chepstow Bridge,
Monmouthshire
1790 (17) View in Herefordshire
(85) Tintern Abbey,
Monmouthshire
(134) Wenlock abbey, Shropshire
(148) View in Herefordshire
1792 (47) Part of Pevensey castle
(103) Strand gate, Winchelsea
(177) View on the coast of Sussex
(438) Battle Abbey-gate, Sussex

(23, Dean-street, Soho)
1793 (124) Winchelsea castle, Sussex
(271) Hastings cliff and castle,
Sussex

(616) View from Hensome hill,
Herts.
(620) Windcliff hill, near
Chepstow, Monmouthshire
1794 (339) Haughman's Abbey,
Shropshire
(349) Caesar's tower, &c.
Warwick Castle
(414) Llanegwast or Valle Cruci's
Abbey, Denbighshire
(420) Two views of Kenilworth
Castle, Warwickshire
(423) Two views of Kenilworth
Castle, Warwickshire
1795 (574) Glastonbury Abbey,
Somersetshire
(578) Glastonbury Abbey,
Somersetshire
(601) Romsey church, Hants
(606) Netley Abbey, Hants
1796 (653) Landaff Cathedral,
Glamorganshire
(657) Lantony Abbey,
Monmouthshire
(666) Two views
(671) Two views
(684) Arundel Castle, Sussex
(691) Lewes Castle, Sussex
(705) Two Views of the Chapter-
house at Margam, in
Glamorganshire
(710) Two views of the Chapter-
house at Margam, in
Glamorganshire
1797 (417) Llandilo,
Caermarthenshire, and
Newport on Usk,
Monmouthshire
(432) Chepstow Castle,
Monmouthshire; and Coity
Castle, Glamorganshire
(467) East front of the Abbey
Gate, Bury St. Edmunds,
Suffolk
(485) West front of the Abbey
Gate, Bury St. Edmund's,
Suffolk
(711) North and South Gates,
Yarmouth
(721) Two Views of Neath
Abbey, Glamorganshire

1798

(722) Great Hall, Caerpilly Castle, Glamorganshire

(748) Inclined Tower, &c. Caerpilly, Glamorganshire

(340) Ponty Pridd, Glamorganshire

(341) Leystone Abbey, Suffolk

(368) Castle Acre Priory, Norfolk

(412) St. John's Abbey-gate, Colchester; and Guildford Castle, Surry

(577) Castle Dinas Bran, Denbighshire

(614) Denevor Park, Caermarthenshire

(624) Wookey hole, Somersetshire

(630) The Abbot's bridge, Bury St. Edmund's, and the conduit at Bayswater

1799

(324) The Abbot's kitchen, Glastonbury, Somersetshire

(333) The kitchen at Netley Abbey, Hampshire

(660) Drusllwyn Castle, Carmarthenshire, and Ragland Castle, Monmouthshire

(661) Two views near Breton Ferry, Glamorganshire

(829) A landscape

(845) A landscape

(854) St. Botolph's Priory, Colchester, Essex

(861) St. Joseph's Chapel, Glastonbury, Somersetshire

1800

(314) Buildwas abbey, Shropshire

(329) View in Hyde-park, and Castle Acre Castle, Norfolk

(345) Wokey, Somersetshire, and Framlingham castle, Suffolk

(346) A piggery at Warwick

(369) Under part of the Market-hall, Warwick

(391) Part of Leystone abbey, Suffolk

* A note in the catalogues states that 'The pictures, &c., marked with an (*) are to be disposed of.'

Check-list of Michael Angelo Rooker's drawings & watercolours in British public collections

Note: (s) refers to a signature or monogram in the artist's own hand. Dimensions are given in centimetres.

Aberdeen, City Art Gallery
The Cast Iron Bridge near Coalbrook Dale, 39·4 × 62·2

Aberystwyth, National Library of Wales
Coity Castle (s), 25·5 × 35·5
Entrance to Kidwelly Castle, 15 × 24
Glastonbury Abbey (s), 26 × 35·5
Llandeilo Bridge (s), 26 × 36
Part of Usk Castle, 19 × 27·5

Accrington, Haworth Art Gallery
Figures near abbey ruins (s and d 1795), 26·7 × 35·5

Bedford, Cecil Higgins Museum
Entrance to the Bishop's Palace, Wells (s), 23 × 28

Belfast, The Ulster Museum
View of Hyde Park, London, 22·2 × 30·6

Birkenhead, Williamson Art Gallery & Museum
Framlingham Castle, 31·6 × 28

Birmingham, Museums & Art Gallery
Abbey Gate, Bury St Edmund's, east front (s), 38·4 × 53·4
Abbey Gate, Bury St Edmund's, west front (s), 38·6 × 53·1
Caerphilly Castle from the Boar's Head Inn (s), 23·2 × 36·3
Drusllwyn Castle (s), 25 × 36·4
Gabled farmhouse (s), 24·4 × 36·1 (a version of *A farmyard near Thetford,* BM)
Magdalen Bridge and Tower, 31·3 × 45·2
A market town (s), 25·4 × 36·1
Netley Abbey (s), 47 × 55·2

Bolton, Museum and Art Gallery
Composition by the lake, 26·4 × 36·5

Brighton, The Royal Pavilion, Art Gallery & Museums
Near Leiston Abbey (s), 27 × 20·9

Cambridge, Fitzwilliam Museum
Caerphilly Castle (s), 26·7 × 36·2
Castel Dinas Bran and the Vale of Llangollen (s), 31·4 × 47·8
The Clarendon Press, Oxford, 31·5 × 45
Merton College, Oxford (s), 29·5 × 44·2
The Old Manor House, Marylebone, as a school, front view (s and d 1791), 25·4 × 35·7

Cardiff, National Museum of Wales
Abergavenny Castle, 19 × 28
Abergavenny Castle, 19 × 28
Brecon Bridge, 19 × 26·7
Chepstow Bridge (s), 30·5 × 47·6
Coity Castle (s and d 1795), 18·7 × 26·6
Donington Castle, 21·5 × 28
Llandaff, Bishop's Castle, 19 × 25·4
Margam Chapter House, 28 × 38·1
Margam Chapter House, 28 × 38·1
Newport Castle, 29 × 28
Newport Castle and Bridge, 28 × 38·1
Ogmore Castle, 29 × 28
Ogmore Castle, 19 × 28
Ponty Prydd Bridge (s and d 1795), 31·8 × 38·1
Ponty Prydd Loch, 19 × 28
Ragland Castle, 19 × 28
Ragland Castle, 19 × 28
Usk Bridge, 18·4 × 27·3

Colchester, Colchester and Essex Museums (on loan to the Minories)
St Botolph's Priory (s), 27·3 × 39·4

Coventry, Herbert Art Gallery
Caesar's Tower, Kenilworth Castle (s), 28 × 37
Entrance to the Hall, Kenilworth Castle (s), 27·5 × 37·5

Dublin, National Gallery of Ireland
A shaded farmyard (s), 26·4 × 36·5
North Gate, Great Yarmouth (s), 25·6 × 35·5
South Gate, Great Yarmouth (s), 25·6 × 35·5
St Oswald's Church, Oswestry (s), 27·8 × 37·2

Edinburgh, National Galleries of Scotland
Castle at Newport on Usk, Monmouthshire,
18·5 × 27·5

Leeds, City Art Gallery
A lane near Hindhead (s), 36·3 × 26·2
St John's College, Oxford, 30·7 × 44·9

Liverpool, Walker Art Gallery
Kenilworth Castle, 22·5 × 27·5
Kirkstall Abbey, Leeds (s), 27·5 × 41·5
Liverpool from the bowling green, 31·4 × 76
The south-east prospect of Liverpool from
Seacombe boat-house, 30·4 × 76

London, British Museum
Design for a garden scene, 30·2 × 48·2 (1964-
12-12-3)
Entrance to a park (unfinished), 45·7 × 35·2
(1889-6-3-261)
Farmyard, Thetford (s), 16·5 × 22 (1857-2-
28-210)
Landscape with castle and cathedral, 43·2 × 34
(1862-10-11-725)
The Old Manor House, Marylebone, as a school,
front view 16·4 × 24·1 (Pennant V 180)
The Old Manor House, Marylebone, as a school,
garden view, 16·3 × 24·2 (Pennant V 181)
The Old Manor House, Marylebone (sketches
of interior details), 17·3 × 24·6 (Pennant V
182)
The Old Manor House, Marylebone: staircase,
17·3 × 24·6 (Pennant V 183)
Porch of Montagu House (s and d 1778),
15·5 × 20·3 (1868-3-28-334)
Ruined Abbey, Margam (s and d 1795), 27 ×
35·6 (1935-1-3-26)
Ruined Abbey, Margam, 27·1 × 36·1 (T.B.
CCCLXX-A)
A scene-painter at work in his studio, 37·6 ×
30·2 (1968-2-10-32)
View of a castle (*Lewes Castle*) (s), 20·6 × 27·3
(1868-3-28-333)
28 illustrations to *The Dramatick Works of*
Beaumont and Fletcher, 10 vols., 1778 (1859-
7-9-71 to 98)

London, Courtauld Institute of Art
Castel Dinas Bran and the Vale of Llangollen
(s), 33·2 × 59·1
Haughmans Abbey (s), 28·2 × 37·6

London, Forty Hall, Enfield
Figures outside an inn, 22·5 × 29·5
A ruined abbey in Essex, 15·5 × 20·8

London, Passmore Edwards Museum,
Newham
View of Romford, Essex (s), 23 × 29

London, Royal Academy
Battle Abbey (s and d 1792), 41·9 × 59·7
Caesar's Tower, Warwick Castle (s), 28 × 38
The Hall at Kenilworth Castle from Lancaster's
Buildings (s), 28 × 38
The North Foreland Lighthouse, Kent (s and d
1780), 22·8 × 39·4
Valle Crucis Abbey (*Llan-Egwast*) (s), 44·5 ×
63
View at Margam, Glamorganshire, 22·8 × 29·2
Winchelsea Churchyard, 22·8 × 29·2
Wooded landscape with cattle (s), 16·5 × 20·3
Wooded landscape with horses (s), 16·5 × 20·3
Wooded landscape with fence and horseman (s),
16·5 × 20·3
Wooded landscape with distant figures (s),
16·5 × 20·3

London, Tate Gallery
The Abbot's Kitchen, Glastonbury (s), 35·5 ×
45·8

London, Victoria & Albert Museum
(see detailed catalogue)

London, Woodlands Art Gallery,
Blackheath
The Great Hall of Eltham Palace, 21 × 26·6

Manchester, Whitworth Art Gallery
Buildwas Abbey, 36·8 × 46·3
Leiston Abbey (s), 26·7 × 36·5
Llanthony Abbey (s and d 1796), 38·5 × 53·8
Usk Castle (s), 30·2 × 42·8

Newport, Museum and Art Gallery
Caerleon Castle (s), 18 × 26
Chepstow Castle (s and d 1788), 26 × 36

Hornsey Church (*An old Church*), 18·1 × 22·5
Ragland Castle: Entrance (s and d 1795),
19 × 25·4
Ragland Castle with Horses (s and d 1795),
19 × 25·4

Newcastle upon Tyne, Laing Art Gallery
An old castle (s), 26 × 36·2

Norwich, Castle Museum
The Avon Gorge and Bridge, 30·5 × 48·1
The Avon Gorge with St Vincent's Cliff (s),
30·5 × 47·9
Norwich Castle (s), 23·7 × 33·2

Oxford, Ashmolean Museum
Buildwas Abbey (s), 24 × 29·3
Distant view of Kenilworth Castle (s), 22·8 ×
27·9
North-west view of Friar Bacon's study, 31·5 ×
45
*Magdalen College, Oxford, from the north side of
the First Quadrangle* (s and d 1778), 31·3 ×
45
The Queen's College, Oxford, from the High (s),
31·4 × 45
St John's Abbey Gate, Colchester (s), 36·5 ×
26·3

Rochdale, Art Gallery
Landscape with trees (s and d 1799), 25·4 ×
32·8
A ruined castle, 27 × 36·5

Southampton, City Art Gallery
The Kitchen, Netley Abbey (s), 34 × 45
Romsey Abbey (s), 46·4 × 61

Sheffield, Graves Art Gallery
Netley Abbey (s), 27·3 × 36·5

Southport, Atkinson Art Gallery
Kenilworth Castle, 23 × 28

Stoke-on-Trent, City Museums & Art
Gallery
Farmyard (*St Botolph's Chapel, Bury St
Edmunds*) (s), 15·2 × 21·2

Swansea, Glynn Vivian Art Gallery &
Museum
Caerphilly Castle, 24 × 37

Windsor, Royal Collection
The New Lodge (*Belvedere*), *Windsor Forest*
(s and d 1776), 13·3 × 18·7 (after Paul
Sandby)

Bibliographical note

Manuscript material

A group of typescript and manuscript papers relating to Rooker is in the
Department of Prints and Drawings at the British Museum (1964–12–12–3, items
1–16). This includes records of some of the purchasers and prices at Squibb's sale
of Rooker's estate held from 29 April to 2 May 1801; a copied extract from
Rooker's diary, reproduced here as Appendix 1; a manuscript obituary
corresponding with that published in the *Gentleman's Magazine* for May 1801,
p. 480; and several small sketches.

Secondary sources

The richest contemporary source is *The Diary of Joseph Farington*, edited by
Kenneth Garlick and Angus Macintyre (Yale, 1978 etc.). Short but useful
assessments of Rooker can be found in the following general histories of
watercolour painting:

John Lewis Roget, *A History of the 'Old Water-Colour' Society*, 2 vols., 1891
(reprinted 1972)

Cecil E. Hughes, *Early English Water-Colours*, 1912 (reprinted 1929 and 1950)

Iolo Williams, *Early English Watercolours*, 1952 (reprinted 1970)

Martin Hardie, *Water-Colour Painting in Britain*, vol. 1, 'The Eighteenth Century',
1966 (reprinted 1975)

Articles

Sybil Rosenfeld, 'A Georgian scene-painter at work', *British Museum Quarterly*,
XXIV, 1969, nos. 1–2, pp. 33–6

Patrick Conner, 'A View of the first St Mary's', *Hornsey Historical Bulletin*, 23,
1982, pp. 10–11

Patrick Conner, 'Michael Angelo Rooker in East Anglia', *The Old Water-Colour
Society's Club Annual*, Volume 57, 1982, pp. 48–52

Index